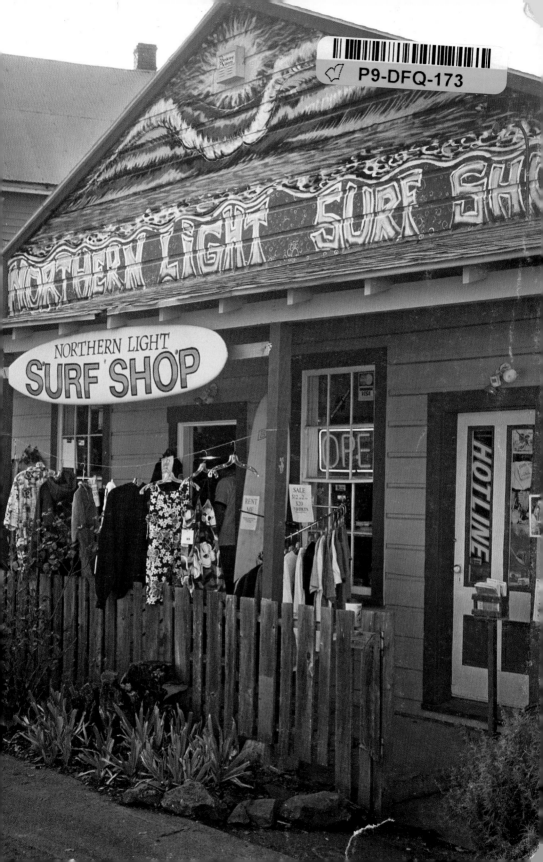

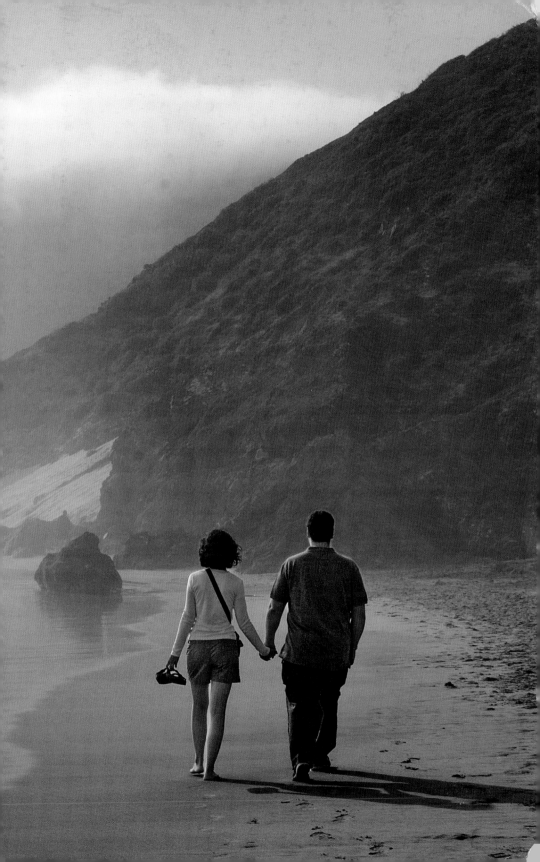

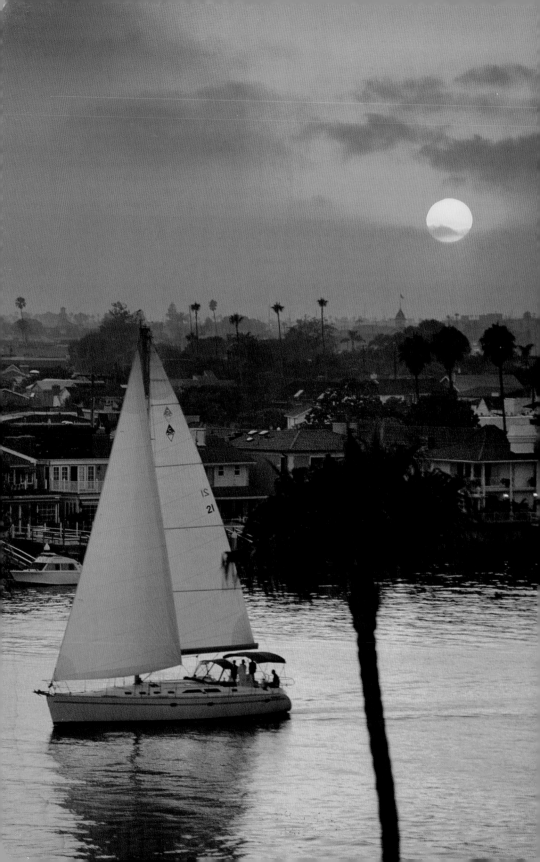

Backroads

of the California Coast

YOUR GUIDE TO SCENIC GATEWAYS & ADVENTURES

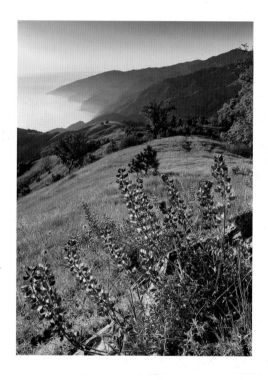

TEXT BY **Karen Misuraca**

PHOTOGRAPHY BY **Gary Crabbe**

Voyageur Press

First published in 2009 by MBI Publishing Company and Voyageur Press, an imprint of MBI Publishing Company, 400 First Avenue North, Suite 300, Minneapolis, MN 55401 USA

The information in this book is true and complete to the best of our knowledge. All recommendations are made without any guarantee on the part of the author or Publisher, who also disclaims any liability incurred in connection with the use of this data or specific details.

We recognize, further, that some words, model names, and designations mentioned herein are the property of the trademark holder. We use them for identification purposes only. This is not an official publication.

Voyageur Press titles are also available at discounts in bulk quantity for industrial or sales-promotional use. For details write to Special Sales Manager at MBI Publishing Company, 400 First Avenue North, Suite 300, Minneapolis, MN 55401 USA.

To find out more about our books, visit us online at www.voyageurpress.com.

Library of Congress Cataloging-in-Publication Data

Misuraca, Karen.
 Backroads of the California coast : your guide to scenic
getaways & adventures / text by Karen Misuraca ; photography by Gary Crabbe.
 p. cm.
Includes index.
ISBN 978-0-7603-3343-3 (sb : alk. paper)
1. Pacific Coast (Calif.)–Guidebooks. 2. California–Guidebooks. I. Crabbe, Gary. II. Title.
F868.P33.M56 2009
917.9404'53–dc22

2009001326

Editor: Leah Noel
Designer: Chris Fayers

Printed in China

FRONTISPIECE: The eclectic Northern Light Surf Shop in Bodega, California, is a prime example of the Golden State's long association with this sport.

PAGES 2–3: A couple walks hand in hand on a foggy day at Pfeiffer Beach along the Big Sur Coast in California's Monterey County.

TITLE: A sailboat cruises out to sea at sunset from Inspiration Point in Newport Beach.

TITLE DETAIL: Lupine wildflowers bloom in the green hills of the Ventana Wilderness, part of the Los Padres National Forest in central California.

CONTENTS

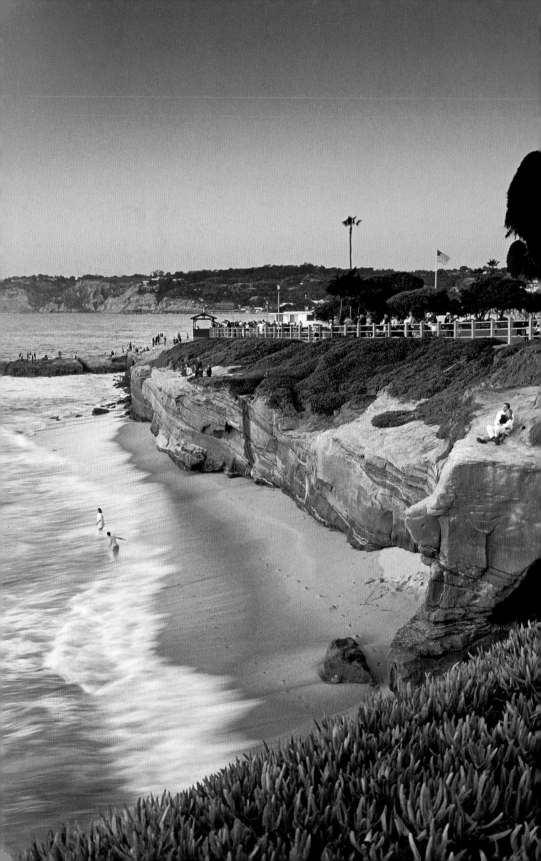

INTRODUCTION

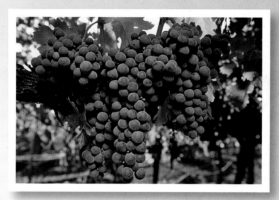

Overwhelming in its vastness, California stretches down the Pacific Coast for 1,264 miles. The state is split lengthwise by a wide central valley, warmed by intense heat of the inland Mohave and Sonoran deserts, and bordered by the high mountain frontiers—the Cascades, the Sierra Nevada, and the Coast Ranges.

Drawn irresistibly to the blue Pacific Ocean, eighty percent of Californians live within thirty miles of the sea. They turn to their coast for refreshment of their minds and bodies, as do visitors who come here by the millions from across America and the world to see the region's famous landmarks and historical sites and to enjoy the weather. Some people never touch the sand nor dip their toes in the water. They drive to the seacoast, sit in their vehicles, and breathe in the invigorating salt air.

More than one hundred California beaches, parks, preserves, and monuments, and several national parks are easily accessible from

ABOVE: Wine grapes grow on the vine at Kunde Estates, near Kenwood in California's most well-known wine-making region, Sonoma County.

OPPOSITE: La Jolla Cove, part of Scripps Park in San Diego County, is one of the most photographed beaches in California. With crystal waters allowing for underwater visibility up to thirty feet, this cove also is a popular spot for scuba diving and snorkeling.

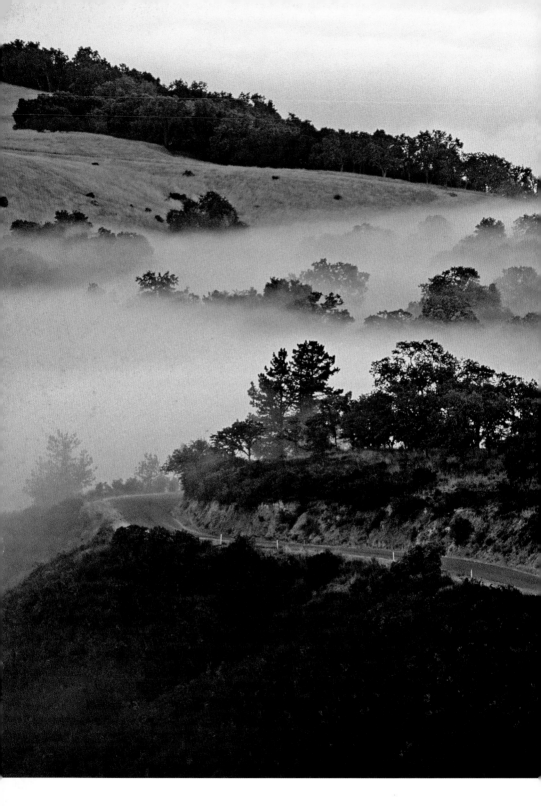

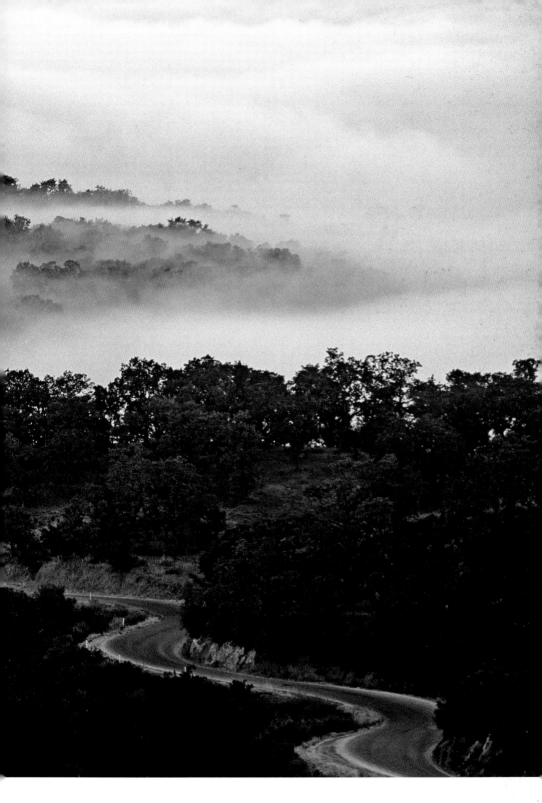

the meandering coastal routes of State Route 1 (Highway 1) and U.S. Highway 101. And for adventurous travelers who venture a few miles off the two main highways, even more natural and historic attractions are in store. And that is what *Backroads of the California Coast* is all about—discovering the lesser-known, quiet pleasures away from the sometimes maddening crowds and the well-trodden destinations.

Bill Ahern of the California Coastal Conservancy, a nonprofit organization that protects shoreline access, advises backroad adventurers to "get away from roads and parking lots and hike or stroll along the spectacular trails in the state parks, which stretch along a quarter of the coast, or even across private property where we and other agencies have acquired easements [allowing] the public to walk along the coast." "Bring binoculars," he adds, "and check out the birds on the wetlands, the river and creek estuaries, and the beaches where the endangered snowy plovers forage for food."

About midway along the coast, around Pismo Beach, legions of palm trees signal sunny Mediterranean weather and sandy beaches all the way to the Mexican border. Everything below is Southern California; everything above is Northern California—and that, as they say, makes all the difference. Which is best? The cool redwood forests and romantic fishermen's villages up north? Or the warm waters and vacation resorts of the southern part of the state? The central coast has its appeal, too, from the winelands of the Santa Cruz Mountains to the architectural icons of Carmel and the wild cliffs and coves of Big Sur.

Mountains meet the sea on the north coast—a land of big rivers, evergreen rainforests, and an irregular shoreline scrubbed by raucous surf. It's a romantic place with few inhabitants and vast tracts of untrodden wilderness. Travelers come north for the dramatic beauty and the feeling of isolation, when the only footprints on a beach may be your own and a brooding grove of redwoods stands in utter primeval silence, as it has for more than a thousand years. Wrapped in mists and pummeled by storms, northern seacoast towns are small and snug, picturesque with Victorian- and Gold Rush–era buildings.

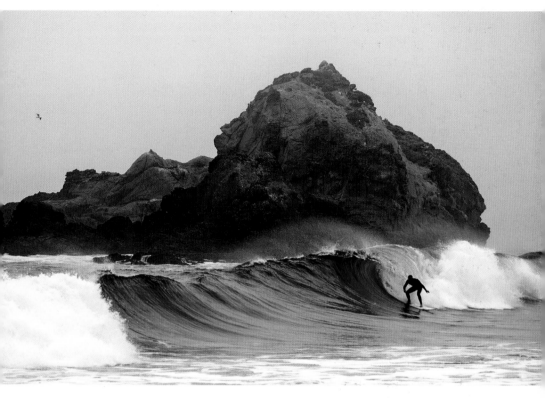

A surfer rides the waves at Pfeiffer Big Sur Beach, decorated with sea stacks and rock arches.

To the north, beaches are narrower, rockier, and home to more tide pools. Although the climate remains mild most of the year, you can expect more fog and rain in the wintertime (and even in the summertime in San Francisco). Ocean swimming in the colder northern waters is given up for beachcombing and bonfires.

The weather on the central coast south of San Francisco is always in flux. Clouds come and go, and even the densest fog usually burns off by midday. The colors and moods of the sea and sky shift, often in the span of an hour or two. Tracing the coastline south from Monterey Bay to Morro Bay, Highway 1 rides along above rocky promontories, coves, and harbors. Country roads head inland to quaint mountain villages and historic valleys where the first tourists—Spanish *conquistadors*—once galloped.

The Anderson Valley is one of California's many places that are perfect for growing grapes used in the region's abundant winemaking.

At the entrance to the Santa Barbara channel, Point Conception is where the north–south run of the coastline turns east–west, and beaches are oriented toward the sun. This golden fragment of the edge of the continent creates a great, convex sandy shore separated from the intense heat of the interior deserts by narrow mountain ridges. A brilliant, overexposed sky is a blue umbrella year-round, save the occasional midwinter day. In San Diego, near the Mexican border, it rains less than ten inches a year.

Even near the population centers of Los Angeles, San Diego, and Santa Barbara, seekers of the backroads will find 1940s glamour on Catalina Island, historic ranchos and missions, some of the best bird-watching in the world in a handful of precious estuaries, and a high valley Shangri-la promising pink sunsets over Pacific shores. As Joan Dideon wrote in an essay describing her experiences living in California, ". . . Things had better work here, because here, beneath that immense bleached sky, is where we run out of continent."

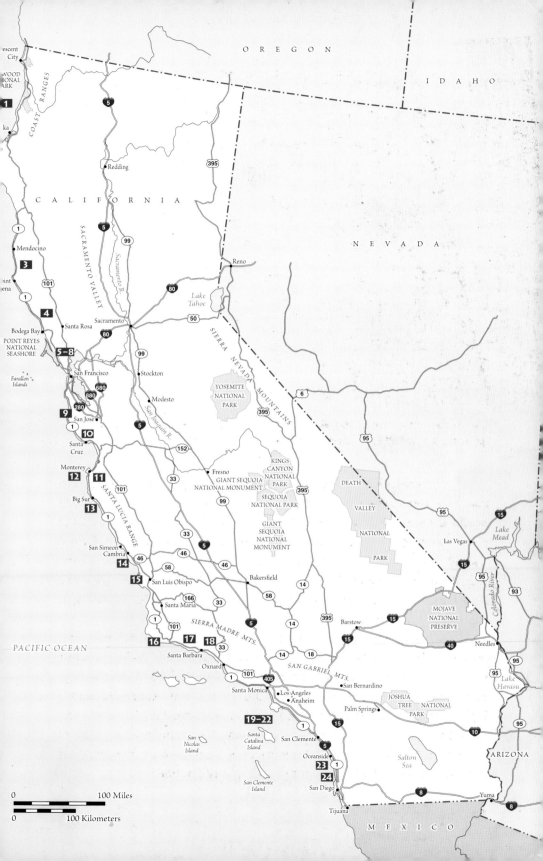

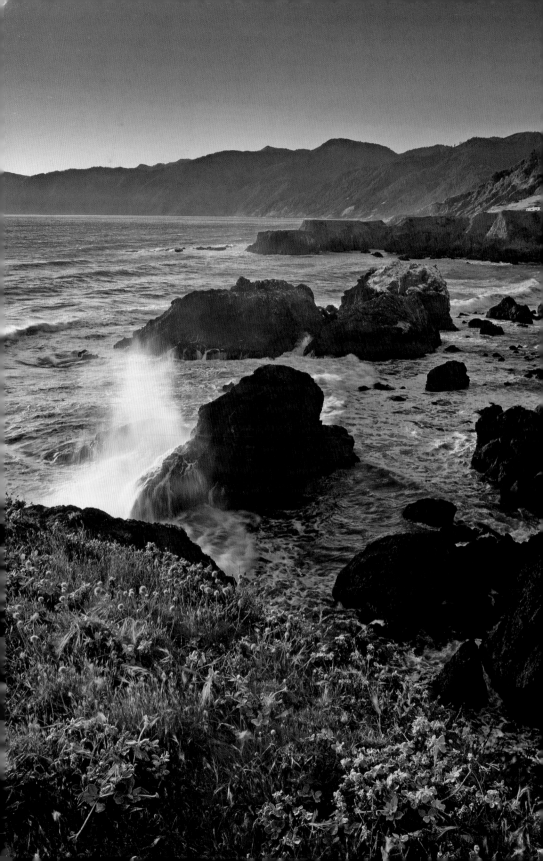

PART I

The North Coast

Smashing Surf and Towering Trees

The best months for travel on the north coast are May and June and September and October, when seas are calm and skies are clear. Wintertime is for romantics who love the drama of a tumultuous gale and the warmth of a fireplace while rain pelts the roof and stiff winds drive smashing surf into rocky pinnacles offshore. Thriving in the moist climate is a breathtaking, true wilderness, most of it readily accessible—luxuriant forests of redwood, ponderosa pine, and Sitka spruce; magnificent river valleys; the National Wildlife Refuge at Humboldt Bay; and the pristine Lost Coast.

Above the Golden Gate Bridge, meadows on the Marin Headlands turn a brilliant green in the spring, while the hot days of summer ripen

OPPOSITE: Wildflowers bloom on coastal bluffs above Shelter Cove in Northern California's Lost Coast.

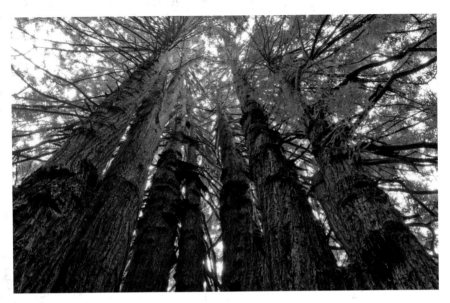

The Cathedral Redwood Tree, on the Kingdom of the Trees Trail, a part of the Trees of Mystery attraction in Del Norte County, California.

the wine grapes along the meandering backroads of the Green Valley in the Sonoma wine country. Fishing party boats sail from the harbor at Bodega Bay at the south end of a string of jewel-like coves and beaches. A Victorian-era village floating on a high bluff above the mouth of the Big River, the entire town of Mendocino is a California Historical Preservation District.

Surrounded on three sides by the Pacific Ocean and San Francisco Bay, Marin County is one-third public parks, from the Marin Headlands to Muir Woods, Angel Island, and China Beach. The birthplace of the mountain bike, the county sports hundreds of miles of trails for hikers, bikers, and horseback riders. The gem among Marin's nature preserves, Point Reyes National Seashore, is an elongated triangle of beaches, lagoons, and estuaries, as well as dark forests and endless, windy headlands.

Among myriad adventures on the north coast, explorers on the backroads will discover an old Chinese fishing camp, Land's End in San Francisco, and vestiges of the Civil War and Spanish settlements.

OPPOSITE: A short hike brings visitors to the quiet Trinidad State Beach, where lupine wildflowers bloom in late spring.

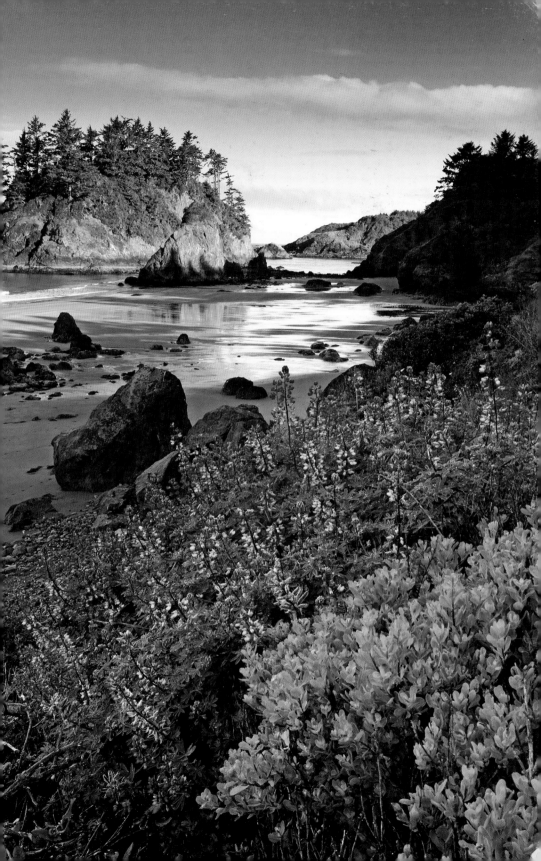

Marshlands, Rainforests, and a Rocky Seacoast

ARCATA TO PRAIRIE CREEK REDWOODS STATE PARK

Directions From Arcata, take U.S. Highway 101 north to Trinidad, where you will take Stagecoach Road north. Then connect to Patrick's Point Drive north and eventually return to U.S. 101. From here, continue north to Orick and Prairie Creek Redwoods State Park.

Arcata Marsh and Wildlife Sanctuary on the north end of Humboldt Bay is best seen in the mists of early morning, when stilt-legged herons stand motionless, hidden in the bulrushes. As the air warms, coots mutter and green-winged teal squawk in the narrow canals. Red-winged blackbirds prattle loudly as they cling to the tall reeds, their sharp talons alert for live prey. Northern harriers work the marsh, browsing for voles and squirrels on the pastureland edges. Northern river otters are often seen swimming along in the canals, their heads barely above water, searching for fish, frogs, and turtles—their favorite foods.

The best times of the year to wander the four miles of footpaths in the sanctuary are early spring and in November and December, when flocks of migrating ducks and birds number in the thousands. Hundreds of birders are on hand in March for Godwit Days to observe and celebrate the bird that breeds in Alaska and heads south, arriving in the marsh in crowds of twenty thousand or so.

Although it is usually unapparent to visitors, Arcata Marsh is actually a wastewater reclamation project; in fact, it is a model of how to combine wastewater treatment with recreation and wildlife preservation. The city of Arcata also manages the Arcata Community Forest. Established in the 1950s, it was the first city-owned forest in the state. Sustainably logged from time to time, the second-growth

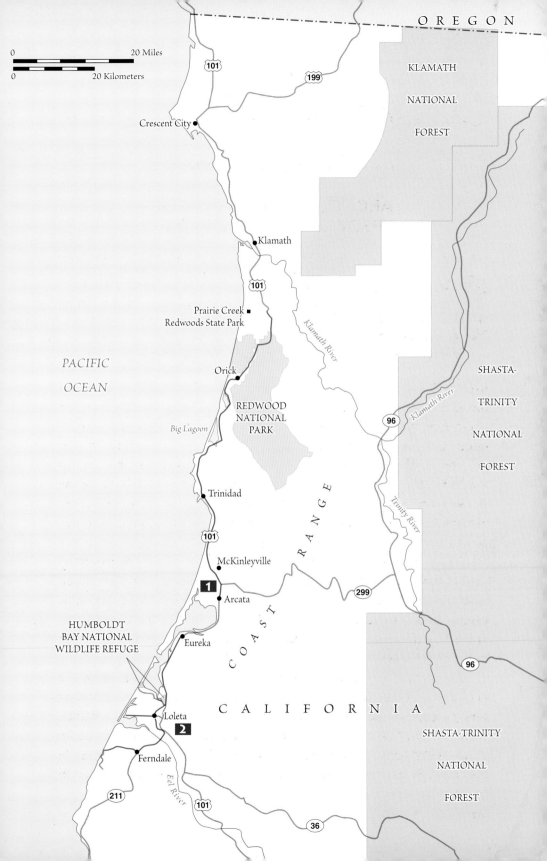

OREGON

0 ——— 20 Miles
0 ——— 20 Kilometers

KLAMATH

NATIONAL

FOREST

101

199

Crescent City •

Klamath

101

Prairie Creek ■
Redwoods State Park

Klamath River

Orick

SHASTA-
TRINITY

NATIONAL

FOREST

PACIFIC

OCEAN

REDWOOD
NATIONAL
PARK

Big Lagoon

96

Klamath River

Trinidad •

Trinity River

C
O
A
S
T

R
A
N
G
E

101

McKinleyville •

1

299

Arcata •

HUMBOLDT
BAY NATIONAL
WILDLIFE REFUGE

Eureka •

96

C A L I F O R N I A

Loleta •

2

SHASTA-TRINITY

Ferndale •

NATIONAL

211

Eel River

101

FOREST

36

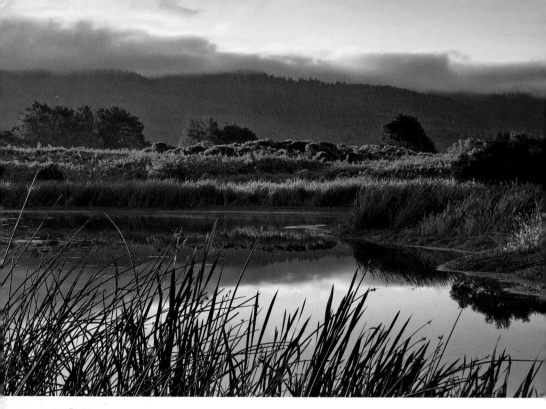

The Arcata Marsh represents a unique model where nature handles the final steps in treating Arcata's city sewage, using ponds and reeds to cleanse the water.

redwoods here provide habitat for the endangered spotted owl. Trails for walkers, horseback riders, and bikers wind beneath the towering trees and through fern grottos and meadows.

A few miles north, Trinidad is a seaside village with a small harbor dotted with fishing boats and sheltered on the north end by Trinidad Head, a massive rock outcropping topped by a lighthouse. Fishing for salmon, rockfish, and lingcod is popular off the shore and off the pier or by kayak, by small boat, and on charter boat expeditions. Founded in 1850, Trinidad first boomed during the California Gold Rush and then became a sawmill town in the 1870s. In the early twentieth century, it was a busy whaling port, yet today's population only numbers in the hundreds.

Just south of town, travelers veer west from U.S. Highway 101 onto Scenic Road to enjoy the sea views and the series of small beaches. North of town, Patrick's Point Drive is another side road offering a scenic alternate to the main highway. For many miles along this stretch of coastline, dramatic sea stacks, coves, beaches, and headlands

compose one of the most magnificent ocean shorelines on the edge of this continent.

About five miles north of Trinidad, Patrick's Point State Park is a square mile of high cliffs; beaches scattered with driftwood; and a forest of fir, pine, and red alder. Visitors can walk on an old Native American trail along the bluffs from which they can spot sea lions, seals, and, in the wintertime, gray whales. At the north end of the park at Agate Beach, tide pools are colorful with sea anemones, sea stars, and crabs, and bits of jade and agate are often found at the water's edge.

Off U.S. 101 about six miles north of Orick is Prairie Creek Redwoods State Park, one of four state parks within Redwood National Park. Prairie Creek's twelve-thousand-acre tract of magnificent coastal redwoods

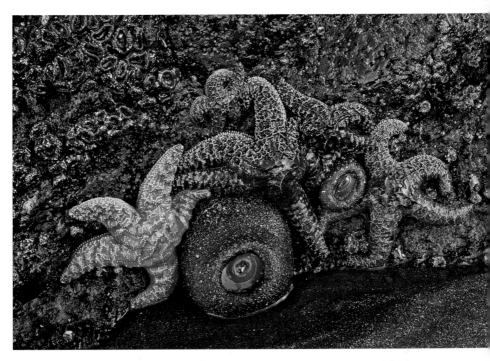

Low tide offers the chance for people to walk among the rocks and find creatures like these ochre starfish (*Pisaster ochraceus*) and a giant green sea anemone at Trinidad State Beach.

PAGES 24–25: The Sky Trail gondola ride at Trees of Mystery—a popular visitor attraction for many years in Del Norte County—travels through a thick forest to the top of a mountain.

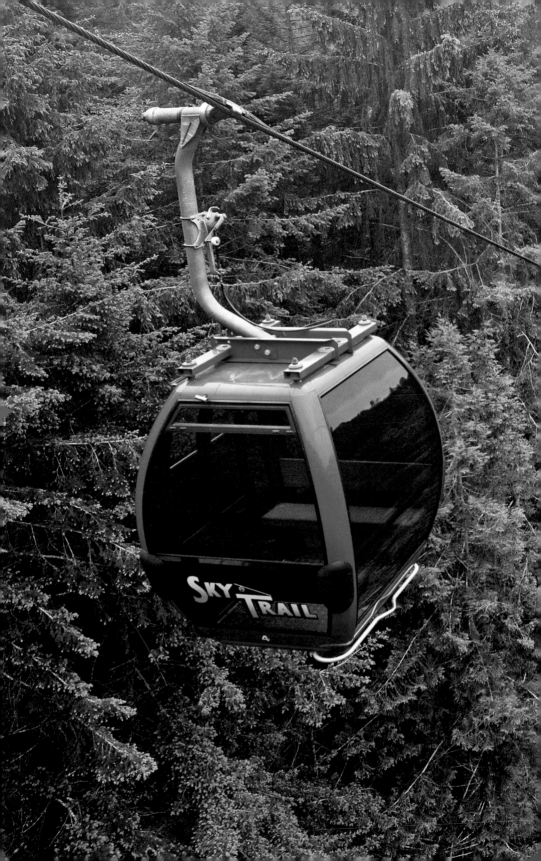

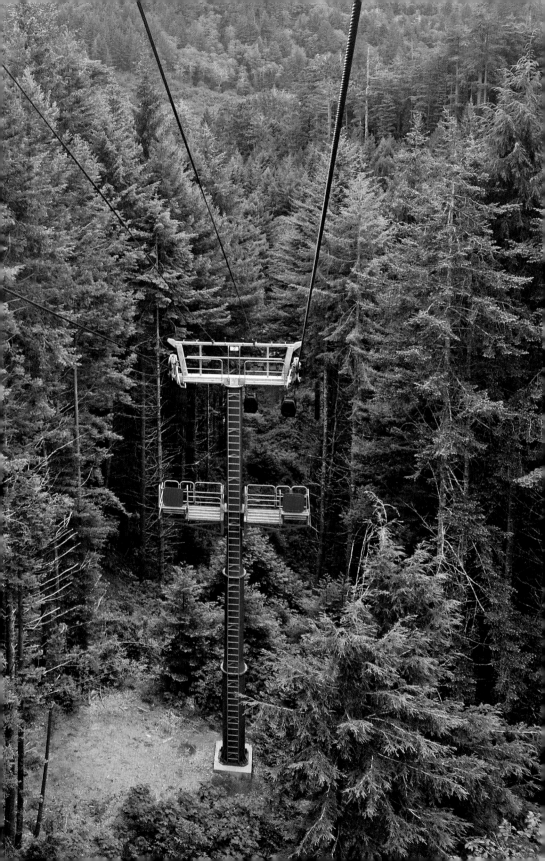

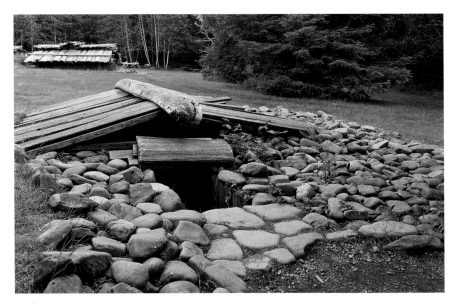

A recent addition to Trinidad's Patrick's Point State Park is this reconstruction of a traditional Native American Yurok Indian lodge at Sumeg Village.

was set aside in the early 1920s. A place of surreal beauty, the park is a dense rainforest that has seldom, if ever, echoed with the sound of an axe or a saw. The forest may seem familiar to moviegoers who saw 1997's *The Lost World: Jurassic Park*. Backgrounds for the lumbering dinosaurs were filmed here.

The paved Newton B. Drury Scenic Parkway runs ten miles through Prairie Creek, accessing several trailheads along the way. In meadows along the roadside, wild elk herds are often sighted. Fern Canyon, the crown jewel of the park, is a mile-long gorge splitting a coastal bluff and walled by fifty-foot cliffs lavishly draped in sword ferns, lady ferns, horsetail, and five-finger ferns. The creamy white bells of fairy lanterns hang in clusters among the greenery. Monkey flowers are flickers of sunny yellow through the dense green. In the wettest areas of the trail, boardwalks and wooden bridges traverse the creeks and marshes. Nearly a foot long, the Pacific giant salamander creeps among the golden globes of the skunk cabbage found here.

The Fern Canyon loop trail connects with a path to Gold Bluffs Beach, which is also accessible by an unpaved road. Bursting out of

the canyon as it meets the sea is a profusion of emerald-green ferns, scattered in the spring with wild strawberry blossoms, blue and yellow lupine, and pink rhododendron.

High sandstone cliffs frame eleven miles of driftwood-scattered sand and high dunes. The vigorous surf here creates a vaporous, low-level atmosphere that mingles with the foamy, breaking waves as they stretch out across sand speckled with real gold, which was mined here in the mid-1800s. Adding to the allure of Gold Bluffs Beach is the sight of grazing Roosevelt elk, which often congregate on clifftops and along the road that runs above the shoreline.

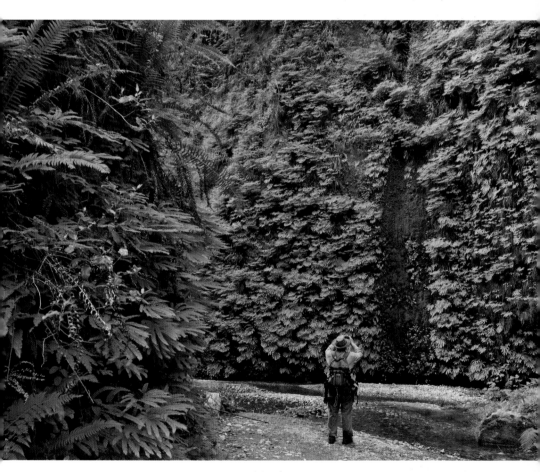

Known for its steep canyon walls and a popular hiking spot, Fern Canyon in Prairie Creek Redwoods State Park provides visitors with a unique forest experience.

REDWOOD NATIONAL PARK

A UNESCO WORLD HERITAGE SITE, Redwood National Park is one of the last stands of the California coastal redwood. Dedicated in 1968 by President Lyndon B. Johnson, the park shelters half of the remaining old-growth redwoods on earth. The national park actually encompasses three state parks—Prairie Creek Redwoods, Del Norte Coast Redwoods, and Jedediah Smith Redwoods—and includes more than 100,000 acres along forty miles of coastline. Within the park, visitors will find rivers, streams, hiking trails, campgrounds, and scenic roads.

Flourishing in drizzle and damp, these silent forests resemble a primordial world in which one expects to see pterodactyls flying by. As it is, black ravens do swish through the branches, their shadows flickering in the ancestral gloom. In the understory where the sun breaks through and on the edges of the creeks and rivers, wildflowers and shrubs flourish.

Illuminated by shafts of sunlight glinting through a dense, high canopy, the redwood groves are often described as cathedrals. According to Denise Delle Secco, a state park interpretive specialist, "Most people say the same thing when they see the redwoods for the first time: 'awesome.' They do silly things like stand in the middle of the road or walk in circles. . . . People actually get quite overwhelmed at the sight of the tremendous trees."

In drier months, redwoods draw moisture from the air through their boughs, up to a thousand gallons of water a day, one molecule at a time. This adaptation explains, to a degree, why they are able to live on average five hundred to seven hundred years. Some of the trees are more than two thousand years old. Descendants of gigantic evergreens that grew during the age of the dinosaurs and related to the massive

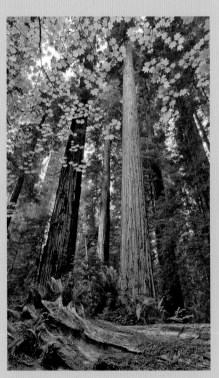

Abundant maple leaves and towering redwood trees block much sunlight from reaching the innermost portions of the north coast's Jedediah Smith Redwoods State Park, part of Redwood National Park.

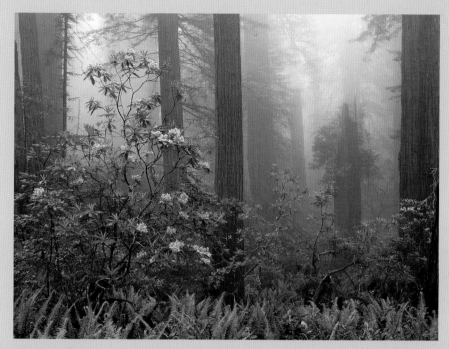

Wild rhododendron flowers add a splash of bright color to Redwood National Park, dedicated in 1968.

giant sequoias found in Kings Canyon, Sequoia, and Yosemite national parks, redwoods are not as wide or quite as long-lived as sequoias; however, they are considerably taller. Its sapless, cinnamon-colored bark, as much as a foot thick, gives the redwood its distinctive fluted appearance.

In the windy treetops are osprey nests and habitat for two endangered birds: spotted owls and marbled murrelets. Rather than build their own nests, the owls nest in the broken crowns of trees and openings in rotted trunks. About twenty inches long with white speckles and brown-colored feathers, they have a sharp hoot that sounds like a small dog barking. Logging roads cut through the mature redwood forests have resulted in the birds' near-extinction.

The most popular destination in the park, Lady Bird Johnson Redwood Grove, is named for one of the leading environmentalists of the twentieth century and lies at the end of a half-mile, old logging road. Standing beneath the towering trees on the occasion of the naming of the grove, Mrs. Johnson said, "Here on the north coast of California, the ancient and awesome redwoods make their last stand. The Latin name for the great redwoods— *Sequoia sempervirens*—means 'the tree that never dies.' Let us be thankful that in this world, which offers so few glimpses of immortality, these trees are now a permanent part of our heritage."

ROUTE **2**

Victorian Splendor

FERNDALE, LOLETA, AND HUMBOLDT BAY

Directions From U.S. Highway 101, take California Highway 211 west to Ferndale. Proceed west on Centerville Road to Centerville Beach, and return to just short of U.S. 101. Then take Fernbridge Drive/Eel River Drive northwest to Loleta. From there, take Cannibal Island Road west to the Eel River Wildlife Area. Return to Loleta and take Copenhagen Road north to Hookton Road. Follow Hookton Road west to Table Bluff Road. From Table Bluff Road, turn onto South Jetty Road, tracing the western edge of the Humboldt Bay National Wildlife Refuge. Then return to Hookton Road and head east to U.S. 101. Follow U.S. 101 north to Eureka.

Built in 1911, the concrete arch span Fernbridge carries California Highway 211 over the Eel River and west to Ferndale, past ranches and farmland on the south end of the Eel River Delta. Retaining a pastoral innocence from a hundred years ago as an isolated dairy farming community, while floating behind the gossamer veil of its Victorian heyday, is the little town of Ferndale—nicknamed the Cream City. The entire town is a state historic landmark because its streets are lined with more than two hundred gloriously restored houses, stores, and farm buildings from the late 1800s. The architectural beauties include Queen Annes, Eastlakes, and Carpenter Gothics in a colorful cacophony of turrets and gables. The oldest house in town is a Carpenter Gothic from 1854, said to be a replica of Nathaniel Hawthorne's *House of the Seven Gables*.

Built in 1899 and now a bed-and-breakfast inn, the Gingerbread Mansion is a half-block-long beauty dressed in bright yellow and peach with cascades of lacy white wood trim set in whimsical English gardens. Stuffed inside are fancy accouterments like claw-foot tubs, mirrored ceilings, canopy beds, stained-glass windows, marble fireplaces, and a fainting couch. Tea and cakes are served in one of five parlors in the afternoon.

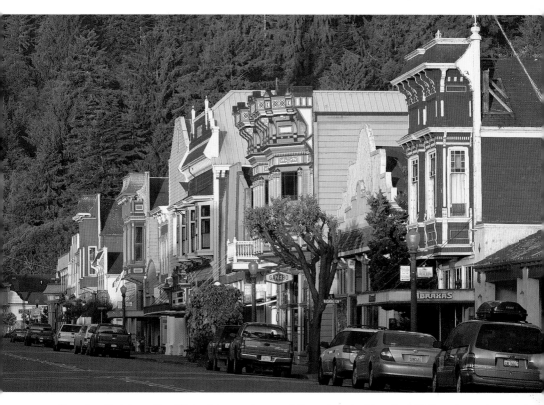

Sunrise light on the Victorian-era town of Ferndale in Humboldt County, California. Save for the cars, trucks, and people carrying cell phones, the town appears outwardly as if it has been frozen in time.

The main attractions in Ferndale are art galleries, antiques shops, ice cream parlors, and cafés. In the Golden Gait Mercantile, you'll feel like it's the 1850s with barrels of penny candy, big-wheeled coffee grinders, and glass cases filled with old-fashioned restoratives and hair pomades. Dave's Saddlery sells cowboy boots, beaded hat bands, hand-tooled saddles, and silver buckles. The confectionary, Sweetness and Light, is famous for Moo Bars (homemade marshmallow topped with almonds and caramel, smothered in chocolate) and for fudges, brittles, and caramels, made in plain sight in big copper kettles.

The oddest place in town, the Kinetic Sculpture Museum, exhibits handmade, people-powered machines that travel over land, mud, and water in the World Championship Great Arcata to Ferndale Cross-County Kinetic Sculpture Race held each May. Called the "triathlon

AVENUE OF THE GIANTS

MORE THAN HALF OF THE TALLEST REDWOOD TREES on the planet can be seen along the thirty-one-mile Avenue of the Giants in Humboldt Redwoods State Park. The largest and one of the least visited of California's state parks encompasses several small towns, is divided by the highway, and has no main entrance. Most visitors do not realize that most of the park lies to the west and is reached by leaving the Avenue of the Giants and taking Mattole Road to Rockefeller Forest, a ten-thousand-acre tract of uncut coastal redwoods alongside Bull Creek that contains some of the tallest redwoods in the world.

Dyerville Giant, the former champion sequoia at 362 inches in diameter, fell here in rain-saturated ground in the spring of 1991. And although the new champ, a 369-foot-tall dazzler named Hyperion, was found in 2006 in a remote area of the Redwood National Park, several behemoth contenders stand tall in the Rockefeller groves.

The giant trees and the recreational glories of the park are easily accessible from the Avenue of the Giants by way of the many vehicle turnouts, parking areas, and short loop trails. Sunbathers and picnickers can head down a short trail to sandy riverbanks, while one hundred miles of trails are used by hikers, backpackers, mountain bikers, and horseback riders who encounter old homesteaders' cabins and apple orchards planted by early settlers. In the fall, these pathways are aglow with big-leaf maples, alders, and buckeyes in blazing red and gold. At Bull Creek Flats, a sunny pebbled beach makes a graceful bend along the Eel River. Wild lilacs bloom in great purple clouds in the spring, when the river runs with salmon and steelhead trout.

State Park Interpretive Specialist Denise Delle Secco said Humboldt Redwoods and California's other redwood parks should be further explored; in fact, few visitors go any farther than the roadside or a quarter mile from the visitor's centers. "Even though the backcountry is easily accessible, most people never see the parks as they were when first created, never experience

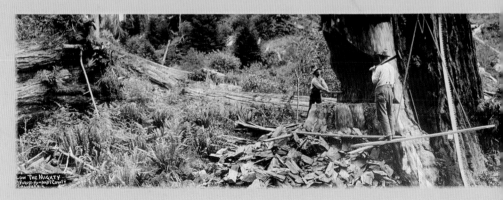

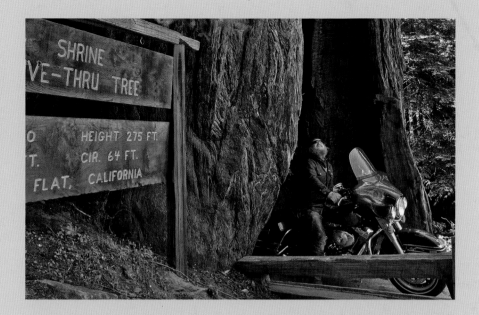

the grandeur of the trees and the virgin wilderness that has been so carefully saved for them. I call the redwood parks 'living museums.' It's like going to the Smithsonian, a once-in-a-lifetime opportunity."

Along the Avenue of the Giants is a string of sleepy little towns—Pepperwood, Redcrest, Weott, Myers Flat, Miranda, and Phillipsville—where tourists marvel at such oddities as the one-log house, a gift shop inside the Eternal Tree House, the Shrine Drive-Thru Tree, and the Step-Thru Stump, plus redwood burl souvenirs and chainsaw sculptures.

ABOVE: A motorcyclist drives through the Shrine Drive-Thru redwood tree tourist attraction at the Avenue of the Giants in Humboldt County.

BELOW: Loggers take down and chop up one of the mighty redwood trees in Humboldt County, California, in 1915. *Library of Congress*

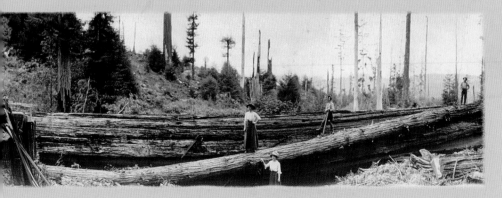

A strange helicopter-shaped contraption crosses the Eel River near Ferndale during the Great Kinetic Sculpture Race. The annual event, where human-powered art vehicles must travel nearly forty miles over land and water, takes place over the Memorial Day weekend.

of the art world," the three-day event is great fun to watch, as the fantastical entries are driven, dragged, and floated over roads, sand dunes, Humboldt Bay, and the Eel River. Among the machines in past races were the *Nightmare of the Iguana* and *Tyrannosaurus Rust*, which was powered by cavemen.

Since Ferndale was settled by Scandinavian and Portuguese immigrants, the town celebrates with such annual events as the Portuguese Pre-Easter Dance, including the crowning of the Holy Ghost Queens. Other gatherings unique to the town are the Cow Pie Bingo and Barbecue; the lighting of what is touted as America's tallest living Christmas tree, followed by the Portuguese Linguica and Beans Dinner; and the Christmas Lighted Tractor Parade.

Ferndale also is a favored destination for bird-watchers and kayakers who share the surrounding wetlands with more than a hundred feathered species that live in the marshes or pass through. At Centerville Beach five miles west of town, rough surf pounds a stretch of brown sand littered with driftwood that is home to Canada geese, sandpipers, pelicans, and cormorants. Tundra swans overwinter at the north end of the beach, and whales can be sighted offshore in the wintertime.

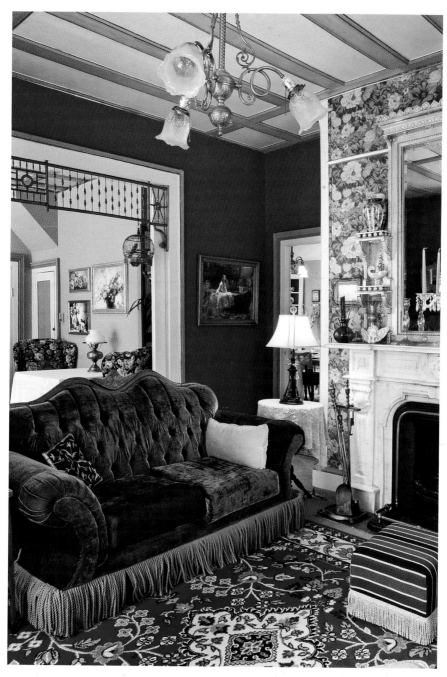

For weary travelers, comforts like this interior sitting room at the Shaw House Inn in Ferndale are the lure for staying in one of the town's bed and breakfasts.

In a bucolic postcard-esque scene, dairy cattle graze lazily in a spring pasture of green grass in the Eel River Valley near Ferndale.

A network of two-lane roads winds through the Eel River bottoms and the flat pasturelands between Ferndale and Loleta—a hamlet founded by immigrants in the early 1850s. Its name means "pleasant place at the end of the tide water."

"Downtown" Loleta consists of a grocery store, an antiques shop, a post office, and a tavern. The Loleta Cheese Factory is a good stop for sandwiches and to see cheesemakers turning out dozens of types of luscious cheeses made from the rich Eel River Valley cream.

From Loleta, Copenhagen Road turns west to the southern edge of Humboldt Bay National Wildlife Refuge, where mudflats attract masses of plovers, swans, and curlews. One of more than five hundred national wildlife refuges, this is a true wilderness of wetlands, salt marshes, and open bay, with riparian and freshwater habitat for thousands of birds and waterfowl that migrate through. With cameras and binoculars, visitors follow trails along the brackish waterways to good birding viewpoints. About twenty-five thousand black brants fly here from their nesting grounds in the Arctic on their way to Baja, California, and in March, flocks of hundreds of Aleutian cackling geese can be seen on the wing. Alongside the Hookton Slough footpath, tundra swans and

northern pintails swim in the ponds and tidal channels in the wintertime, while Canada geese and cinnamon and green-winged teal come in the summer. Black terns hover above the cattails, swooping to scoop up the damselflies, while great blue and black-crowned night herons and great and snowy egrets tiptoe stiffly about the mudflats, stabbing small fish.

About midway in Humboldt Bay, Eureka is the county seat with a two-hundred-year history as a fishing and logging port. The large fishing fleet based here harvests much of the shrimp, oysters, Dungeness crab, salmon, and cod consumed on the Pacific Coast. The vast bay can be accessed by small boat, canoe, and kayak, and by the *M. V. Madaket*, the oldest passenger-carrying commercial vessel in the United States. This wooden, steam-driven ferry was built in the 1920s. A cruise on this perfectly restored old steamer passes oyster farms, hundreds of fishing and pleasure craft, the third-largest colony of harbor seals in the West, and a large egret rookery. Boat rentals are offered at the public boathouse on Eureka's Old Town waterfront, just up the street from the iconic William Carson Mansion, a four-story extravaganza of Queen Anne, Italianate, and Eastlake styles that took one hundred men

Old logging equipment, a remnant of this area's past, is on display at the Fort Humboldt State Historic Park near Eureka. The fort was originally built to serve as a buffer between settlers and Native Americans. It was also home to Ulysses S. Grant, who was stationed there for a short time during the 1850s.

THE LOST COAST

THE HIGHWAY BETWEEN FERNDALE AND GARBERVILLE loops inland, forsaking what is known as the Lost Coast and bypassing what is arguably the only true wilderness remaining directly on the coast. A pleasant, if long, daytrip drive traces the rugged coastline, following Mattole Road south from Ferndale to Cape Mendocino and Petrolia and back through Humboldt Redwoods State Park to Weott, while a longer drive drops farther south on Wilder Ridge Road past the King Range National Conservation Area to Shelter Cove.

Wildly beautiful and often stormy, this coastal run is best in spring and fall; fog may obscure the views at other times of the year. Through the winter, moist sea air bumps into the high barrier of the King Range, making this one of the wettest spots on the Pacific Ocean. It often receives more than one hundred inches of rainfall annually. As one local resident best put it, "Some days it rains more, some days less." From May to September, dry days as warm as eighty-five degrees Fahrenheit often alternate with dense fog, making for good hiking weather.

A tortuous corkscrew nicknamed the "Wildcat," two-lane Mattole Road winds out of Ferndale through a dense coniferous forest, plunging downhill past grassy cattle ranches and falling-down barns to Cape Mendocino, the westernmost point in the lower forty-eight states. From the one-horse village of Petrolia, a five-mile, usually passable, paved road leads to the mouth of the Mattole River at the ocean, where a windswept beach makes for good shelling and tide pool viewing for vividly colored starfish, sea cucumbers, anemones, and urchins.

Dating to 1865 when oil was discovered here, Petrolia is located at the northern end of King Range National Conservation Area, accessed primarily by a handful of dirt roads and hiking trails backed by a dozen peaks. Crowned by the 4,087-foot Kings Peak, this mountain range is a favorite of hardy back-packers ready to explore a drizzly forest of Douglas fir, big-leaf maple, and alder, in which mule deer, bobcats, and the occasional Roosevelt elk can be spotted. Weighing upwards of thousands of pounds and outfitted with racks of five-foot-long antlers, the elk bulls are crabby and territorial during the mating season in the fall and early winter. Hikers may hear them thrashing saplings and polishing their antlers on small tree trunks—yes, an encounter with a bull and his harem on the trail can be a unique experience.

Before heading back to U.S. Highway 101, travelers often stop in the charming burg of Honeydew, where century-old farmhouses are scattered around the countryside. Sandwiches and provisions are available in the general store, where you'll also find the only gas pump for many miles.

The final leg of the drive is a magnificent route through the ancient redwoods of the Rockefeller Forest in the Eel River Valley.

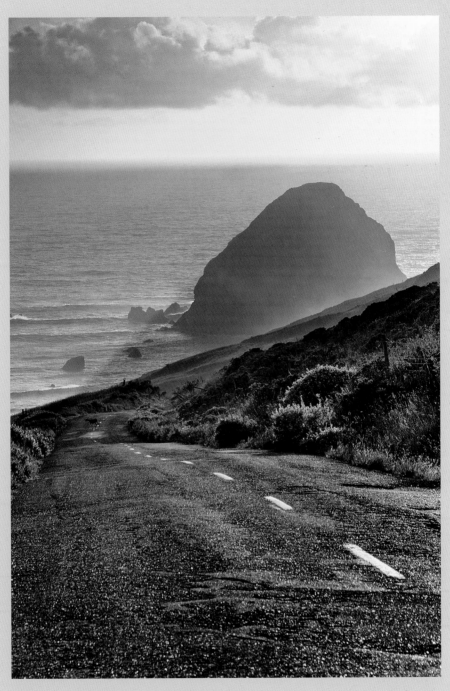

The Mattole Road at sunset on the Lost Coast at Cape Mendocino, the westernmost point in the contiguous United States.

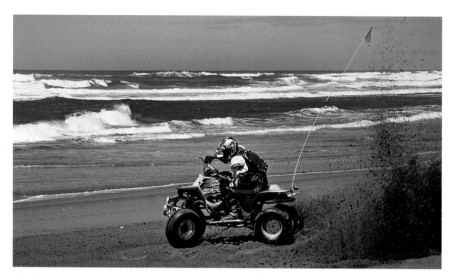

The Samoa Dunes Recreation Area near Eureka is a great place for local residents to go play in the sand, explore the seashore, fish, surf, or ride off-highway recreational vehicles.

OPPOSITE: California's north coast is known for long stretches of sand dune–lined beaches, like the Samoa Dunes near Eureka, home to these native coastal grasses.

more than two years to build. Completed in 1884 for a lumber baron, the mansion is said to be the most-photographed Victorian home in the United States.

Across the Samoa Bridge from Eureka, on Woodley Island, the Samoa Cookhouse has been operating since 1885 and is the last surviving lumber camp cookhouse in the West. Family-style meals are served at long, oilcloth-covered tables with charmingly mismatched chairs. Huge loaves of bread, cauldrons of soup, platters of ham and roast beef, and big bowls of salad and vegetables accompany the entrees, followed by wedges of homemade pie. Sated diners stagger around the little adjacent museum of logging equipment and photos of early days.

A few hundred feet behind the cookhouse are the empty streets of an old logging company town and breezy walking and biking trails in the Samoa Dunes Recreation Area. Fluttering like pieces of torn white paper, flocks of egrets can often be seen flying above a grove of cypress trees they call home.

ROUTE 3

Along the Navarro

ANDERSON VALLEY

Directions From Elk on State Route 1 (Highway 1), take Philo–Greenwood Road southeast to California Highway 128. Follow Highway 128 south to Boonville. Return to the coast by heading north on Highway 128 to Little River.

Rimmed by low mountains, about ten miles from the Pacific Ocean, Anderson Valley is watered by the Navarro River and three major creeks that serve as spawning grounds for salmon and steelhead trout. Through the narrow, sixteen-mile-long valley, California Highway 128 rambles through open meadows between a dark redwood and pine forest on the west and mixed hardwoods on the east. Cows teeter precariously on steep mountainsides, and eagles soar over mossy, split-rail fences and barns built in the nineteenth century, vestiges of when the valley was a remote logging and sheep-ranching area. The loggers are gone and the wooly crop has passed its heyday, although the remaining sheep farmers still gather every July for lamb barbecue, a sheep show, and sheep-dog competitions at the Woolgrowers and Sheep Dog Trials.

Open to marine weather patterns on the north end, the valley has a long growing season perfect for such cool-climate crops as apples; pears; and pinot noir, riesling, chardonnay, and Gewürztraminer wine grapes. Not surprisingly, touring wineries is a popular daytrip activity. The valley is home to twenty or so family-operated wineries housed in rustic, often historic farm buildings, as well as a few larger operations, including those making French-style sparkling wines and those that have elegant tasting rooms.

A loop on a country road from the hamlet of Elk on the Mendocino Coast to the sunny inland valley and then north through the redwoods back to the coast makes for a full day or weekend of bucolic pleasures. Formerly a thriving sawmill town, Elk has dwindled to a cluster of

Born in the Coast Range of Mendocino and Sonoma counties, the Navarro River flows through Hendy Woods State Park near Philo en route to its mouth at the Pacific Ocean.

quaint bed-and-breakfast inns on a bluff with stupendous ocean views. Running east from Elk, Philo–Greenwood Road climbs Greenwood Ridge and descends through oak-studded hills and pasturelands, passing apple orchards and vineyards. Near the valley is the turnoff for Hendy Woods State Park. Warmer and drier than the rainforest-like redwood parks along the northern California coast, this lesser-known preserve of ancient trees stands on the banks of the Navarro River. Two miles of forest trails lead to Big Hendy and Little Hendy groves, where thousand-year-old redwoods are nothing short of spectacular in size, reaching 270 feet into the air. On the sandbanks and meadows along the river are picnic grounds and launching sites for kayaks and canoes.

Just past the park near a historic bridge arching over the Navarro River, the old-fashioned, all-organic farm stand at Philo Apple Farm provides an introduction to the agricultural riches of the valley. More than eighty varieties of apples are for sale here at various times throughout the year, along with pears, homemade chutneys and jams,

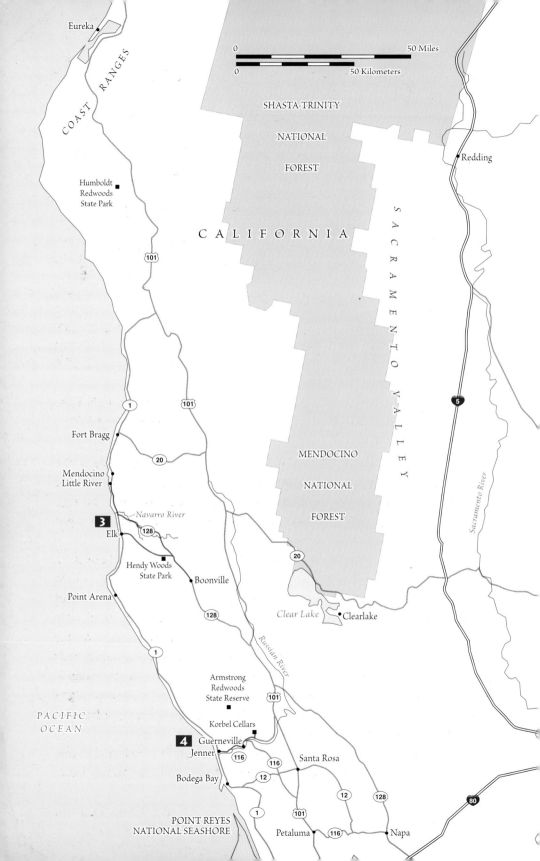

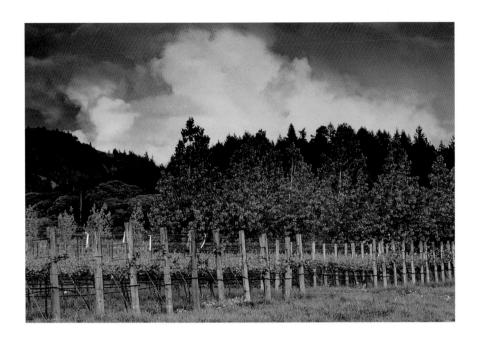

A setting sun's light strikes violent spring storm clouds, turning the sky hues of pink and purple over a green vineyard and trees in the Anderson Valley.

and juices and ciders. Visitors are welcome to wander around the voluminous gardens, orchards, and potting shed and to enjoy watching the bunnies and the chickens. Those too entranced to leave can sign up for a cooking class and stay the night in one of the rental cottages hiding in the trees.

A few minutes south on Highway 128, a short row of buildings on the roadside composes the whole town of Boonville, a village world famous for a bizarre American dialect called Boontling. The dialect originated here in the late 1880s and is still spoken here (and only here). When Boontling emerged, the valley was an isolated, sparsely populated Shangri-la, and local farmers and shepherds made up their own lingo as a way of avoiding strangers and having a few laughs. Today's visitors learn a little bit of the Boontling lingo through signs pointing out such things as a Buckey Walter (phone booth), a Horn of Zeese (cup of coffee), and bahl gorms (good food).

The pub restaurant, Highpockety OX, is a good place to sit a spell on a bronze saddle at the bar and listen to the strange language. Don't

THE VICTORIAN TOWN OF MENDOCINO

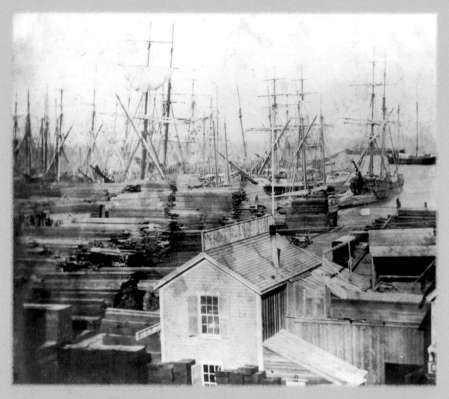

Mendocino was one of Northern California's many communities that served a booming lumber industry in the mid-1800s. *Library of Congress*

IN THE MID-NINETEENTH CENTURY, loggers from Maine, Connecticut, and Nova Scotia sailed around Cape Horn in South America to the north coast of California, voyages that took about six months. The area's misty river valleys, untracked mountains thick with massive redwoods, and rugged seacoast were true wilderness then, inhabited only by indigenous tribes and a few fur trappers. The first redwood mill was erected on the Big River below the town of Mendocino. It provided work for all, cutting timber and milling lumber for the booming Gold Rush city of San Francisco.

By 1878, the population of Mendocino was twenty thousand—compared to one thousand or so today—and was home to nineteen saloons and more than a dozen pool halls and "fast houses," all places that were no strangers

to rough crowds. According to the local newspaper, "the one bastion of good Christian morals in a town of loggers" was the Temperance House, which is today the Mendocino Hotel. The hotel is loaded with nineteenth- and early twentieth-century art and furnishings. From the Louis XIV–style Victorian loveseat to the carved, fluted, and scrolled mahogany sideboards, the lobby alone is worth a look.

Looking across the Big River at the postcard view of Mendocino with its white clapboard storefronts, Victorian-era mansions, and distinctive water towers, it is easy to imagine when horse-drawn carriages were tied up in front of Temperance House and ladies with parasols swept along the boardwalks in their long gowns. Ships captains' mansions are now bed-and-breakfast inns, and in the old saltbox cottages are quaint shops and art galleries guarded by picket fences that scarcely hold back rampant old-fashioned gardens. Clematis vines and honeysuckle clamber unchecked over water towers and tilting-over barns, and wild strawberry creeps up the fence posts, bursting into white blossoms in the spring. Briar roses riot at the foot of gnarled, old apple trees. With scenery and historic homes like this, it is no surprise the entire town is a national historic landmark.

At the home of the Mendocino Historical Society, the Ford House, a scale model of the town during the 1890s shows dozens of tall, wooden water towers that existed at that time. More than thirty of the towers, some double- and triple-deckers, remain in the skyline today. Across the street next to a huge water tower and a duck pond surrounded by an old garden, the Kelley House Museum displays historical photos of burly loggers hand-sawing redwoods of a size no longer seen in this region.

This wooden water tower, adjacent to the Connemara House on Little Lake Road in Mendocino, was one of the remnants of the community's logging days when this photo was taken in the 1930s. *Library of Congress*

forget to try the Boont Amber Ale, brewed by the Anderson Valley Brewing Company (open for tours) located up the road. Across the road from the pub in a circa-1860 roadhouse, the Boonville Hotel has a highly rated restaurant, a few Shaker-inspired guest rooms, and a glorious overgrown flower and herb garden where guests laze away warm afternoons in hammocks.

On the highway north of Boonville, Gowan's Oak Tree is another farm stand where local produce is abundant—from apples, apricots, and berries to cherries, peaches, and pears. In April, when the apple blossoms are fragrant clouds of pink and white, the Gowans open their orchards for wagon tours.

Greenwood Ridge Vineyards offers picnic grounds by a pond and crisp white rieslings and merlots. Next door, Navarro Vineyards makes Alsace-style, dry Gewürztraminers and rieslings, as well as some nonalcoholic wines. Housed in what was once a chicken coop, Husch Vineyards Winery is the oldest winery in the valley. The rose-draped charmer produces more than a dozen varieties of wine, notably a flowery, fruity Gewürztraminer.

Anderson Valley's foggy mornings and nights and warm days make an ideal climate for pinot noir, a phenomenon that lured the French company Louis Roederer Champagne to establish Roederer Estate here. In a contemporary-design redwood winery built into the hillside, lovers of the bubbly step up to the antique zinc bar to taste citrusy L'Hermitage Brut, Anderson Valley Brut, and the Brut Rosé. All are made by the traditional French *méthode champenoise* process. The winery's glowing pink-rose terra cotta floor tiles came from a two-century-old chateau in France.

Highway 128 tunnels north through ferny glens and eleven miles of dense groves of second-growth redwoods that hug the road and filter the light into flickering shafts. Two miles east of the Highway 1 junction, on both sides of the road, Navarro River Redwoods State Park is popular with anglers, campers, and kayakers. Just north on Highway 1 is the Albion

OPPOSITE: Blink and you'll miss this old, wooden, one-room church in the hamlet of Philo in the Anderson Valley.

PAGES 50–51: Steep, rocky cliffs and eroding bluffs are the hallmarks of this less-traveled part of California's coast near Elk in Mendocino County.

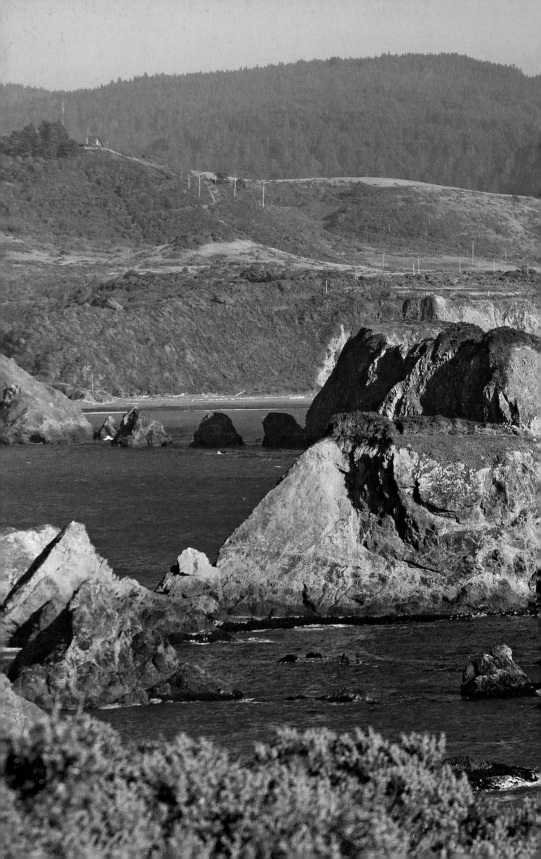

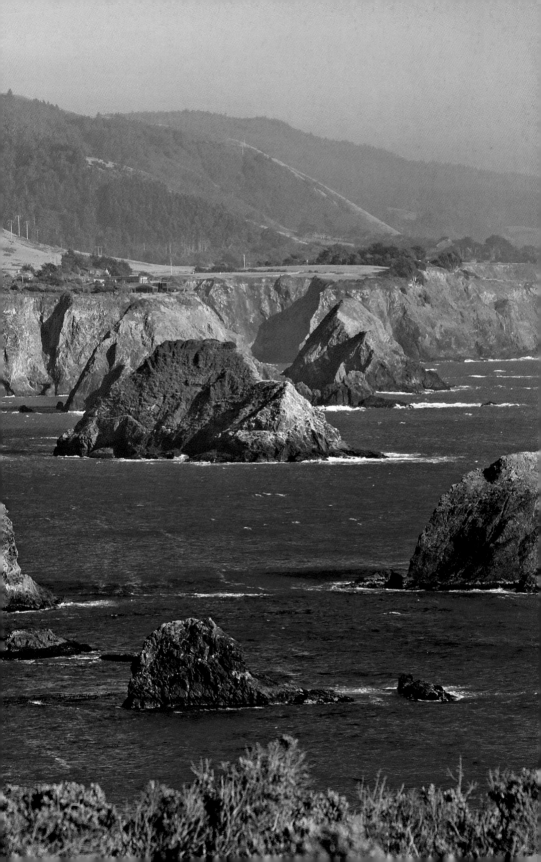

Known for selling imported stone Hindu statues and other objets d'art, Handley Cellars Tasting Room near Navarro also has this antique wooden carving of an African elephant for sale as a chair.

River Bridge, constructed from salvaged wood during World War II. It is the last wooden bridge in operation along the highway.

A few miles up the coast, the Little River Inn makes a nice stop for refreshment, a meal, or an overnight stay. On a bluff above Van Damme State Park Beach, surrounded by lush gardens and redwood groves, the inn has long been a weekend destination. As fancy as a white wedding cake, the main house—built in the 1850s—is embellished with lacy white trim, intricately cut-out banisters, and turned columns. Purple wisteria and trumpet vines cascade over the veranda, and heirloom roses bloom in the salt air, making this inn a perfect last stop on your getaway tour.

ROUTE 4

Russian River Roundabout

JENNER TO KORBEL CELLARS AND BACK

Directions From Jenner on State Route 1 (Highway 1), take California Highway 116 east through Duncans Mills and Monte Rio to Guerneville. Follow River Road to Korbel Cellars. Then retrace your route to Jenner.

Flowing out of California's coastal mountains, the Russian River winds through redwood canyons, past sandy beaches, orchards, and vineyards, sliding calmly all the way to the sea at Jenner—a place that stands between the rugged coves and high coastal headlands north of the river and the wider marine terraces and calmer beaches running south. In winter, ocean waves clash with the river's flow in a stormy

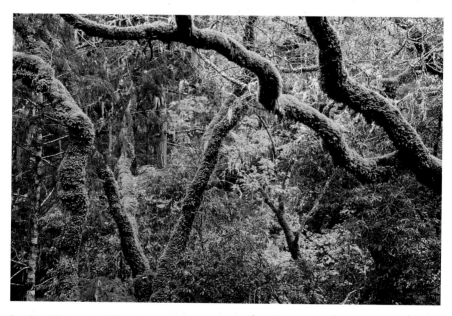

Lush, wild, and with a hint of golden color, fall foliage mixes with soft green moss-covered tree limbs in the forest at Armstrong Redwoods State Reserve in Sonoma County, California.

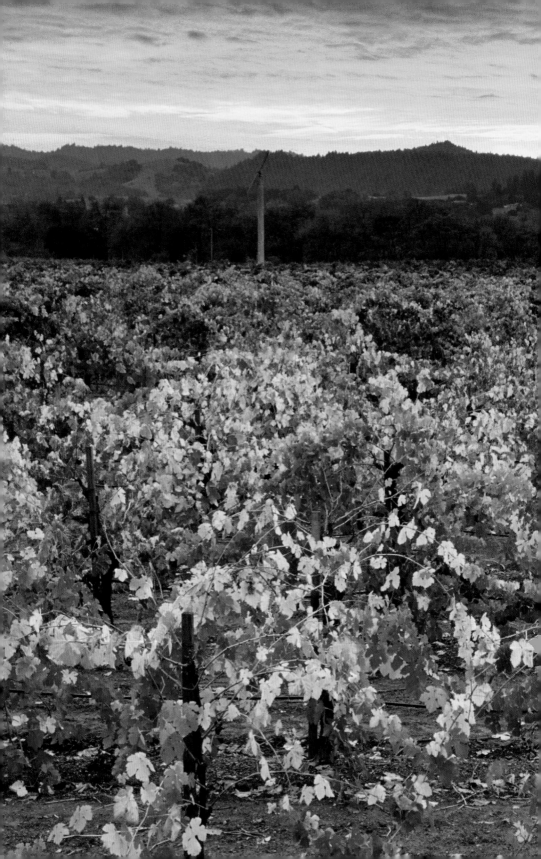

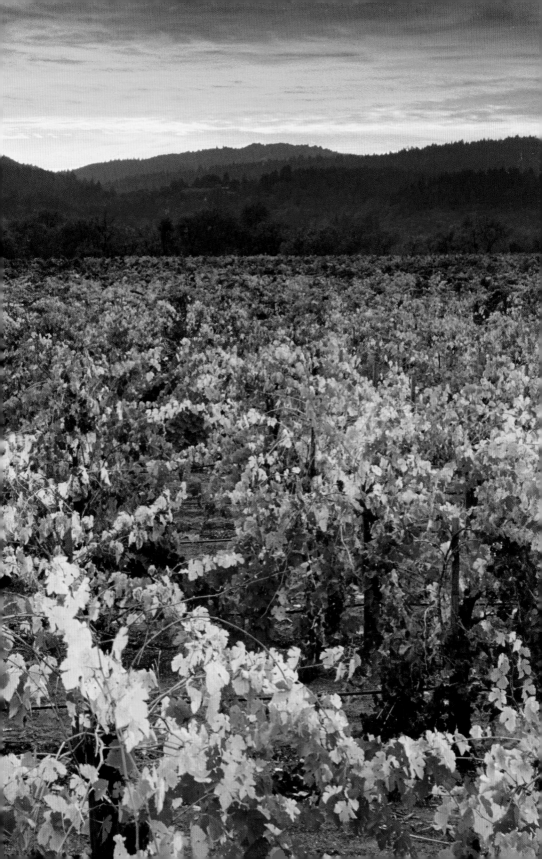

drama, while seals give birth in the shallows away from the sharp eyes of hungry sharks and whales.

The river was named for the Russian fur trappers who arrived in 1812, accompanied by Aleut fur hunters, to harvest otter and sea lion pelts. Later, nineteenth-century timbermen floated their logs from inland redwood forests to ships at Jenner, from where they were transported to the burgeoning city of San Francisco. Today, Jenner is nothing more than a collection of hillside cottages and bungalows, most of which offer wonderful views of the ocean below.

Highway 116 follows the river from the coast to a handful of villages and one small town, Guerneville. Hiking trails and campgrounds in shady redwood groves are cool retreats when days are hot and dry inland, also prime season for canoeing, kayaking, and tubing on the river. A good paddling route is the scenic ten-mile stretch from Forestville to Guerneville, with sunny stopping points at beaches and sandbars for picnicking and sunbathing. Osprey, blue herons, and turtles often hide beneath silvery gray-green willows in the freshwater marshes, and trout flicker in the shady pools.

Duncans Mills, a railroad stop dating to 1877, is a cluster of galleries, cafés, and shops and is home to the only remaining North Pacific Gauge Railroad station, now a museum showing historic photographs, memorabilia, and old rail cars. Fishing is fabulous here near the steel bridge. Anglers hook everything from shad and catfish in the spring to bass in the summer and Chinook salmon and steelhead trout in the wintertime. The biggest annual event in Duncans Mills is the Russian River Rodeo, a small-town spectacle of pancake breakfasts, horseshoe tournaments, antique tractor displays, and the crowning of the rodeo queen, with all ages participating in the rodeo events.

The highway winds on a few miles through a corridor of redwoods to the tiny burg of Villa Grande, a riverbend community in a time warp, looking as it did in the 1920s when it was a summer escape for San Franciscans flush enough to have second homes. Most tourists never find the hidden beaches here and the delightful lanes of early California Craftsman-style cottages.

Just beyond the Pink Elephant saloon, the World War II–era movie house in a Quonset hut, and the neon "Welcome to Monte Rio Vacation Wonderland" sign over the roadway is Northwood Golf Course,

Summer brings crowds of weekend and holiday revelers to relax on the popular Johnson's Beach on the Russian River.

PREVIOUS PAGES: Although not as famous as other wine-growing valleys like those in Napa and Sonoma, California's Russian River Valley is also home to a number of vineyards, including Foppiano Vineyards near Windsor.

designed in 1928 by the Scottish architect Alister MacKenzie. He is most well known for designing Augusta National, Cypress Point, and other legendary golf courses. Since the 1920s, Northwood has hosted politicians, world leaders, and corporate magnates from the exclusive nearby Bohemian Club summer encampment and mere mortal golfers, too. Hundreds of towering redwoods and firs stand on the fairways in misty magnificence above the river, impervious to golf balls bouncing off their trunks. Their long arms droop over small greens well guarded by mounds and bunkers.

A teenage caddy at Northwood in the 1940s, Rich Quistgard recalls carrying Bing Crosby's golf bag. Not a bad player, Crosby asked for his

REDWOOD MAGIC

THE TALLEST AND SOME OF THE OLDEST TREES IN THE WORLD, *Sequoia sempervirens*—commonly known as coast redwoods—live in a narrow, five-hundred-mile band along the Northern California and Oregon coastlines and a few miles inland. The magnificent groves are clustered in what is known as the Redwood Empire of Northern California.

In Armstrong Redwoods State Reserve in Guerneville, the Parson Jones Tree is more than three hundred feet tall—three times longer than the length of a football field. Meanwhile, the Colonel Armstrong Tree, named for the lumberman who set the groves aside for public use in the 1870s, is at least 1,400 years old. (In fact, some redwoods live for more than two centuries and reach a diameter of sixteen feet.)

A springtime walk through these towering trunks can be enchanting, when the forest floor is carpeted with clover-like sorrel, creamy-white trillium flowers, fairy bells, and wild purple-pink orchids. In winter, mushrooms, mosses, and lichens are vibrantly multicolored. Come September and October, the maples, alders, and buckeyes sparkle red and gold among the dark, cinnamon-colored trunks of the towering trees.

"niblick" (today's nine-iron), his "mashie niblick" (a seven-iron), and his "spoon" (a three-wood). In those days, the usual tip for a caddy was $1.25. Once, when called away by a phone call after only three holes, the gracious Crosby handed the wide-eyed Quistgard a twenty-dollar bill. Another big tipper was the American baritone John Charles Thomas, who walked the Northwood fairways while singing arias from *La Traviata*.

At Guerneville, the river widens, coastal mountains become foothills, and redwood and fir forests give way to oak groves. Honky-tonk cafés and saloons are lined up in old wooden false-front buildings on the four-block-long main street, a busy place on sunny weekends when beachgoers flock into town. Johnson's Beach is the site of the Russian River Blues Festival in June, and Jazz on the River in September, the best month of the year for warm days and starry-clear nights.

Settled in 1865 by loggers, Guerneville boomed when the railroad hauled out millions of board feet of redwood lumber and tourists from

A splash of sunlight pierces the thick forest canopy, illuminating the massive trunk of a large redwood tree at Armstrong Redwoods State Reserve.

San Francisco rode ferries across the bay and hopped onto narrow-gauge railroad cars that chugged through the redwoods to river resorts. When the motorcar arrived on the scene, city dwellers were lured farther afield, and lumbering declined around the same time, causing river towns like Guerneville to fall into a deep sleep. The last train carrying logs and tourists rolled out of town in 1935.

The town still managed to thrive through the Big Band era when Benny Goodman and Harry James kept the revelers coming, a heyday that faded until the 1970s when the tremendous growth of wineries

GREEN VALLEY WINE ROADS

ONLY THE ADVENTUROUS SPIRIT discovers the secrets of Green Valley, a verdant triangle of the Russian River Valley between Sebastopol, Occidental, and Guerneville. Misted by the nearby Pacific Ocean, gloomy redwood groves thrive in rocky canyons and march across wild, windy hilltop ridges here. Fogs drift in off the sea and linger, resulting in long growing seasons and late harvests.

In rivulets on either side of the Russian River, vineyards and orchards dominate the landscape in a climate perfectly suited to the noble pinot noir grape. Notoriously difficult and expensive to grow because of the danger of powdery mildew in cool, moist air, Green Valley pinots are often described as buttery, redolent of bing cherry, dark fruit, pomegranate, spicy cola, cinnamon, and clove.

Named for an old wine-making family, Martinelli Road is a lovely lane where a redwood, bay, and maple forest is the backdrop for split-rail fences and vintage farmhouses. The Martinelli Vineyard and the Jackass Hill Vineyard on the hillside above have been owned by the Martinelli family since the late 1800s. The family recalls that before the vines were planted, family and friends would gather on Sundays, with Bing Martinelli playing his violin as people danced and drank vino. Since 1896, five generations have produced apples and wines, and they welcome visitors to their historic red hop barn on River Road, where Muscat the cat holds court in the tasting room.

began a new era of tourism. And although the resident population remains small, a number of top-notch restaurants and inns have emerged throughout the Russian River Valley, catering to weekenders and summer vacationers. Armstrong Woods Road leads from downtown Guerneville into Armstrong Redwoods State Reserve, a rustic park with eight hundred acres of redwoods on Fife Creek. Footpaths lead to centuries-old trees that stand up to three hundred feet tall. A less-developed, adjacent preserve, Austin Creek Recreation Area, spreads out in thousands of acres of canyons and river glens that campers, hikers, and horseback riders love to explore. Anglers head for Redwood Lake for the bluegill and black bass. In late winter and spring, this area is lush with blooming wild azaleas; rushing creeks; and maples, ash, and alder in full greenery.

Poured for travelers who drop in, the pinots of Hartford Family Winery are vinted from grapes grown on a patch of land off Martinelli Road that is said to be the chilliest in the valley—harvest often does not occur until the end of October. The vineyard has been referred to as the "Snow Shoe Vineyard" because pruning crews have sometimes worn snowshoes to move around the muddy rows. Intensely flavored due to the long harvest, the ruby-hued Hartford pinots have the fragrance of red raspberries, cherry jam, smoke, and spice.

Pinots are created with Spanish flair at Marimar Torres Estate Winery on Graton Road. Descended from the house of Torres, a Spanish family famous for wine-making since the 1870s, Marimar planted her Green Valley pinot noir vineyards at two thousand vines per acre, over four times the normal density in California. The organically farmed vines are trained quite low, to better absorb warmth from the ground and protection from the sun, with the result of small yields of fruit with concentrated flavors. Wine lovers gather in the tasting room, a tile-roofed, golden-toned hacienda resembling a Catalan farmhouse, elegantly decorated inside with antiques and ceramics from Spain.

Ross Station Road, a narrow, oak-lined byway, crosses a bridge and coils up a hill to a spectacular view of the Green Valley, the Sonoma and Mayacamas ranges, and Mount St. Helena. Here on the grounds of Iron Horse Ranch and Vineyards, palm and olive trees and stepped gardens surround the restored 1876 Carpenter Gothic home of the Sterling family. Iron Horse sparkling wines have been served at state dinners in the Reagan, the Clinton, and both Bush White Houses.

A few miles west of Guerneville is Korbel Champagne Cellars, one of the largest of the more than sixty wineries in the Russian River wine-growing region. It was founded in 1886 by Czech immigrants who built the massive, ivy-covered stone tower that still stands today. The guided tour here is among the most complete of all California wineries and includes a museum, a film, an in-depth explanation of classic *méthode champenoise* production, and a tasting of bubbly. The gardens of the Victorian-era house, open to tour, are encircled by hundreds of antique rose bushes, spring-blooming bulbs, and a rare redwood hedge.

From here, wine lovers head north on Westside Road and other backroads, where more than ten thousand acres are planted in vineyards that produce the famous fruit-intense chardonnays, pinot noirs, and merlots of the Russian River Valley.

The Applewood Inn in Guerneville is one of the many small, charming country inns in Russian River wine country. The inn's architecture was inspired by the missions and homes of the early Spanish settlers to the area.

ROUTE 5

The Sleeping Maiden

MUIR WOODS, STINSON BEACH, AND A MOUNT TAMALPAIS LOOP

Directions

From U.S. Highway 101 near Mill Valley, take State Route 1 (Highway 1) west to Muir Woods, Stinson Beach, and Bolinas, returning to Mill Valley over Mount Tamalpais by way of the Panoramic Highway.

A few miles north of the Golden Gate Bridge, impossible to ignore from any point in Marin County, is the profile of 2,571-foot-tall Mount Tamalpais, sometimes called "the Sleeping Maiden." Sixty-three hundred acres of the mountain is contained in Mount Tamalpais State Park, a

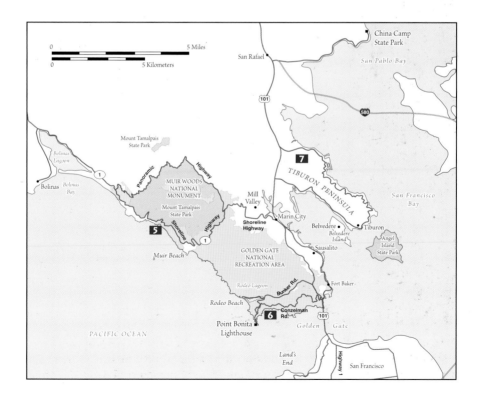

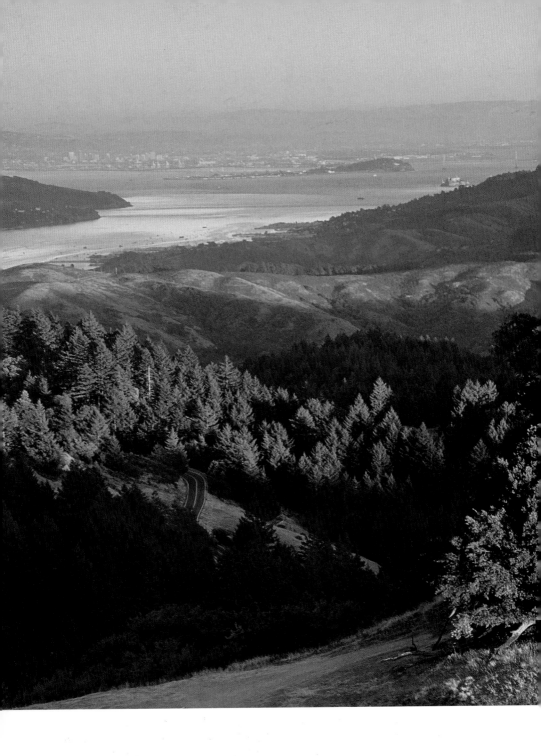

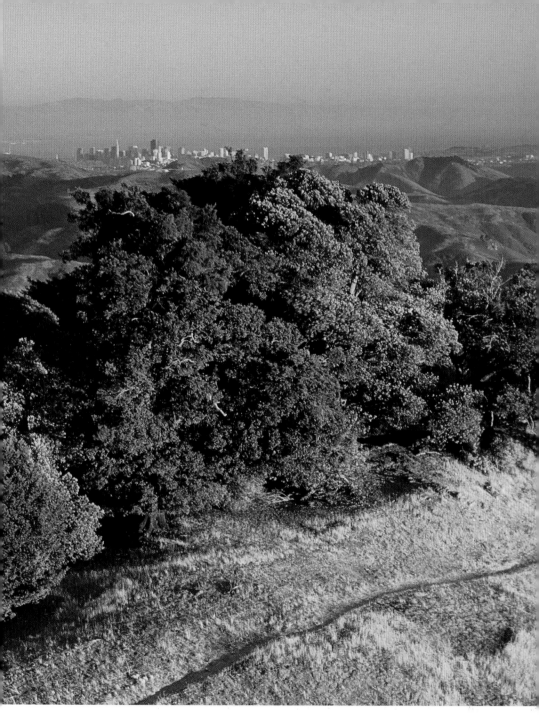

Rising to more than twenty-five hundred feet in elevation, Mount Tamalpais is the sentinel of the North Bay. The drive to her summit affords many great vistas, like this sunset on the hills above the Golden Gate, looking toward San Francisco.

POINT REYES NATIONAL SEASHORE

A GLANCE AT A MAP SHOWS JAGGED DOUBLE PENINSULAS jutting into the Pacific Ocean off the Marin County coastline. An elongated triangle of beaches, lagoons, and estuaries, as well as dark forests and windy headlands, this area is Point Reyes National Seashore, one of the greatest coastal wilderness preserves in the world.

Actually a part of the submerged Pacific continental plate, Point Reyes was once attached to the Tehachapi Mountains, 350 miles to the south. Tectonic movement shoved it north over millions of years, and it is still moving along the San Andreas Fault, which runs through Tomales Bay and down the eastern edge of the park and into the sea. During the 1906 earthquake that devastated San Francisco, the peninsulas moved north twenty feet, an occurrence that is chronicled with photos and signs on the Earthquake Trail near the visitor's center. This land became nationally protected in 1962 by order of President John F. Kennedy.

Set apart from the mainland geologically, and exceptional in their rough beauty, the peninsulas are often wreathed in fog and rudely whipped by Pacific winds. When the English explorer Sir Francis Drake sailed his galleon the *Golden Hinde* into the great curve of Drakes Bay in 1579, he paused here for a month. He claimed the region for Queen Elizabeth I and named it Nova Albion—meaning new England. A subsequent European mariner, Don Sebastian Vizcaino, named the land La Punta de los Reyes—The Point of Kings—in 1603.

Due to its inclusion in the national seashore, Drakes Bay remains largely as it was four hundred years ago, fringed with sandy beaches and mottled with deep tide pools alive with anemones, urchins, fish and crabs, leopard

verdant world of redwood groves, oak woodlands, grassland slopes, and rocky ridges. On the south side of the mountain, Muir Woods National Monument shelters the last remaining virgin redwood groves in the San Francisco Bay Area. The tallest redwood in the park is 258 feet high and about a thousand years old, still young for redwoods, since they can live for more than two thousand years.

In 2008, the park celebrated the centennial anniversary of President Theodore Roosevelt's declaration that protected this land: "Whereas,

rays, and baby sharks. The most developed of the beaches, Drakes Beach is somewhat protected from prevailing north winds by mountainous dunes. The water is too cold and riptides too dangerous for swimming, although body surfers and boogie boarders brave the waves.

On the north end of the bay, surf fishing and sunbathing are the main activities on windswept Limantour Beach. From here, Muddy Hollow Trail traces the edge of Limantour Estero Reserve, a five-hundred-acre intertidal lagoon with a giant tide pool. The smallest North American duck, the striking black-and-white bufflehead, swims about along with common goldeneye ducks, their heads shiny green black with a large round white spot beneath the eye and a dramatic black-and-white body.

Many shipwrecks occurred off Point Reyes until the Point Reyes Lighthouse was built in 1875. Still in operation, the lighthouse is reachable by climbing down more than three hundred steps from a high bluff to the windy Sea Lion Overlook, where most days contingents of sea lions and elephant seals are on view, barking and posing.

Beaches north of the lighthouse are exposed to the full force of storms and pounding surf. Dark pines crowd the headlands above sea stacks and wave-carved caves, and the rocky promontories are alive with birds— brown pelicans, cormorants, surf scooters, sandpipers, grebes, and terns. From February through early summer, meadows and marine terraces are blanketed with California poppies, sky-blue lupine, baby blue-eyes, Indian paintbrush, and some wildflowers existing only here. Often cool and foggy in the summer, the seashore frequently has spring and fall days that are dependably clear and warm. Visitors walk on easy meadow trails, go mountain climbing, bike to the beach, or horseback ride and backpack through this area. The most popular footpath is the Bear Valley Trail. Nearly five miles one way, it wanders through native grasses and through tunnels of Douglas fir, buckeye, and moss-hung bay laurel, arriving at the end of a narrow finger of rock fifty feet above a churning sea. Enveloped in the mists of crashing surf, one might mistake the offshore sea stacks for a fleet of Spanish sailing ships heading up the coast to Drakes Bay.

an extensive growth of redwood trees embraced in said land is of extraordinary scientific interest and importance because of the primeval character of the forest in which it is located, and of the character, age, and size of the trees, I . . . do hereby declare and proclaim that said grove and all of the land hereinbefore described . . . be set apart as a national monument."

Autumn days in Muir Woods are warm and dry, vivid with maple trees turned gold and fluttering monarch butterflies. Wild azaleas,

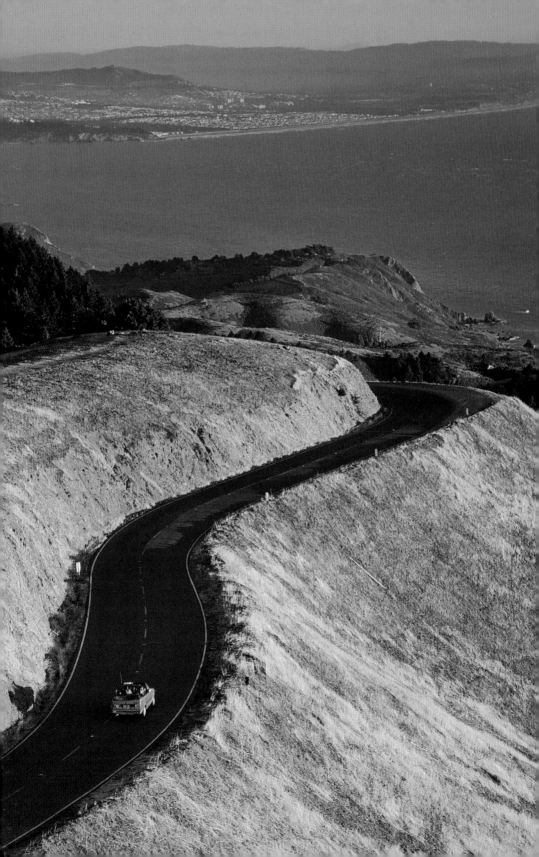

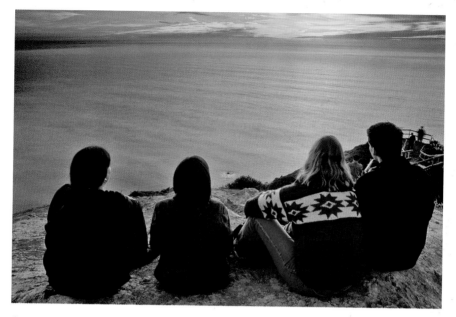

A number of places on the California coast lend themselves to the "feel like you can see forever" category, including this one where a group of friends watch the sunset at the Muir Beach overlook in Marin County.

OPPOSITE: The perfect Sunday drive in the Bay Area is a trip across the shoulder of Mount Tamalpais, high above the Pacific Ocean on the Panoramic Highway.

leopard lilies, and fairybells burst into bloom in the spring, and in the winter, Redwood Creek is in full flood, alive with spawning Coho salmon and steelhead trout. Both are among the West Coast's most imperiled species. Over the last two decades or so, the understory of the woods has been restored with eighty thousand native plants grown from seed collected in the watershed.

Like a mirage at the end of a steep trail on the edge of the woods is a brightly painted Austrian-style lodge, the Tourist Club. It's operated by Naturfreunde, an international organization of outdoor recreation lovers. Built in the early 1900s and a beloved institution of hikers, the lodge serves imported beers and occasionally puts on alpine festivals with traditional music and dancing.

Below the western slopes of Mount Tamalpais on the Pacific coastline, a tropical undercurrent keeps the waters off Stinson Beach surprisingly

warm year-round. Consisting primarily of vacation homes and a short lineup of cafés and a few shops, the village of Stinson Beach is a weekend retreat for San Franciscans escaping the summer fog. Although most Marin County beaches are unsafe for swimming and surfing due to undertows and currents, Stinson is an exception. Still, the occasional shark sighting does clear the waters of bathers for a day or two at a time.

Stinson Beach residents since the late 1960s, the Arrigoni family fishes not far offshore for salmon every year in their motorboat. Marin historian and author of *Making the Most of Marin*, Patricia Arrigoni said, "Our sons grew up at Stinson. They waded and swam in the high-tide pools that formed in the fall and winter and caught little perch with their fishing rods.

"Winter is a magical time of year, when thousands of monarch butterflies cluster in the eucalyptus and Monterey pines. We get huge flocks of overwintering birds, especially in the Seadrift Lagoon behind the beach. . . . We love to watch [the pelicans], with their six-and-a-half-foot wingspans, gliding over the waves, then dive-bombing into the water."

On the opposite side of the Bolinas Lagoon from Stinson Beach, Bolinas is a rustic hamlet inhabited by rogue artists and craftspeople who cut down the road signs regularly to discourage visitors. A few charming nineteenth-century buildings—a couple of cafés, Smiley's Schooner Saloon and Hotel dating from 1851, and St. Mary Magdalene Catholic Church, built in 1878—remain in what passes for a downtown.

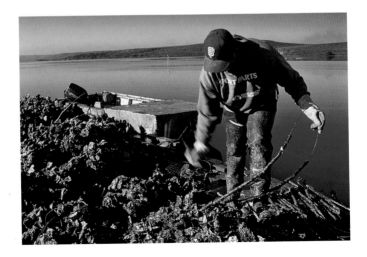

Fresh oysters, a local delicacy, are harvested from one of the many oyster farms at Schooner Bay in Drakes Estero on the Point Reyes National Seashore.

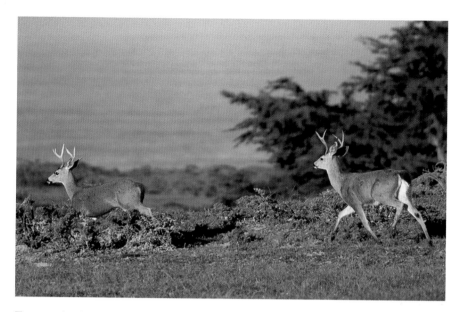

Two mule deer bucks run across a green grass field next to the ocean at Point Reyes National Seashore. Other wildlife in the region include bobcats, coyotes, all sorts of raptors and seabirds, and a herd of elk.

On Horseshoe Hill in the old cemetery, Catholics, Protestants, and Druids from the mid-1800s have their separate burial grounds.

On the west end of town, Agate Beach is small and rocky, with a footpath leading to Bolinas Lagoon. Its salt marsh and mudflats are a haven for thousands of migrating birds and ducks—as many as thirty-five thousand birds have been spotted here in a single day. One of the easiest to identify is the glossy black oystercatcher, about seventeen inches long with bright red-orange eyes and a long, narrow red bill and flesh-colored legs. Gathering in noisy groups, the birds make shrill whistles—*whee-whee-whee*—that can be heard above the surf.

Adjacent to the lagoon, the tops of redwoods and pines in the deep canyons of Audubon Canyon Ranch are nesting sites for hundreds of pairs of great blue herons and great egrets. Monarch butterflies spend the winter in a grove of eucalyptus trees along a nature trail outfitted with fixed telescopes for bird-watching. A research station, the ranch is open to the public from March through July on weekends and holidays.

Northwest of Bolinas on Mesa Road, the Point Reyes Bird Observatory is one of America's only full-time ornithological research

Mount St. Helena rises in the distance above rolling green hills and Tomales Bay, as seen from Point Reyes National Seashore. Only an hour north of San Francisco, this area is best known for wide-open spaces, farming, and dairy cattle.

facilities. Visitors can watch the scientists at work, banding rufous-sided towhees, song sparrows, and other shorebirds. This is also the trailhead for the Palomarin Trail, which leads to four freshwater lakes that are lively waterfowl habitats and to Double Point Bay, where harbor seals bask and breed. Just beyond Pelican Lake, a steep canyon trail is generously decorated by the pools and freshets of Alamere Creek, which eventually drops in spectacular style into the sea.

Driving over Mount Tamalpais from the Pacific Coast to U.S. Highway 101, travelers stop near the summit at the Pantoll Ranger Station to browse the small museum and get maps showing sixty miles of trail. An easy hike from here on Old Stage Road/Easy Grade Trail affords wide views, and as the trail connects to the Old Mine Trail, panoramas in all directions are magnificent. On a clear day, you can see the Farallon Islands, about twenty-five miles out to sea; San Francisco and the bay; the hills and cities of the East Bay; and Mount Diablo. On some occasions, the Sierra Nevada's snow-covered mountains can be seen 150 miles away.

ROUTE **6**

Golden Gate North

THE MARIN HEADLANDS

Directions From U.S. Highway 101 at the north end of the Golden Gate Bridge, take Conzelman Road west into the Marin Headlands to Point Bonita. At Point Bonita, take Field Road north to Bonita Road. Then follow Bonita Road east to Bunker Road, returning east to U.S. 101. Drive under the highway to Alexander Road. From Alexander Road, drive down to a left on Bunker Road and follow it to Fort Baker.

At sixty miles long and twelve miles wide, San Francisco Bay is the largest protected coastal bay for a thousand miles. Fed by the mighty Sacramento River, the San Joaquin, the Petaluma, and the Napa rivers, the bay was discovered in 1769 by Spanish explorer José Francisco de Ortega. Looming above the entrance to the bay, at the north end of the Golden Gate Bridge, are the bare hills of the Marin Headlands, rimmed with a few beaches and laced with footpaths on breezy ridges. Among other attractions are a Victorian-era lighthouse, an animal rescue station, and World War II fortifications.

The first vista point on Conzelman Road is often bristling with photographers' tripods because it offers the quintessential view of the Golden Gate Bridge. The 4,200-foot-long, glowing red-orange span of cable, iron, and steel sweeps across the neck of the bay in magnificent style, a symbol of San Francisco that seems to represent the open arms of a city that has welcomed immigrants, fortune seekers, and admirers for more than 150 years. From the headlands, the icons of the city come into view: Alcatraz, the Transamerica Pyramid, the tall towers of Embarcadero Center, and dozens of piers and wharves. Beneath the south end of the bridge, Fort Point National Historic Site endures the constant pummel of waves as they crash against the sea wall, an exhilarating backdrop for Civil War–era cannons meant to protect the city from attack by sea, which has never come.

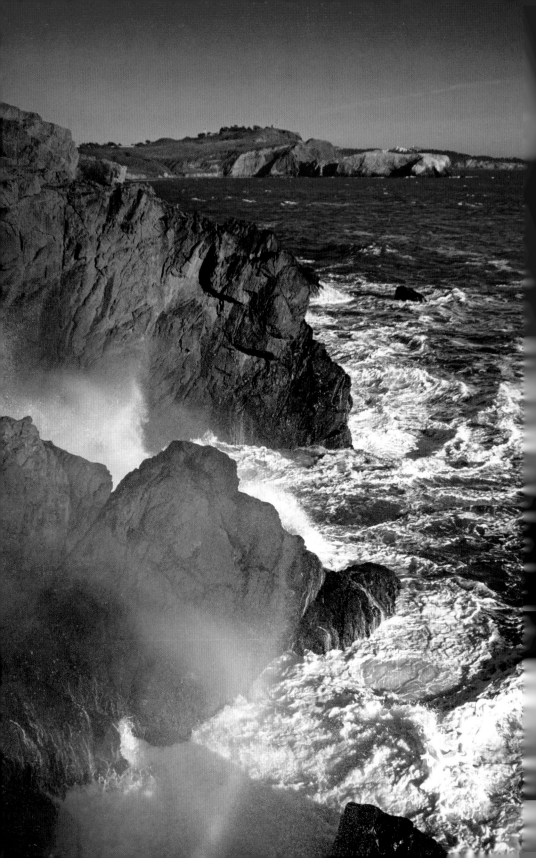

On clear days from the headlands, Point Reyes National Seashore is visible to the north, and twenty-six miles west, the Farallon Islands are usually visible. The largest seabird rookery south of Alaska, the Farallones are jagged bits of granite surrounded by the waters of the Gulf of the Farallones National Marine Sanctuary. A rare phenomenon around the islands is the annual, dense phytoplankton bloom, which creates a nutrient-rich feeding range for humpback and gray whales, elephant seals and sea lions, and dolphins and northern fur seals. Great white sharks love the islands, too, for the abundance of the yummy plankton-eaters. Bird-watchers and whale-watchers take boat trips to the islands in December through March, when whale sightings are nearly a sure thing.

Today part of the Golden Gate National Recreation Area, the headlands belonged to the military for many decades. As a result, the hills are dotted with old military buildings and bunkers. History buffs and kids climb around the spooky old tunnels and batteries that guarded the bay from the Spanish-American War through the Cold War.

Just as Conzelman Road narrows to one lane and plunges dramatically down toward the coastline, a fire road leads to the top of Hawk Hill and the Golden Gate Raptor Observatory. Each year, more than twenty thousand raptors fly over the headlands during a five-month migration season. Volunteers have counted as many as 2,800 raptors in a day.

At the bottom of Field Road, a narrow footpath leads to Point Bonita Lighthouse, built in 1855 on a bit of rock on the edge of the continent. Visitors access the lighthouse by walking through a tunnel hewn through solid rock and crossing a swaying footbridge over foaming surf. Salt spray and whooshing sounds fill the air, creating an unforgettable few minutes for visitors who teeter between the security of the bedrock mainland and the sight of the tiny white building defended by Victorian gargoyles at the end of the bridge. Originally, the lighthouse keeper was required to fire a cannon every half hour when it was foggy, which

OPPOSITE: Scenes like this, where crashing waves meet the coastline's cliffs near Rodeo Beach, are the reason many travelers come to see the beauty of California's coastline. However, be aware that each year people are swept right off the shore by the ocean's powerful and dangerous waves.

OPPOSITE: The sets over a majestical coastal rock seastack at Rodeo Beach in Northern California's Marin Headlands.

at this spot can be for hours and sometimes days; fortunately for the keepers, that practice was abandoned after a few years.

On the western edge of the headlands, Rodeo Beach is a favorite of surfers and birders who observe the voluminous populations of cormorants and pelicans on nearby Bird Island and the tufted and harlequin ducks and terns that frequent the adjacent lagoon. Rock hounds search for bits of red jasper, greenstone, and carnelian on the pebbled beach. From the bluffs above the beach, trails amble into the hills through the Rodeo Valley; some connect with the Bay Area Ridge Trail, which eventually will stretch 550 miles.

Across from the beach, the Marine Mammal Center is a hospital for orphaned, sick, and injured seals, sea lions, dolphins, otters, and whales; many of the patients are endangered or threatened species. Visitors can watch them being fed and treated. Spring is pupping season, a busy time. Between February and June, elephant seal and harbor seal pups are in residence; during summer and fall, California

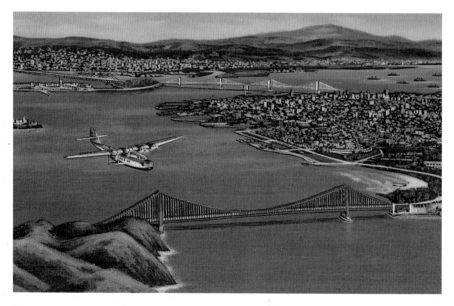

This vintage postcard of Golden Gate Bridge shows the structure's distinctive orange paint, known as International Orange. *Voyageur Press Archives*

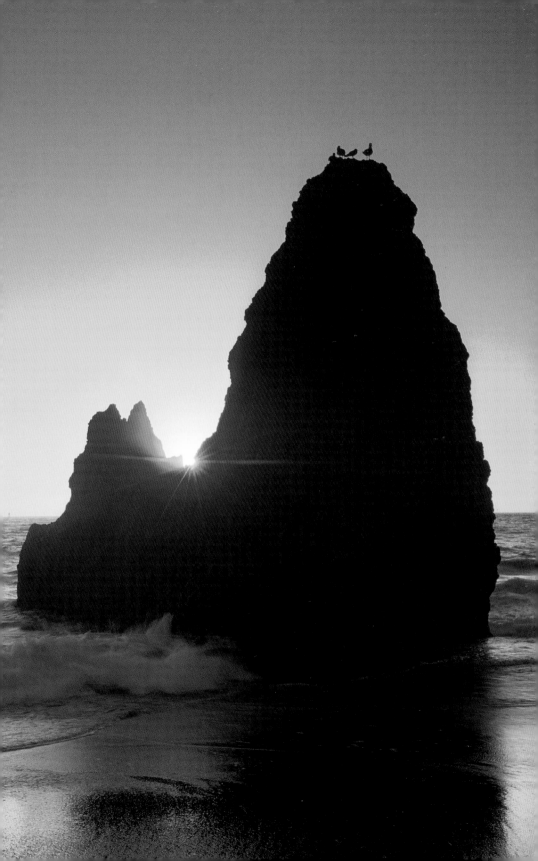

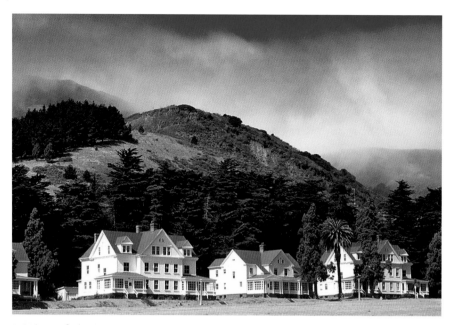

Lying in the shadow of the Golden Gate Bridge, these Victorian-era officers' houses at Fort Baker are now part of the new Cavallo Point conference center.

sea lions are usually on site. On the opposite side of U.S. Highway 101, nearly under the Golden Gate Bridge, Fort Baker is a former 1905 U.S. Army post. Today, a compound of historic buildings clusters around a main parade ground, a sheltered harbor and a fishing pier, walking trails, and a large children's museum and learning center, the Bay Area Discovery Museum. Still quite active along the coastline are the U.S. Coast Guard vessels based at a station here.

In the 1990s, the fort was decommissioned and became part of the Golden Gate National Recreation Area. The old buildings now serve a variety of uses. For example, the gracious, completely refurbished officers' quarters house a luxury hotel, Cavallo Point; the Lodge at the Golden Gate; and a learning center focused on sustainability, the Institute at the Golden Gate.

Some visitors park at Fort Baker and take the easy hiking trail beneath the dramatic understructure of the bridge and up to the North Vista Point, from where they set off on a never-to-be-forgotten walk across the Golden Gate Bridge.

ROUTE 7

Tracing the Tiburon Peninsula

TIBURON TO CHINA BEACH

Directions From U.S. Highway 101, take Tiburon Boulevard east into Tiburon. Then follow Paradise Drive along the waterfront past Paradise Beach Park, reconnecting with U.S. 101 briefly to San Rafael. In San Rafael, take 3rd Street east, which becomes Point San Pedro Road tracing the shoreline of San Pablo Bay to China Camp State Park. After visiting the park, follow the road west, returning to U.S. 101.

Perched at the end of a narrow peninsula that pokes out into San Francisco Bay, the picturesque little town of Tiburon lies on the shores of Raccoon Strait, a wind-lashed channel carefully navigated by sailboats and motor yachts, between the mainland and Angel Island. A loop from U.S. Highway 101 through Tiburon and around the waterfront is a sea-breezy delight, with shoreline walks, beach picnics, views of the big-city skyline, and historical sites.

Just off U.S. 101 at the north end of Richardson Bay is the start of the Tiburon Peninsula Historical Trail at Blackie's Pasture. The trailhead is marked by a life-size bronze sculpture of a horse, Blackie, who retired and was buried here after a career as a rodeo cutting horse. The three-mile trail is popular with bikers, walkers, and those pushing babies in strollers, who proceed along the shoreline of Richardson Bay past sweeping lawns; narrow, rocky beaches; soccer fields; a few tide pools; and a playground. Sandpipers bob along the tidal flats while kayaks and rowing shells glide by, and the odd harbor seal peers at the joggers and inline skaters. Occasionally, a small whale will wander away from a migrating pod beyond the Golden Gate and swim up and down in the bay for a few days.

ANGEL ISLAND

REACHED BY FERRY ACROSS RACCOON STRAIT from Tiburon, and from Pier 41 in San Francisco, Angel Island State Park offers the outdoor explorer many recreational opportunities. Whether you want to spend the day hiking or mountain biking on forested hills, kayaking, or just a relaxing picnic on the grass, you'll get many chances to watch the ships and the boats in San Francisco Bay.

Once a Miwok hunting ground, then a cattle ranch, a U.S. Army base, and a prisoner-of-war camp and immigration station, this island and state park has a lively and unique past. The easiest way to discover it is to take a narrated tour in an open-air tram. While on it, you'll see the historic buildings that remain from World War II, when five thousand soldiers a day were processed at Fort McDowell before leaving for the Pacific. Between 1910 and 1940, hundreds of thousands of Asians were detained here in wooden barracks, some for many months, awaiting admission into the United States.

To further your knowledge and get in some outdoor adventure, take a kayak tour around the island, where historical and ecological information about such sites as Ayala Cove is offered. An ancient Miwok Native American ceremonial site, Ayala Cove was also the spot the Spanish ship *San Carlos*, the first European surveyor of the bay, anchored at in 1775.

Angel Island served as an immigration station in the early twentieth century.
Library of Congress

Off the trail, the Richardson Bay Audubon Center and Sanctuary, open to the public, is a bayside wildlife preserve of uplands and marshes and a habitat for thousands of birds migrating along the Pacific Flyway. Among the more colorful species commonly seen are Clark's grebes, double-crested cormorants, black-and-white buffleheads, greater scaups, and rusty-hued, ruddy ducks.

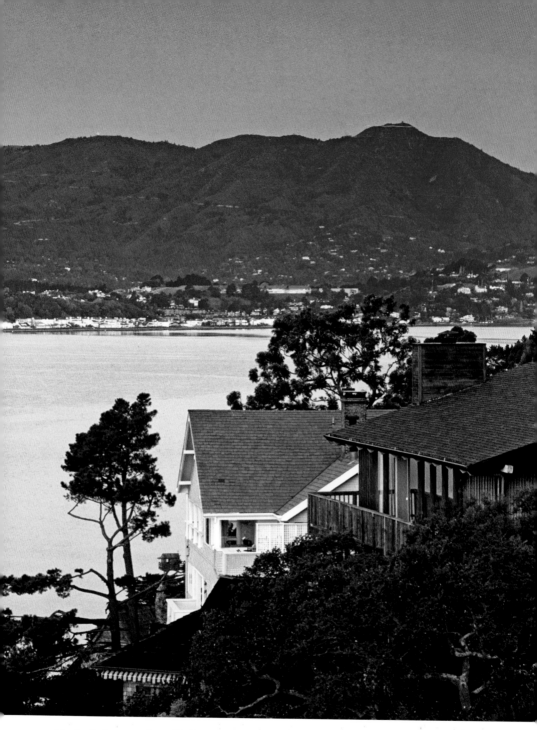

Marin is known for offering world-class views like this one across Richardson Bay toward Mount Tamalpais. In the sweeping vista, you can spot homes in Tiburon and all across the North Bay.

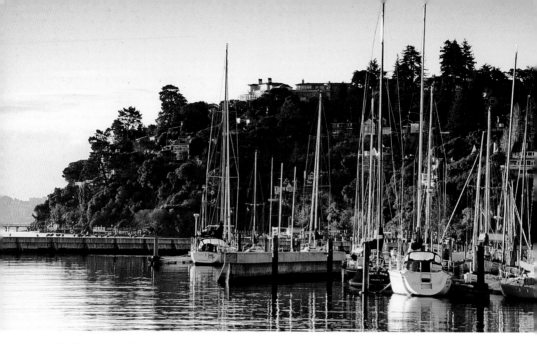

Sailboats in Tiburon sit peacefully docked in calm waters at sunrise, waiting for cool ocean breezes to propel them gracefully across the San Francisco Bay.

As bright yellow as a canary is the center's Lyford House, a circa-1870 mansion with mansard-capped cupola, dormers, and fancy finials. The Victorian house was barged across the bay to its present location, where it is carefully preserved by the Audubon Society.

On a high ridge in the hills above Richardson Bay, walking trails crisscross the Nature Conservancy Ring Mountain Preserve, where knee-high native grasses are dotted with wildflowers in the spring. Bay trees, madrones, live oaks, and buckeyes provide shade for several endangered plant species, including the Tiburon mariposa lily, existing nowhere else in the world. Blooming all through the spring on a stalk about two feet tall, the lily has a tan, cinnamon, and yellow bowl-shaped flower. The one-mile trek to the Ring Mountain summit offers hikers the reward of a stunning panoramic view of San Francisco Bay, Mount Tamalpais, Marin County, and the East Bay hills.

At the end of the peninsula in the town of Tiburon, shops and restaurants line a marina where ferries from San Francisco expel throngs of tourists who settle right in on the open-air decks of places like Sam's Anchor Café to enjoy fresh seafood and libations, while seagulls wheel overhead.

On opening day of yachting season in April, decorated pleasure craft sail and motor along the waterfront. Locals arrive early to lay down their picnic blankets and watch the blessing of the boats and the all-day waterborne parade.

A block or so west, a yawning lagoon once was filled with primitive houseboats in the 1880s. Known as "arks," these hand-built houseboats were common at the time, anchored in several coves and sheltered spots around San Francisco Bay. Numbering in the hundreds, the Tiburon arks were inhabited by sea captains, summer vacationers, railroad workers, and artists. In the 1940s when the lagoon was filled in for development, some of the arks were moved to the mainland and transformed into galleries and shops. Several remain today along tree-lined Ark Row.

Below Ark Row, the China Cabin is the delightful remaining fragment of a side-wheel steamer that plied trade routes between San Francisco and the Orient in the late 1800s. The saloon, or drawing room, was salvaged when the ship burned and is now a maritime museum of period antiques and elaborate gold-leaf ornamentation.

Off Tiburon Boulevard, Lyford Drive leads up to a mile-long trail on Tiburon Ridge in the Old St. Hilary's Open Space Preserve, where a sweet, small, Carpenter Gothic–style 1888 church lies amid grassy meadows. Here, on south-facing slopes (and nowhere else in the world), the small dark purple bloom of the endangered black jewelflower appears in May.

West around the peninsula, Paradise Beach Park is a popular stop for sunbathing, fishing off the pier, and picnicking in the woods.

North of the Tiburon Peninsula on San Pablo Bay, China Camp State Park—where a beach and hillside trails have wide Bay Area views—awaits those who can find it. (Many have a hard time finding the camp, even though signage for it is good.) In a pickleweed swamp, the salt marsh harvest mouse and the clapper rail are protected, endangered species. Mountain bikers head for the Back Ranch trailhead, accessing about fifteen miles of ridgeline.

Windsurfing is a big deal from May through October at China Camp, where you'll also find a small museum, a fishing pier, and remnants of a Chinese immigrant shrimp fishing village from the late 1800s. A China Camp resident who still catches and sells bait shrimp, Frank Quan helps to maintain the *Grace Quan*, a replica of a nineteenth-century shrimping junk that, along with hundreds of others, once plied the bay.

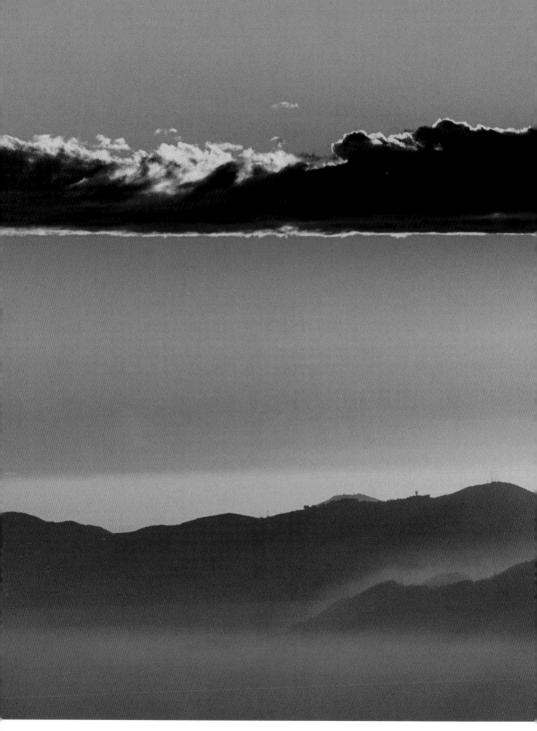

The sun sets through a layer of clouds hanging over San Francisco Bay, Angel Island, and the southern part of Marin County, as seen from high in the Berkeley Hills.

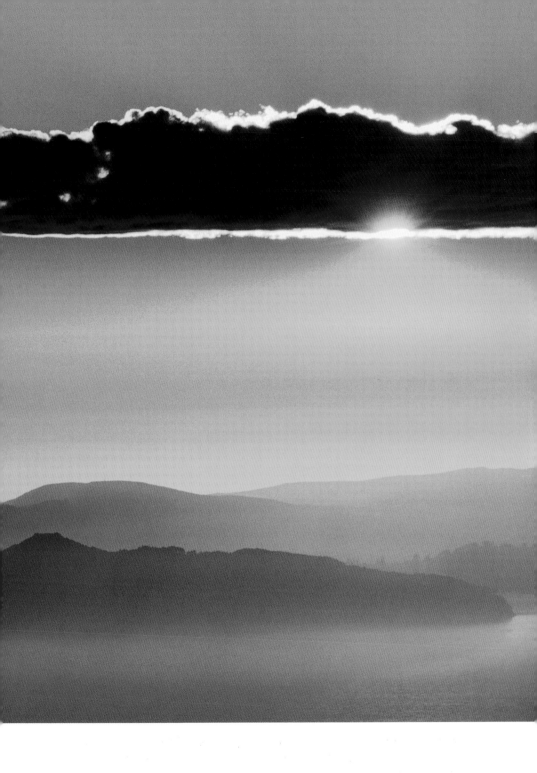

ROUTE **8**

Where the Bay Meets the Pacific

SAN FRANCISCO BAY TO LAND'S END

Directions From the Golden Gate Bridge, take the 25th Avenue exit west, connecting to Lincoln Boulevard west. From Lincoln Boulevard, follow El Camino Del Mar west to Legion of Honor Drive, where you'll head south. Then take Clement Street west to the junction of El Camino Del Mar and Point Lobos Avenue. Head north on El Camino Del Mar to Land's End.

Enjoyed entirely through vehicle windows or greatly enhanced by strolls and stops along the way, the western edge of San Francisco—in fact, the edge of the continent—is a magical, natural world away from busy city streets. Bordering a shady walking trail, Lincoln Boulevard enters a dark cypress and Monterey pine forest, passes a fragment of the historic Presidio, then winds through a swanky neighborhood and meets the sea at Land's End. Offering a sample of stunning views to come, the first vehicle pullout beyond the bridge frames a glimpse of Baker Beach and the open ocean where it flows under the Golden Gate Bridge into the bay.

The boulevard ambles on through Seacliff, a neighborhood of vintage mansions, and passes the California Palace of the Legion of Honor, where a replica of Auguste Rodin's bronze sculpture, *The Thinker*, ponders his idyllic view of the city from his pedestal guarding an impressive classical edifice. Built in 1924 in the Beaux Arts style of the eighteenth-century Palais de Legion d'Honneur in Paris—complete with a triumphal arch, heroic equestrian bronzes, and colonnades—the museum stands in a wooded setting above Lincoln Park Golf Course. Inside, four thousand years of ancient and European art is on view—from a magnificent Medieval Spanish ceiling from the Palacio de Altamira and Benvenuto Cellini's bust of Cosimo de Medici to Claude

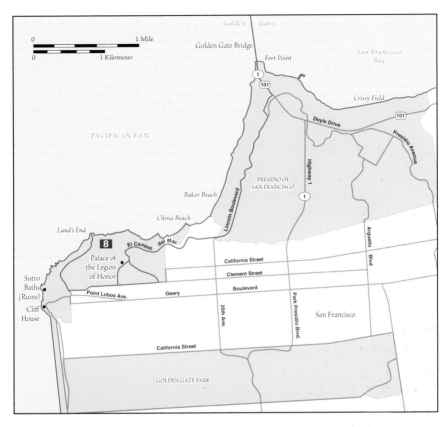

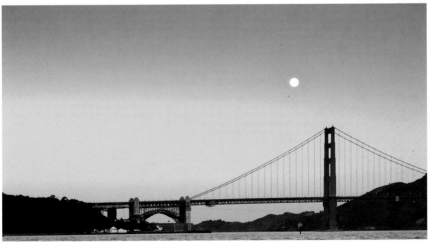

Sunrise heralds a golden start to a new day for golfers enjoying the course at Lincoln Park. Nestled in the northwestern tip of the San Francisco Peninsula, Lincoln Park was the western end of the first cross-country road.

THE PRESIDIO OF SAN FRANCISCO

BETWEEN **1776** AND **1846,** the Presidio of San Francisco was occupied by the Spanish and then the Mexican army before it became the treasured preserve of the U.S. Army. In 1994, the army turned it over to the National Park Service.

A vast sweep of woodlands, coastal bluffs, and beaches in the shadow of the Golden Gate Bridge, the magnificent park is threaded by quiet roads and paths for walking and bike riding, and shuttle buses make it easy to explore. There is much to see throughout the park, from seventeenth-century bronze cannons to Civil War barracks, pre-1906 San Francisco earthquake Victorians, adobe walls built by the Spanish, and picturesque rows of Queen Anne–style officers' homes.

In the mid-1800s, U.S. soldiers recovered from disease and injury in the Old Station Hospital, which today is guarded by artillery pieces and cannon balls. Behind the building are earthquake cottages, tiny dwellings with sparse furnishings that were erected and lived in by refugees from the great earthquake of 1906. Daily army life of several eras is chronicled in dioramas, photos, weapons, uniforms, and military paraphernalia in the Officers' Club.

Secluded trails wind through a cypress, pine, and eucalyptus forest of more than four hundred thousand trees planted in the 1800s. Picnic tables are perched on breezy headlands with sea views or hidden in rhododendron groves. A creek and a spring-fed pond are habitats for hundreds of birds.

On the west side of the park, you'll find World War II bunkers to explore at Baker Beach. With dangerous undertows, the beach is unsafe for swimming, although popular for sunning and shore fishing. Peregrine falcons and eagles nest in the tops of one-hundred-foot-tall evergreens on the Presidio Golf Club, founded in 1895, one of the earliest courses on the West Coast. In 1903, the Ninth Cavalry Buffalo Soldiers assembled on the course to greet President Theodore Roosevelt, and in the 1990s, the Arnold Palmer Company took over management, bringing the course up to twenty-first-century standards.

Below the main park, along the waterfront and also part of the Presidio, is Crissy Field, a former World War II army airfield that has been restored to wetlands and dunes. A sea-breezy trail leads through it, giving trekkers the opportunity to take photos of the Golden Gate Bridge, fly a kite, and watch windsurfers, freighters, and pleasure craft sailing offshore. With water temperatures around fifty degrees, currents breaking four knots, and gales as high as thirty knots, this is one of the most formidable patches of sailing water on the planet.

In the late 1990s, Crissy Field was transformed from concrete parking lots and falling-down old buildings to a splendid tidal marsh as part of the

ABOVE: Survivors of the devastating 1906 San Francisco earthquake set up camp at the Presidio. BELOW: A panaromic view of the Presidio and Fort Winfield Scott, circa 1919. *Both photos Library of Congress*

city's campaign to restore the bay's original wetlands. Located here, the Gulf of the Farallones National Marine Sanctuary visitor's center exhibits photos of some of the sea creatures that are protected in the open ocean preserve offshore, including the Farallon Islands, which are usually visible from the bridge. Among the animals featured are the great white sharks that breed in large numbers around the islands.

Part of the U.S. National Park Service, the Presidio is a new kind of national park, funded in part by the rental of some of the eight hundred renovated vintage buildings. In a white-shingled house with a spectacular view of San Francisco Bay, a notable tenant is the Gorbachev Foundation, founded by the former Soviet Union president to study world problems. The park-like campus of another tenant, the Letterman Digital Arts Center—home to Lucasfilm Ltd., one of the world's leading film and entertainment companies—makes a cool, green resting place for Presidio visitors.

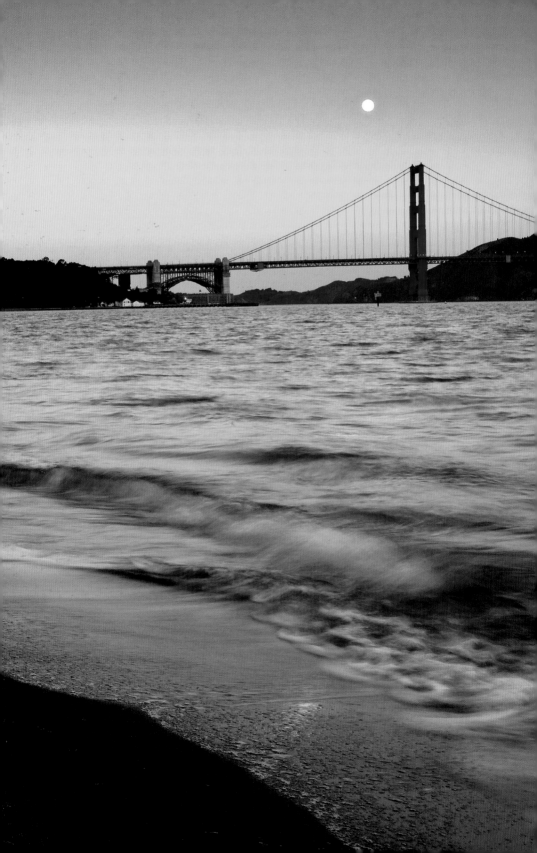

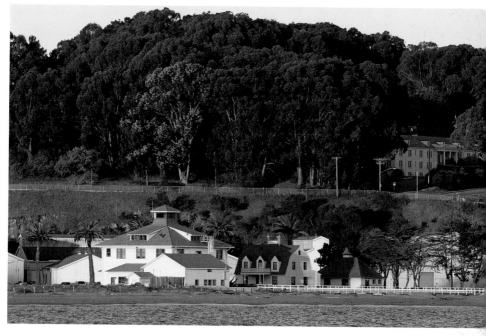

Old military buildings and barracks within the Presidio of San Francisco—
like these that sit at Crissy Field, or the many tucked inside pine- and
eucalyptus-covered hillsides—are an integral part of San Francisco's history.

Monet's *Grand Canal at Venice*, Flemish tapestries, and the huge
Achenbach collection of prints and drawings.

Beyond Lincoln Park at Land's End on the westernmost rim of the
city is a portion of the Golden Gate National Recreation Area Coastal
Trail. This meandering footpath atop rugged bluffs offers dazzling
views of the Golden Gate Bridge, the Marin Headlands, and the Pacific
Ocean. The icon of San Francisco, the bridge is a glowing red-orange
sweep of cable, iron, and steel that seems to represent the open arms
of a city that has welcomed immigrants, fortune seekers, and admirers
for over a century and a half. The number one attraction for first-time
visitors, the suspension bridge is 1.7 miles long, extending from Fort
Point in the city to the Marin Headlands.

OPPOSITE: A full moon sets at dawn over the south tower of the Golden
Gate Bridge as waves gently lap against the sandy beach at Crissy Field.
Many people start their day by walking or jogging the trail that leads to the
foot of the bridge.

A windsurfer rides the waves in the San Francisco Bay between the Presidio and Marin.

The quintessential photo-op of the Golden Gate Bridge can be found on the Land's End path, just below the USS Memorial Overlook, which honors the USS *San Francisco*, a World War II cruiser that sustained forty-five hits and twenty-five fires during the Battle of Guadalcanal in 1942. The names of the 107 men lost in the battle are engraved in the memorial, flanked by the actual shell-riddled bridge of the warship.

Also from this trail, when the tide is out, you can spot the bones of three ships that wrecked on the jagged cliffs below in the 1920s and 1930s. You may also see raptors—including peregrine falcons and red-tailed hawks— flying overhead, since habitat was created here for them as part of an ambitious program of forest restoration. Also as part of that program, hundreds of Monterey pines now line the pathway.

Adjacent to Land's End, the ruins of Sutro Baths can be seen from the veranda of the Cliff House restaurant. Mayor of the city from 1894 to 1897, mining czar Adolph Sutro once owned one-twelfth of San Francisco, including a thousand acres in the Land's End area. He planted thousands of trees and plants and created Sutro Baths, huge, heated, indoor saltwater pools under glass roofs, surrounded by potted palms and Egyptian relics. The baths were destroyed by fire in 1966, and the ruins remain, creating a seabird rookery and interesting site. Photos of Sutro Baths in their halcyon days can be seen in the hallways of the Cliff House.

OPPOSITE: The camera obscura located at the famed Cliff House near the site of the old Sutro Baths looks out over the Pacific Ocean toward a blazing red sunset.

Extending for four miles south of Land's End, Ocean Beach is a flat ribbon of sand that is popular for walking, sunbathing, or fogbathing. Because the water is extremely cold and the undertow treacherous, swimming is prohibited. A warm retreat perched above the shore is the Beach Chalet. Since 1925, this terra cotta–tiled Mediterranean villa, one of the masterpieces of the Arts and Crafts–style architect Willis Polk, has been here. In the chalet's museum are vivid Depression-era frescoed murals and a scale model of Golden Gate Park. An old photo shows a day in 1863, when gentlemen in tall, black, beaver-fur top hats and ladies in ostrich feathers and voluminous skirts lined up on Ocean

Sunrise bathes a stone lion statue in front of the Legion of Honor in San Francisco. The design of the "palace" is based on the building of the same name in Paris, France, and houses a notable collection of mostly European fine art.

Bathers head down a slide at the famous Sutro Baths in San Francisco in 1898. The huge, heated, indoor saltwater pools under glass roofs were destroyed by fire in 1966. *Library of Congress*

Beach in their horse-drawn surreys. Today, a brewpub upstairs is lined with ocean-view windows, while in the café below is a light-filled atrium. Adirondack chairs on the lawn provide a pleasant place to warm up after a day in the outdoors.

Visible from the Beach Chalet, and accessed by a garden pathway into Golden Gate Park, is a massive Dutch windmill. Erected in 1902 just a hundred yards from the ocean, the 75-foot-tall windmill has a 102-foot arm span. In the spring, when hundreds of Dutch bulbs, gifts of Queen Wilhelmina of the Netherlands, are in bloom, this is a truly breathtaking place to be.

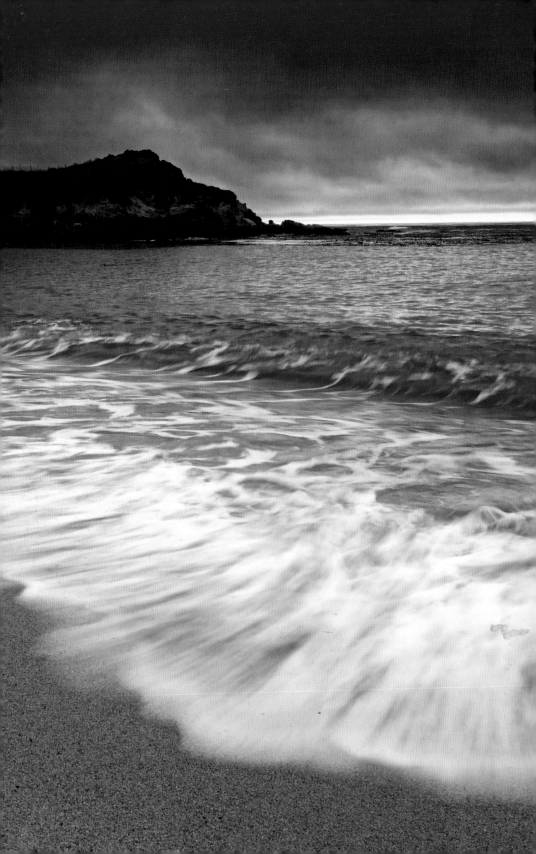

PART II

The Central Coast

Verdant Valleys, Cowboys, and a Castle

Tracing the California coastline south from San Francisco Bay, State Route 1, more commonly known as Highway 1, rides along above rocky promontories, coves, and harbors at the foot of the Santa Cruz Mountains. Backroads roam to a century-old fishing village and a narrow-gauge railroad. John Steinbeck's classic novels are recalled in his hometown of Salinas, and Hearst Castle dazzles visitors as it has since Hollywood stars gamboled there in the halcyon years of the 1920s.

The verdant valleys and the rivers of Central California meet the ocean on fertile marine terraces planted with moisture-loving

OPPOSITE: Waves break at Carmel River State Beach at sunset. The mile-long beach is home to a bird sanctuary in a lagoon.

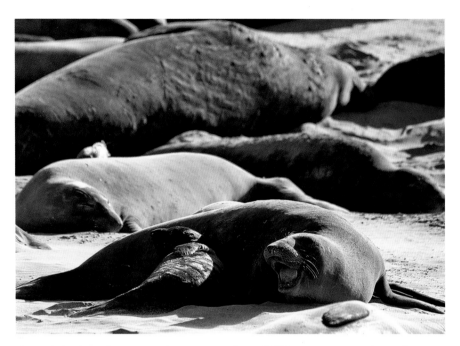

One of the best-known and most popular wildlife encounters along the coast is taking a docent-led walk among the elephant seals on the beach at Año Nuevo State Reserve on the San Mateo County coast.

artichokes, strawberries, and brussels sprouts in a rich geography where temperatures vary no more than ten degrees between summer and winter. Mornings and nights are misty, while sunny days are never really hot. Mists collect on the shoulders of the Santa Lucia Mountains, which shelter the golden, pastoral Carmel Valley.

Slow rambles on a twisting labyrinth of backroads lead to ancient redwood forests and sunny riverbanks in the Santa Cruz Mountains, where lovers of Rhône-style wines make their pilgrimages to the small wineries located there.

A new town has arisen at Avila Beach, just up the road from a circa-1800 hot springs resort. Oblivious to their fans, who come armed with binoculars and cameras, elephant seals recline on their own beaches and battalions of butterflies gather in the trees. Kayakers and sea otters float in the quiet waters of Morro Bay. Cowboys ride into the sunset on historic cattle ranches while intrepid backroad wanderers seek out all the pleasures of the central coast.

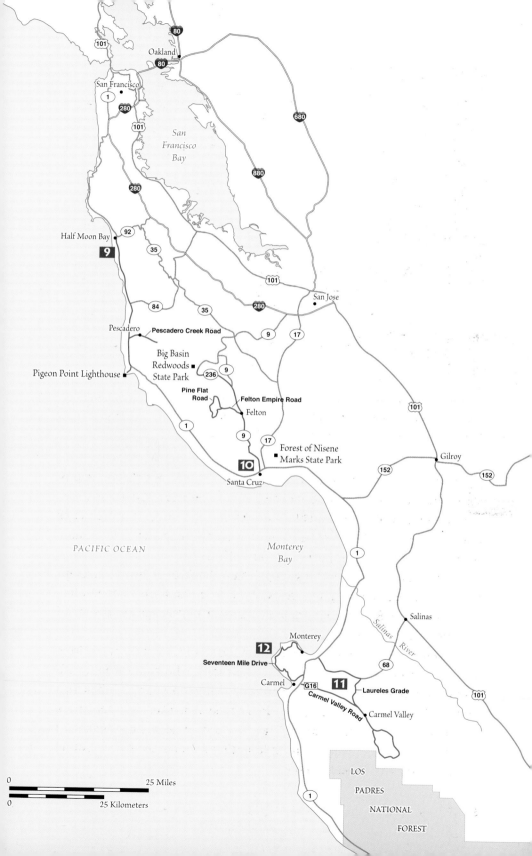

The San Mateo Coast

HALF MOON BAY TO PESCADERO AND PIGEON POINT LIGHTHOUSE

Directions From Half Moon Bay, take State Route 1 (Highway 1) south to Pescadero Creek Road and head east to the town of Pescadero. After visiting Pescadero, return west on Pescadero Creek Road to the loop road, North Street, to Harley Farms. After visiting the farms, return to Pescadero Creek Road and continue east to Pescadero Creek County Park. After visiting the park, head on Pescadero Creek Road to the junction with Highway 1, where you will turn south to Pigeon Point Lighthouse.

Separating the San Francisco Peninsula from the Pacific Ocean, the Santa Cruz Mountains descend in softly folded foothills into the sea. Curvy State Route 1 (Highway 1) runs along the coastline, heading south from the harbor town of Half Moon Bay into agricultural lands. Cows, sheep, horses, and a few farmhouses are scattered on windswept headlands above a necklace of wild beaches; among them is San Gregorio State Beach, a driftwoody strand at the mouth of San Gregorio Creek. An estuary and a freshwater marsh fan out into lush habitat stalked by such birds as shearwaters, godwits, and willets. Sometimes sighted is the marbled murrelet, a threatened species that nests in the tops of redwood trees in nearby Purísima Creek Redwoods Open Space Preserve.

About four miles farther south, Pescadero Road heads inland between fields of artichokes and aromatic herbs to the historic village of Pescadero. A stagecoach stop in the mid-1800s and a seaside resort at the turn of the century, the tiny town today consists of a couple of blocks of clapboard, false-front buildings and weathered farmhouses that are now antiques stores and curio shops. The steepled Pescadero Community Church, built in 1867, is the oldest surviving Protestant church on the peninsula. On weekdays, Pescadero is so quiet that visitors walk right down the middle of Stage Road, the main street,

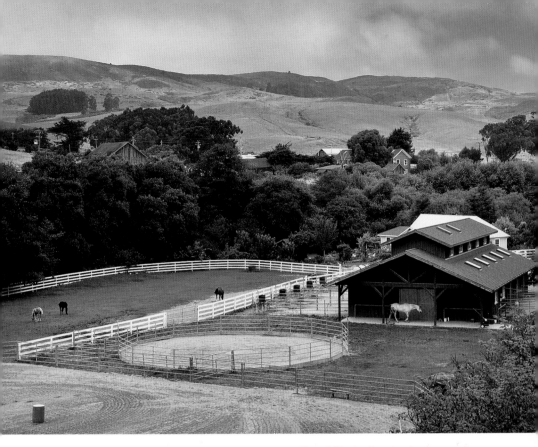

Tucked away in a coastal valley between rolling hills is the rustic town of San Gregorio in San Mateo County. Aside from horse ranches, farms, and old wooden houses, the town is best known for the local hangout, the San Gregorio General Store (and bar), that has been serving customers since 1889.

drawn to the irresistible aroma of warm artichoke and garlic cheese bread wafting out of Arcangeli Grocery. The breads and other goods are "half-baked" all day, and packaged for buyers to take home and finish baking later.

Crowded on sunny weekends, Duarte's Tavern and Restaurant in Pescadero has been operating since 1894, serving *cioppino* (fish stew) with a spicy Portuguese flair, as well as artichoke soup, abalone sandwiches, and olallieberry pie. Local ranchers belly up to the Old West–style, knotty pine bar.

A cow dairy in the early 1900s, Harley Farms has been transformed into a goat milk dairy and cheese-making parlor. Yorkshire, England–born Dee Harley welcomes visitors to mingle with her goats, enjoy the

THE CALIFORNIA COASTAL TRAIL

A 1,200-MILE, CONTINUOUS TRAIL stretching along the California coast from Mexico to Oregon, the California Coastal Trail is a work in progress. In state, national, and local parks; on beaches, on sidewalks, on rural trails, and along highways; and on blufftops and creek sides, the trail's network of footpaths is making it possible for walkers, bikers, equestrians, wheelchair riders, and others to enjoy the entire California coastline, up close.

Some of the completed segments are spectacular in their scenic beauty. From Horsehoe Cove to Salt Point State Park on the north coast, the trail follows the edge of a high bluff, affording glorious views of a rugged, rocky shoreline pounded by Pacific breakers. A bishop-pine forest and a pocket beach are highlights, as well as an old farm road wandering through grassy meadows.

In Ventura County in Southern California, from the Port of Hueneme (pronounced *Wy-Nee-Mee*) to Mugu Naval Base, the trail is a popular retreat for residents of this highly populated area. Starting at the entrance to the deep-water port and shipyard at Port of Hueneme, the trail heads for the dunes on wide, sandy Port Hueneme Beach and the lagoon at the mouth of Bubbling Springs Creek, where signs mark nesting areas for endangered least terns and snowy plovers. Attractions include a 1,200-foot-long fishing pier and the historic Point Hueneme lighthouse, still active and maintained by the U.S. Coast Guard.

Near Moss Beach in San Mateo County, the California Coastal Trail loops through the tangled garden of an old estate into a spooky forest of Monterey cypress and along a bluff above the James V. Fitzgerald Marine Reserve, where some of the richest tide pools on the Pacific Coast are found. Low tide reveals a three-mile-long reef, wherein a kaleidoscope of sponges, green anemones a foot in diameter, colorful sea stars, purple and red rock crabs, mollusks, and fish live.

Continuing south, hikers emerge in the quiet burg of Moss Landing, passing by the Moss Beach Distillery Restaurant, a cozy retreat since the 1920s. Diners and imbibers lounge on deck chairs on an outdoor patio above a surf-splashed cove; when the winds blow cold, blankets are distributed and everyone wraps up. According to local legend, in the 1920s a young married woman fell in love with the handsome piano player in the bar. Wearing a blue dress, she later was killed in an accident. According to some, the "blue lady" continues to look for her lover in the distillery, opening books, locking and unlocking doors, stealing women's earrings, and scaring children.

The trail continues from Moss Beach to Pillar Point Harbor at Princeton-by-the-Sea, where more than two hundred fishing boats and pleasure craft sail in and out. Rockfish and flounder are easy catches from the wharf, and

shelling is good on the little beach west of the jetty. At the harbor bar and restaurant Ketch Joanne, locals and tourists gather in booths next to the woodstove for bowls of clam chowder and mugs of Princeton-by-the-Sea pale ale.

Five miles farther south, Wilder Ranch State Park was a dairy ranch in the 1800s. Today the leafy, meadowy park has picnic tables in an apple orchard and walking and riding trails. In the historic ranch house are displays depicting Victorian-era life on the central coast.

Just north of the city at Natural Bridges State Beach, dramatic sandstone arches and tide pools rich with sea life are reasons to linger. A

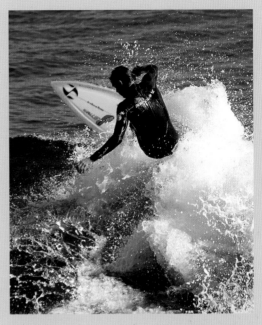

Watching surfers ride the waves at spots like Steamer's Lane at Lighthouse State Beach is one of the popular things to do along West Cliff Drive along the California Coastal Trail in Santa Cruz.

short boardwalk leads through a eucalyptus forest to the California Monarch Butterfly Preserve where, depending on the time of year—early October through March is best—you'll see thousands of butterflies hanging in the trees and moving about in great golden clouds.

Natural Bridges Drive connects, going south, to West Cliff Drive, which winds along the high ocean bluffs; the adjacent paved trail is popular with hikers and bikers. Just where the drive enters the city, the Santa Cruz Surfing Museum at Mark Abbott Memorial Lighthouse showcases a hundred years of surfing history, including the famous "Shark Attack" surfboard. Below the lighthouse, surfers gather for competitions and for the big waves at what's known as Steamer's Lane.

Visitors skirting the tourist crowds of central Santa Cruz head right through downtown and connect with East Cliff Drive, continuing south along the bluffs and stopping at Twin Lakes State Beach. Cleaved by a small-craft harbor and Schwan Lagoon, the beach is a sanctuary for Virginia rails, chickadees, belted kingfishers, and dozens more species of birds and waterfowl.

Within the sandstone cliffs backing two-mile-long Seacliff State Beach are the fossilized remains of multimillion-year-old sea creatures. A five-hundred-foot wooden pier and the wreck of a concrete ship are both roosting spots for sea birds and anglers.

Just down the road from San Gregorio is another bucolic town, Pescadero. The local market is known for its fresh-baked artichoke bread. Artichokes are also one of the region's more popular crops, lining the fields along the coast.

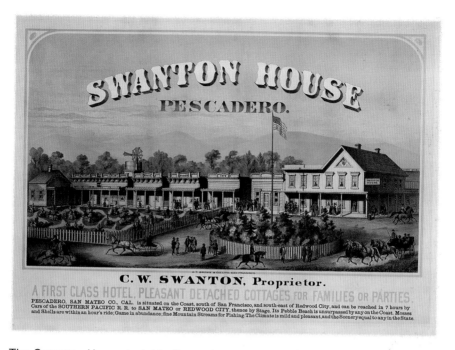

The Swanton House hotel in Pescadero was one of the places in this town where stagecoach travelers stopped for the night in the mid-1800s.
Courtesy of the Bancroft Library, University of California, Berkeley

edible flower garden, and learn how cheese is made. Early spring is a popular visiting time, when about five hundred kids are born.

Up the road a mile from Pescadero, Phipps Country Store and Farm is a combination produce stand, plant nursery, and menagerie of exotic birds and farm animals. Among the cacophony of sounds heard are parrots' squawks, green and orange canaries' songs, and peacocks' trumpetings. The farm is also home to fancy chickens, big fat pigs, a variety of bunnies, and antique farm equipment. Visitors may pick their own strawberries, raspberries, and olallieberries and eat them at a picnic table in the middle of a flower-filled greenhouse.

A little farther up Pescadero Road, an 8,020-acre parkland known as Pescadero Creek Park makes a pleasant stop for a walk beneath towering redwood and Douglas fir trees. On a trek into the valley uplands, hikers come across Santa Cruz cypress, a variety of oak species, and big-leaf maples, and they are rewarded with sweeping

continued on page 112

Pigeon Point Lighthouse was named for the Boston Clipper ship *Carrier Pigeon*, which went down off the point at night in heavy fog. *Courtesy of the Bancroft Library, University of California, Berkeley*

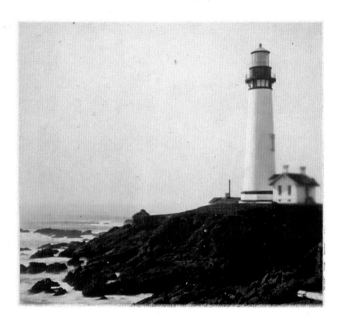

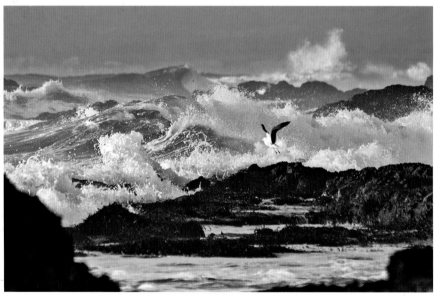

Winter and spring can bring turbulent times to the coast due to wind and weather. Here, a seagull takes to the air from the coastal rocks at Pescadero State Beach, floating out toward the angry surf in search of food.

OPPOSITE: Safeguarding ships traveling along these waters, Pigeon Point Lighthouse stands in pre-dawn light, perched on the coastal bluffs of the San Mateo County coast.

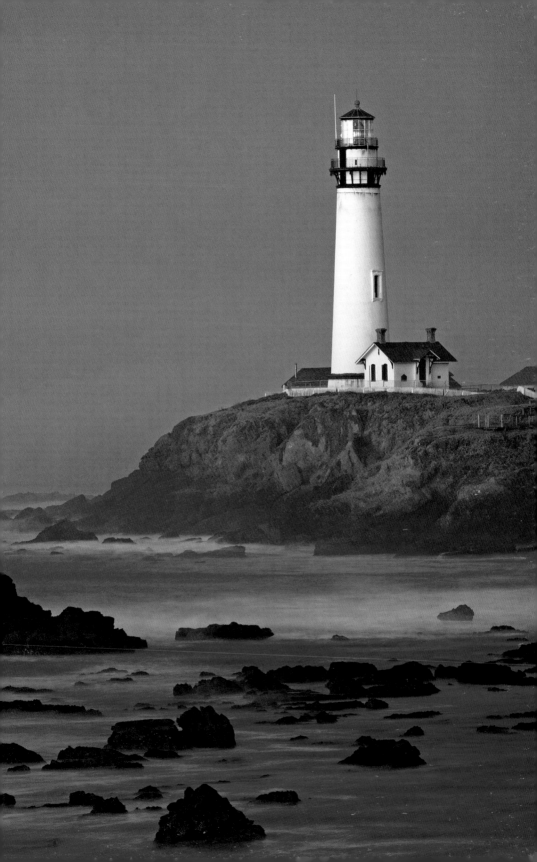

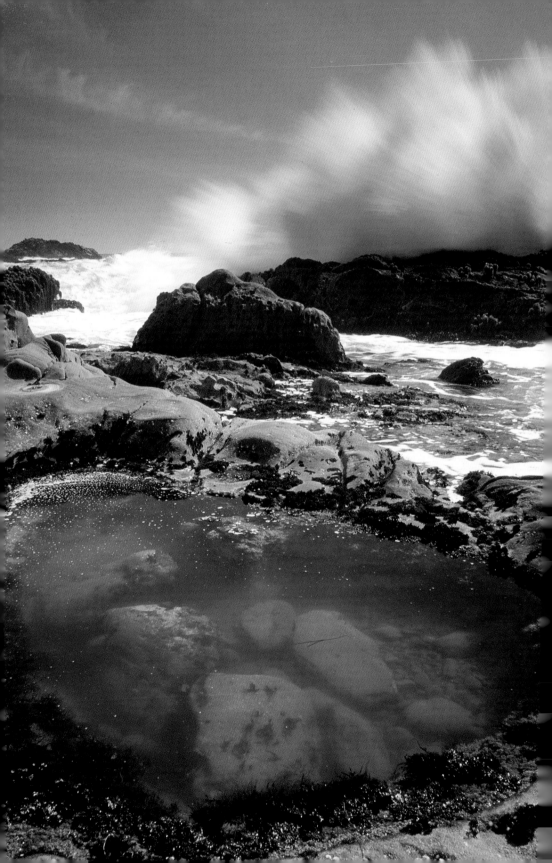

Bean Hollow State Beach treats visitors to some interesting natural features, such as these small pebbles caught in wind-formed holes in the coastal rocks. You can also find eroded rock formations, as well as little snail shells clustered into the rocks.

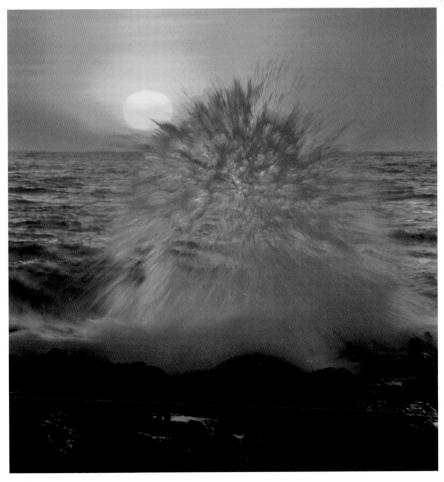

LEFT & ABOVE: Powerful ocean waves crashing on coastal rocks both near and far from this quiet tide pool as the tide returns to shore at Bean Hollow State Beach.

CRUISING AROUND SANTA CRUZ

Summer always brings crowds to the beach, and all of them are seeking some fun in the sun. This water log ride at the Santa Cruz Beach Boardwalk is just one of the many rides and attractions designed to help bring on the fun.

BY EXPLORING STATE ROUTE 1 north and south of the popular vacation destination of Santa Cruz, travelers can enjoy twenty miles of beaches and secluded coves and the wild wonders of several regional and state parks, while still steering clear of tourist throngs.

About nine miles north of the city of Santa Cruz, the roadside hamlet of Davenport consists of the New Davenport Cash Store and restaurant. On the bluff above the ocean is a perfect vantage point from which to watch California gray whales on their annual trips to and from Mexico. Davenport Beach also is a favorite of windsurfers.

South of the city near the village of Aptos, the Forest of Nisene Marks State Park—a cool, green retreat rising in elevations from 100 to 2,600 feet—is a lightly developed wilderness. Clear-cut at the turn of the twentieth century, the dense forest is primarily second-growth redwoods. Marked by a stake on the Loma Prieta Grade Trail in the park is the epicenter of a massive earthquake that destroyed much of downtown Santa Cruz in 1989. The trail follows an old narrow-gauge steam railroad bed, passing some falling-down wooden structures and trestles, vestiges of a lumber camp.

Rimmed with willows and ferns, part of the trail traces the edge of Aptos Creek, a steelhead trout and salmon spawning stream. Rising high on Santa Rosalia Ridge and joined by the waters of Bridge Creek, Aptos Creek spills into Monterey Bay, just above the border of Monterey County.

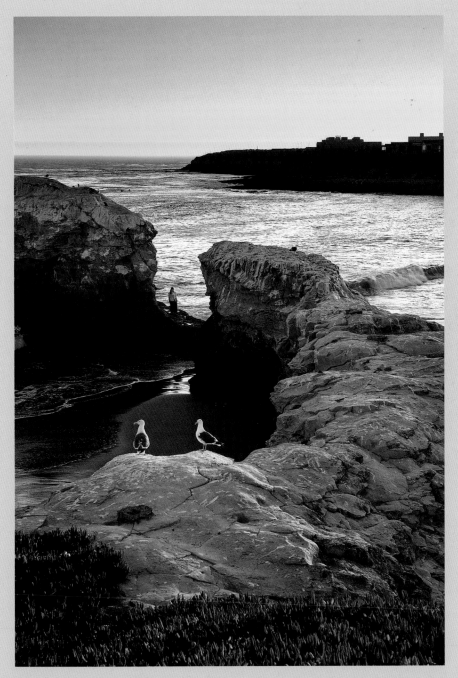

Near the end of town, Natural Bridges State Beach in Santa Cruz is a great spot to get away from the crowds at the boardwalk. The park is also known for being the wintering home of the monarch butterfly.

continued from page 105

views of Butano Canyon and the coast. Pescadero Creek, which flows year-round in the park, is an important steelhead trout–spawning stream (fishing is not allowed).

Where Pescadero Road meets Highway 1, the vast Pescadero Marsh Natural Preserve, the largest marsh between Monterey Bay and San Francisco, is a haven for birds and for bird-watchers. Visitors stand on wooden observation decks with their binoculars, peering into the willows and the tules and catching sight of diving ducks, great egrets stalking in the shallows, and blue herons nesting in the eucalyptus trees. Barely five inches long, long-billed wrens hide in the grasses, calling *chick-chick* out sharply. They fasten domed nests to the stems of reeds; deposit their dark brown, spotted eggs; and sometimes build more fake nests to fool predators. One of the most common of western birds, the red-winged blackbird can also be found here. It is shiny black with bright red and yellow shoulder patches. Clucking low, they flit about in the cattails near the meadows while northern harriers circle above and dive-bomb for small birds and rodents on the edges of the marsh. The best times to spot the nearly two hundred species of birds are in spring and fall.

Across Highway 1 from the marsh, Pescadero State Beach is made up of two miles of tide pools, huge dunes, and trails. Sea lions and seagulls like it here, as do the anglers who catch steelhead trout and salmon where Pescadero Creek meets the sea.

Five miles south, the foggy San Mateo coastline and its offshore rocks and sea stacks caused shipwrecks in the nineteenth century. Built in 1872, the ten-story-tall Pigeon Point Lighthouse was named for the Boston Clipper ship *Carrier Pigeon*, which went down off the point at night in heavy fog. In 1896, the liner *Columbia* ran aground, and the residents of Pescadero scavenged barrels of white paint from the wreckage, using it to paint the entire town, which today continues the tradition of white houses.

Pigeon Point Lighthouse Hostel provides comfortable, affordable accommodations in the restored lighthouse keeper's quarters. Whale-watching and sunset soaks in the hostel's communal hot tub are reasons to linger a night or two.

ROUTE **10**

Foggy Vineyards and Sunny Riverbanks in the Santa Cruz Mountains

SANTA CRUZ TO
BASIN REDWOODS STATE PARK AND FELTON

Directions From Santa Cruz, take California Highway 9 north to California Highway 236 and head west to Big Basin Redwoods State Park. Head back south on Highway 236 and Highway 9 to Felton. Take Felton Empire Road west to Pine Flat Road and to Martin Road and Ice Cream Grade, where you'll loop back to Felton on Felton Empire Road. Return on Highway 9 south to Santa Cruz.

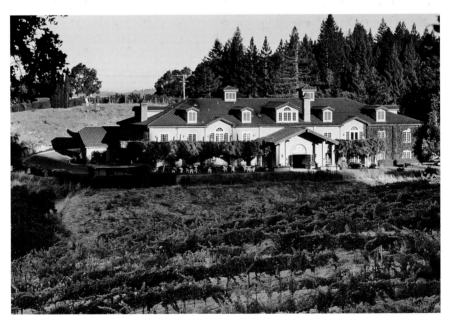

A number of vineyards and wineries can be found not far from San Jose, including Byington Vineyard and Winery in the Santa Cruz Mountains.

In the cool, misty air of the Santa Cruz Mountains, dappled redwood groves and aromatic fir forests line the banks of the twenty-five-mile-long San Lorenzo River. High above the hazy, sometimes too hot Silicon Valley and the beaches of Santa Cruz, the rugged mountain slopes are cooled by marine fogs nearly every night and menaced by strong winter storms. A labyrinth of country roads leads to quiet little old resort towns, covered bridges, a rollicking steam train, and more than seventy small wineries in the first wine-growing region in the nation to be defined by a mountain range.

U.S. Highway 9 through the San Lorenzo Valley links the rustic villages of Boulder Creek, Ben Lomond, and Felton, once loggers' towns, now artists' enclaves and headquarters for weekenders. Among the attractions are hiking and camping in the redwood parks, cabins in the woods, ramshackle antiques shops, and wineries.

Thousand-year-old redwoods stand like Henry Wadsworth Longfellow's "druids of eld" in Big Basin Redwoods State Park— California's first state park—which reaches from the ocean to 2,300 feet elevation in the mountains. Waterfalls and stream canyons and huckleberry bushes and mushrooms are highlights on nearly 100 miles of footpaths and biking and equestrian trails. The Redwood Nature Trail runs along Opal Creek, passing the three tallest redwoods in the park—the Chimney Tree, the Mother of the Forest (329 feet tall), and the Father of the Forest, which makes a huge footprint at more than 16 feet in diameter. Connecting with this trail, the Skyline-to-Sea Trail drops 11 miles from high ridges down to Waddell State Beach. Fifty-foot waterfalls grace the trail along the way. At the beach, a steep path and stairs lead to access for rock fishing. This windy spot is popular with windsurfers and hang gliders.

The one-horse town of Boulder Creek is a colorful hodgepodge of quaint cottages and picket fences, chainsaw sculpture, whimsical redwood burl furniture, and antiques stores. The town rollicked in the 1860s, when loggers frequented the saloons, gambling houses, and brothels. Some of the nineteenth-century architecture remains on

OPPOSITE: The historic Felton Covered Bridge is the tallest wooden covered bridge in the United States. Built in the 1890s, this Santa Cruz County bridge is one of the last covered bridges standing made of redwood.

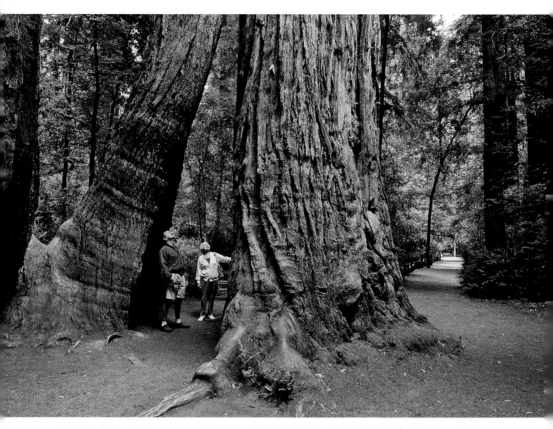

ABOVE: You don't need to walk very far into a redwood grove before you begin to feel very small, just like these tourists looking up at the tall trees in Henry Cowell State Park near Felton.

RIGHT: A look at the prickly bark and twisting branches of a manzanita tree at Bonny Doon Ecological Preserve.

the main street, now housing art galleries and cafés. A seventy-foot-long mural depicts the Southern Pacific Narrow Gauge Railway, which transported logs out of the area in the late 1880s, and a huge redwood flume that floated sawn boards fourteen miles downriver to Felton.

In a leafy park on the riverbank in the village of Felton, the wood plank–spanned Felton Covered Bridge soars 34 feet to the peak of its roof, making it the tallest of its kind in the country. Erected in 1892, the bridge was tall enough to accommodate a fully loaded lumber wagon. The Felton bridge is maintained by funds raised by a yearly pancake breakfast in August, staged right on the bridge itself by the volunteer fire department. Just downstream, the 180-foot-long Paradise Park Covered Bridge, built in 1872, spans the San Lorenzo River.

Just out of Felton on Felton Empire Road, the Hall family planted riesling grape vines in 1941, establishing what would become Hallcrest Vineyards and the Organic Wine Works. It is one of only two vintners in the country making certified organic wines. From the sunny garden deck behind the old cottage, wine lovers enjoy the vineyard views while sipping cabernet sauvignon from old vines.

On up narrow, twisting Felton Empire Road, Henry Cowell Redwoods State Park offers an opportunity to see first-growth redwoods, gnarled oaks, and magnificent sycamores and pines in meadows and canyons on the San Lorenzo River and Eagle Creek. Even without treading the trails, visitors get big views of Monterey Bay and the mountains from the observation deck. A three-quarter-mile loop leads to the tallest tree in the park, about 285 feet tall and 16 feet wide. The oldest trees in the park are between 1,400 and 1,800 years old.

Between Ben Lomond and Felton, Quail Hollow Ranch is a meadow-filled historic site where easy trails lead to the original ranch house, a pond inhabited by bass and bluegill, a shady picnic area, and a dwarf redwood forest. A family homesteaded the property in 1866, raising nine children and growing everything from apples to melons. Later, the ranch became the site of test gardens and a test kitchen for *Sunset* magazine, and after that it was a horse ranch.

Now a county park, the ranch is home to the endangered Ben Lomond spineflower. A member of the buckwheat family, the annual wildflower blooms in small clusters of pale pink, six-petaled flowers with fuzzy leaves, and it is found nowhere else in the world.

ROARING CAMP

TOPS WITH KIDS IN THE SANTA CRUZ MOUNTAINS is a re-created 1880s logging town, complete with a covered bridge and a narrow-gauge steam-powered train that trundles open cars up through a redwood forest to the summit of Bear Mountain. Roaring Camp and Big Trees Narrow-Gauge Railroad is said to be home to the steepest railroad grade in North America, originally built to ferry lumber out of the mountains in the 1870s and 1880s. A second track runs along the San Lorenzo River down to Santa Cruz beaches.

Each year, thousands of children eagerly await Roaring Camp's annual events. In April, ten thousand eggs are hidden at the Amazing Egg Hunt. Civil War battles and camp life are re-enacted at some of the largest encampments in the United States, and the Jumpin' Frog Contest happens in midsummer. In the fall at the Harvest Fair, 1880s crafts are on display, and a scarecrow contest takes place.

A great place for family picnics and children's birthday parties, Roaring Camp at Felton offers visitors a chance to take a ride on a steam train through the redwood forest.

ROUTE 11

Cowboys and Cabernet

CARMEL VALLEY TO THE COAST
ALONG THE CARMEL RIVER

Directions From State Route 1 (Highway 1), take G16 Carmel Valley Road east to Carmel Valley Village. About 4.5 miles farther, take Cachagua Road southeast, winding through the hills back to Carmel Valley Road, where you'll return west. Then take Laureles Grade north to Monterey–Salinas Road/California Highway 68 and return west to Highway 1.

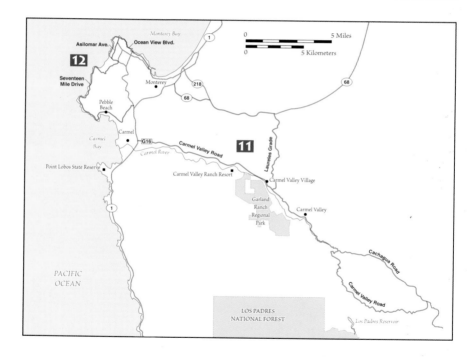

Rushing down steep canyons out of the Santa Lucia Mountains, the Carmel River ambles over the floor of a narrow valley past pastures and palisades, equestrian estates, and farms before spilling into the Pacific Ocean. As Salinas-born, Pulitzer Prize–winning author, John Steinbeck, described it in *Cannery Row*, "The Carmel [River] crackles among round

boulders, wanders lazily under sycamores, spills into pools, drops in against banks where crayfish live. . . . Frogs blink from its banks and the deep ferns grow beside it. The quail call beside it, and the wild doves come whistling in at dusk. It's everything a river should be."

A world away from the bustling tourist towns of Carmel and Monterey and a warm retreat when fog blankets the coastline, Carmel Valley is a favorite for visitors and vineyards because parts of it receive sunshine three hundred days a year.

The area's cattle ranching heritage is very much alive, even with the encroachment of pasturelands by a few vacation resorts and the ever-expanding carpets of vineyards. From the back of a horse on the ridgetops of the Holman Ranch Equestrian Center, the historic country estate looks much as it did when it was founded in 1928, and it is often used as a television and movie filming location because it's reminiscent of the early Western landscape.

Coastal fog is often seen floating in and out over the mouth of the Carmel River at Carmel River State Beach. During the summer, fog banks work their way along the coast, pushing in cool air that often works like natural air conditioning for warmer inland regions.

In mid-valley in Garland Ranch Regional Park, horseback riding and hiking trails thread through five thousand acres of oak savannah and big-leaf maple and pine groves up to a secluded redwood canyon. Snow melt and spring rains flood waterfalls and fill the ponds on the high mesa, making a great habitat for great blue herons. Needless to say, views of the valley and the mountains are mesmerizing.

Hardy souls backpack or four-wheel drive into the Ventana Wilderness above the valley. At the end of a dirt road in a remote box canyon is the Tassajara Zen Mountain Center. Open to the public, this serene retreat has been operated by a monastic Buddhist community since the 1860s, when it was accessed by a horse-drawn stage from

ARCHITECTURAL ICONS IN CARMEL-BY-THE-SEA

A ONE-SQUARE-MILE VILLAGE, Carmel-by-the-Sea is a magic kingdom in an oak and pine forest above a curve of white-sand beach. On narrow, cobbled streets, peaked-roofed stone houses crowd in against miniature castles and whimsical summer cabins built in the 1920s and 1930s. No street numbers, mailboxes, or recreational vehicles mar the storybook look. Trees are registered with the city and may not be cut down. Since 1917, it has been a misdemeanor to "cut down, remove, injure, or mutilate any tree, shrub, or bush" growing in public places in this town, and as a result a number of massive old oaks reign supreme in the middle of streets.

When they can tear themselves away from the hundreds of boutiques, stores, and restaurants clustered downtown, visitors make architectural and cultural discoveries on the winding lanes and alleyways and in the hidden courtyards of this quaint town. After the 1906 San Francisco earthquake, the village received an influx of artists and other creatives escaping the disaster. In 1910, the *San Francisco Call* newspaper reported that 60 percent of Carmel's houses were built by residents who were "devoting their lives to work connected to the aesthetic arts." They built the first

The Tor House, with an iconic stone edifice and four-story tower on a street of vintage homes overlooking Carmel Beach, was built in 1918 by writer Robinson Jeffers.

A vintage postcard of downtown Carmel, where artists and other creatives flocked after the 1906 San Francisco earthquake. *Voyageur Press Archives*

outdoor theater west of the Rockies, still in operation today as the Forest Theater, and the Carmel Arts and Crafts Clubhouse, going strong now as the Golden Bough Playhouse.

Among writers and artists who lived here at that time were Sinclair Lewis and Robinson Jeffers—the poet and literary legend who built Tor House, an iconic stone edifice and four-story tower on a street of vintage homes overlooking Carmel Beach. In 1918, when the area was just a wind-swept, barren knoll—a "tor" in the Celtic language—Jeffers gathered granite boulders from the shoreline and used them to build his house, wherein he wrote his long narratives and epic dramas. The house, tower, and English cottage gardens are open for tours.

Among other architectural icons in Carmel are the Bernard Maybeck–designed city library and a Frank Lloyd Wright–designed home jutting out over the south end of Carmel Bay. In 1905, a country inn, the Hotel Carmelo, was rolled down Ocean Avenue on pine logs, expanded, and transformed into the Pine Inn, where in 1915 actress Lola Crabtree stayed after being toasted by the city of San Francisco.

The most famous of all Carmel buildings is Mission San Carlos Borroméo del Rio Carmelo, dating to 1770, one of the most impressive of the twenty-one California missions founded by Father Junipero Serra. In a setting of shady colonnades, trickling fountains, and mission gardens abloom with roses and bougainvillea, the domed, Spanish Moorish–style cathedral is sienna, burnt umber, and gold inside, with soaring ceilings and star-shaped stained-glass windows. A warren of thick-walled rooms holds a collection of Native American, religious, and early California artifacts. From the mission, a footpath meanders through the Mission Trail Nature Preserve, in an intimate canyon inhabited by hoary oaks and Monterey pine.

Over the years, Carmel has retained a large number of artistic residents, many from Hollywood's television and movie industry, and even elected actor-director Clint Eastwood as mayor for a two-year term in the late 1980s.

Horseback riding, hiking, and biking are all popular activities along the rustic trails that wind through stands of old oak trees at Garland Ranch Regional Park in Carmel Valley.

Salinas. Guests here loll in natural hot springs, wander backwoods paths, meditate, and star gaze.

On the way to Carmel Valley Village, wine lovers are drawn to the soaring, peak-roofed Chateau Julien Wine Estate, where a blaze in the fireplace lights up the stained-glass windows of the tasting room. Art and music festivals often are held in the lush gardens and the courtyard. Among the grouping of wineries around the village, Heller Estate commands attention with a fifteen-foot-high bronze sculpture, entitled *Dancing Partners*, at the entrance to a flamboyant sculpture garden. Organically cultivated and dry-farmed, the roots of the vines that produce grapes for Heller Cabernet Sauvignon reach deep into sandy soil, seeking moisture from the underground springs in the rugged Cachagua Valley in the adjacent mountains.

In the village, you'll find some unique restaurants. One of these is Running Iron Restaurant and Saloon—the oldest continuously operating eating place in these parts. It opened in the 1940s, and each day motorcycles and bicycles and Jaguars and pickup trucks fill its parking lot. Inside, cowboy boots and spurs hang from the ceiling, and steaks and south-of-the-border specialties are on the menu for local ranchers, winemakers, and tourists.

Beyond the village, Carmel Valley Road winds gently on through sprawling cattle ranches and wooded wilderness, connecting to Cachagua Road in the Santa Lucia Mountains. Here arms of gnarled oaks meet over the road, canyons drop, and cliffs ascend. In this precious, nearly untouched vestige of old California, travelers may

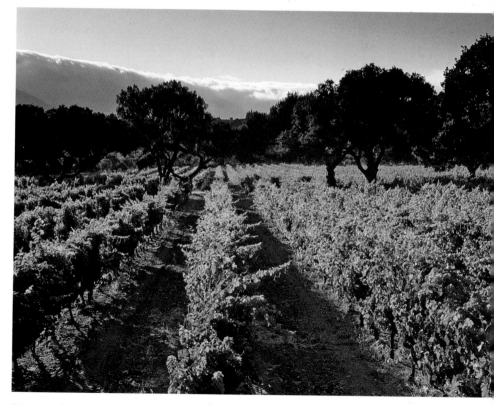

This vineyard along Carmel Valley Road adds to the country ambience of the area. The balance between the cool coastal air and being inland just enough to warm up during the days, without getting too hot, makes for a perfect grape-growing climate.

encounter an eagle flying overhead, a coyote, a couple of cattlemen on horseback, kayakers paddling the river, and, on occasion, wild pigs bolting across the road.

When summertime temperatures far below in the valley hover at one hundred degrees, it is cool at Galante Vineyards and Rose Gardens, where grapes, cattle, and 15,000 rose bushes thrive at 1,800 feet in elevation in a pristine setting less than nine miles overland from the coast. Jack Galante and his wife, Jane, whose father was the founder of the town of Carmel, welcome wine buffs up to their mountain hideaway for an annual Days of Wine Roses festival in the fall. During the festival, fragrant rose petals cover the entrance road to the estate, which hosts live music, winery and garden tours, and a big barbecue. When their dancing feet get hot and tired, partygoers sink them into tubs of cold water and rose petals. The festival's theme echoes the mantra printed on the Galante Vineyards label: Always drink upstream from the herd.

Off Cachagua Road, the Los Padres Reservoir is a prime place for trout fishing. Above the reservoir, the Carmel River's tributaries are habitat for pond turtles and endangered red-legged frogs. From here, at one of the trailheads for the Carmel River Trail, backpackers trod through the mountains all the way to Big Sur.

Heading out of Carmel Valley toward the coast, Jacks Peak County Park is a popular stop for bird-watchers on the lookout for pygmy nuthatches, chestnut-backed chickadees, and black-hooded, dark-eyed juncos among the wild sage and the pines. Not far from the park entrance is a display of fish, crab, and seashell fossils that were found here. The area was under the sea until about twelve million years ago, when an island (what is now the park) began to emerge. The old seashore is exposed in an outcropping called the Aguajito Shale Formation, where several species of leaves, marine crustaceans, fish, and shells are still being unearthed.

OPPOSITE: Monterey, Carmel, and Big Sur are known for their artist communities, and the same holds true for the Carmel Valley, home to this sculpture studio housed in an old wood barn.

PAGES 128–129: Lupine wildflowers bloom in the green hills of the Ventana Wilderness, part of the Los Padres National Forest. People from around the world travel each year to see these majestic slopes plunge directly into the Pacific along the Big Sur coast.

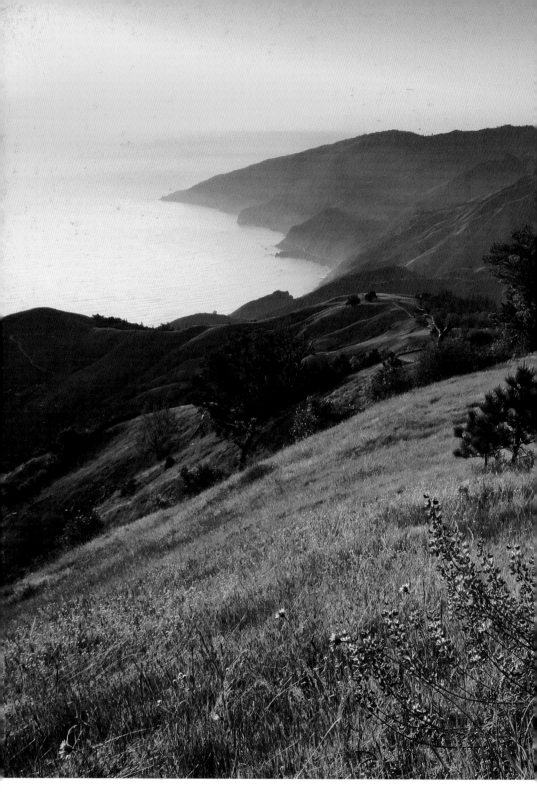

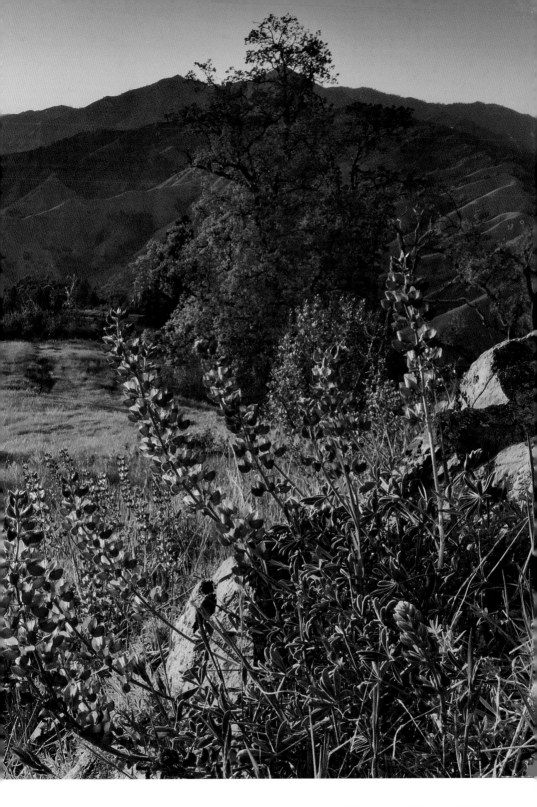

<div align="center">

ROUTE **12**

Along the Monterey Peninsula

MONTEREY TO CARMEL

</div>

Directions From Cannery Row in Monterey, take Ocean View Boulevard northwest, tracing the bayside. Continue on Asilomar Avenue/Sunset Drive through Asilomar State Beach; then take the Seventeen Mile Drive south into Carmel.

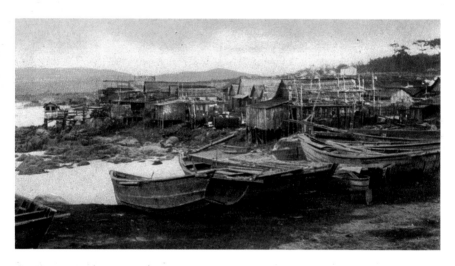

This photo of a Chinese fishing village that has long since disappeared is evidence of Monterey's long seagoing history. *California Historical Society, FN-32811*

The long seagoing life of the Monterey Peninsula is chronicled at the Maritime Museum of Monterey at Fisherman's Wharf in the city of Monterey. Built in 1846, the original wharf was headquarters for whalers and trading vessels bringing goods from around Cape Horn and for the huge harvests of the sardine industry. Across the street from the museum, the Custom House is California's oldest public building, where

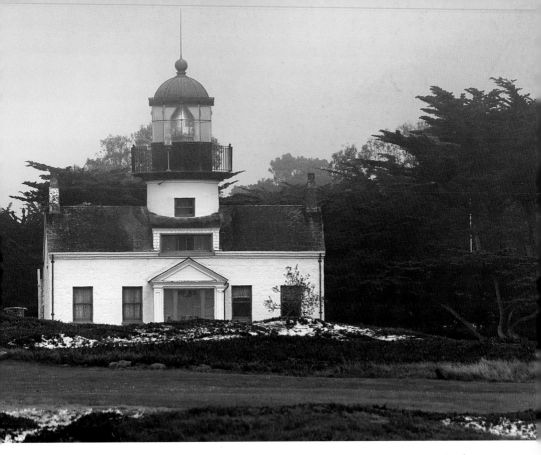

Situated on a golf course, the Point Pinos Lighthouse in Pacific Grove adds an extra bit of coastal ambience for visitors along the Monterey Peninsula.

the twenty-eight-star American flag was raised in 1846, claiming vast western territory for the United States.

In addtion to the museums and the Spanish-style Path of History in the Monterey State Historic Park in downtown Monterey, tourists head for the seafood restaurants and souvenir shops on the wharf and on Cannery Row, home to the top attraction in town—and, in fact, on the entire central coast—the Monterey Bay Aquarium. The aquarium is one of the largest in the world.

Visitors who have taken in the main sights turn away from the madding crowds to enjoy leisurely drives, bike rides, and strolls along the shoreline of the Monterey Peninsula where it juts into Monterey Bay. A segment of the Monterey Peninsula Recreational Trail, a paved pedestrian and biking path, runs between Ocean View Boulevard and the bayfront. Along the way, vista points and pocket beaches are

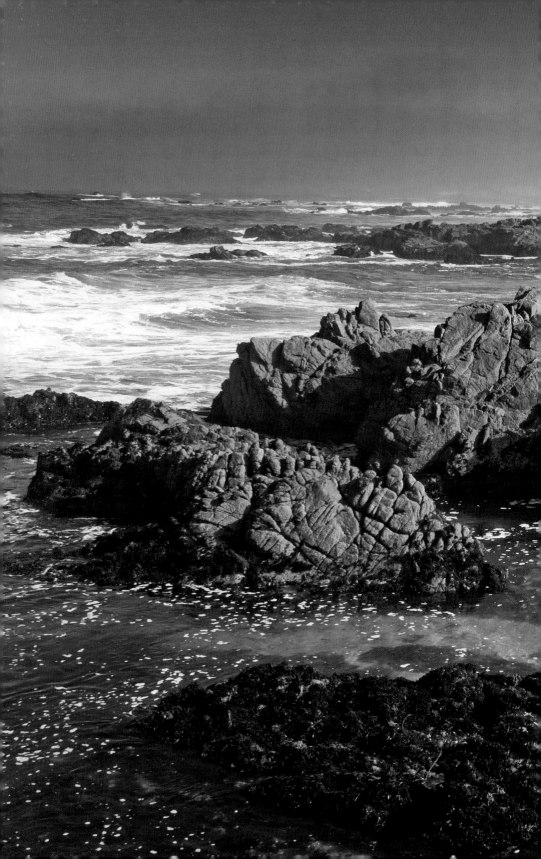

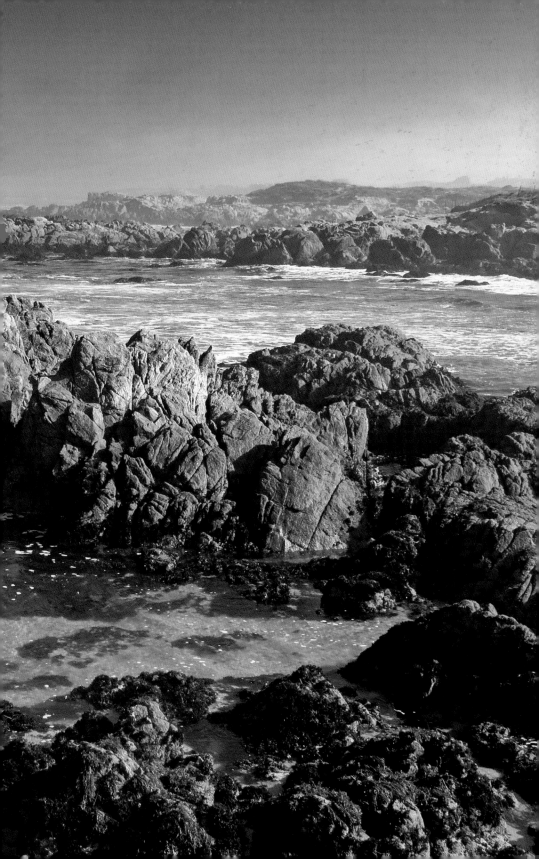

Guests relax outside the main lodge at Asilomar Conference Center in Pacific Grove on the Monterey Peninsula. Asilomar was designed by architect Julia Morgan so that the buildings and environment would blend together naturally, offering visitors a chance to enjoy the rustic atmosphere.

PREVIOUS PAGES: The endless cycle of waves crashing against coastal rocks and of fog turning to blue sky and then back to fog again is evident at many places along the coast, including here at Asilomar State Beach in Pacific Grove.

sunny vantage points from which to watch a lively passing scene of watercraft, from scuba divers' rafts to motor yachts, sailboats, kayaks, and the bobbing heads of sea otters and harbor seals.

Binoculars are great for spying otters floating on their backs in the kelp beds offshore; children are drawn to the friendly looking, inquisitive faces of the hairy little animals. The otters float on their backs with flipperlike hind feet turned up, tap-tapping with small rocks on abalone, sea urchins, mussels, and other shellfish. The distinct knocking sound carries across the surface of the water, confirming that otters are one of few wild species to use tools. Hundreds of thousands

of southern sea otters once lived along the California coast. Their numbers decimated by hunters in the nineteenth century, they are now a threatened species, with about sixteen hundred in existence off the Big Sur and Monterey coasts.

Among a string of parks and greenbelts collectively known as Shoreline Park, Lovers Point is a pleasant grassy blufftop with a playground and access to sandy beaches.

Along the boulevard and the adjoining streets, in the community of Pacific Grove, are beach cottages and Victorian mansions, relics of a Christian summer camp from the 1870s. Annually in April, the Good Old Days celebration recalls the past with pie-eating contests, Victorian fashion shows, and a town parade.

In Pacific Grove, at Ridge Road off Lighthouse Avenue, the Monarch Grove Sanctuary shelters masses of monarch butterflies in the pine and eucalyptus trees. The bright orange-and-black creatures arrive in the thousands and overwinter in the trees and around the town between November and March. The town calls itself "Butterfly Town USA" and holds an annual children's parade to welcome the monarchs.

At the end of the peninsula at the entrance to the bay, the circa-1855, red-roofed Point Pinos Lighthouse is the oldest continuously operating lighthouse on the West Coast. The original light sources were whale oil and lard-fueled lanterns, followed by a kerosene light in 1880. At the turn of the century, an incandescent vapor lamp was used, then electric lights by 1915. Today a one-thousand-watt bulb amplified by lenses and prisms produces a beam visible from about fifteen miles out at sea. In the winter months, gray and blue whales are often seen from Point Pinos, and the lucky observer may also see leaping pods of orcas, dolphins, and porpoises at any month of the year.

Ocean View Boulevard eventually becomes Sunset Drive, which meanders through Asilomar State Beach. Wide, white, and sandy, the beach is traversed by a boardwalk and a trail through the wildflower dunes to coves and rich tide pools. Few tourists know that lodgings at the adjacent Asilomar Conference Center are available to the public. A dozen or so of the buildings at the secluded, rustic conference resort were designed by Julia Morgan, the architect of Hearst Castle.

Tracing the ragged outer edge of the peninsula, the Seventeen Mile Drive is one of the most picturesque avenues in the world. It was a tourist

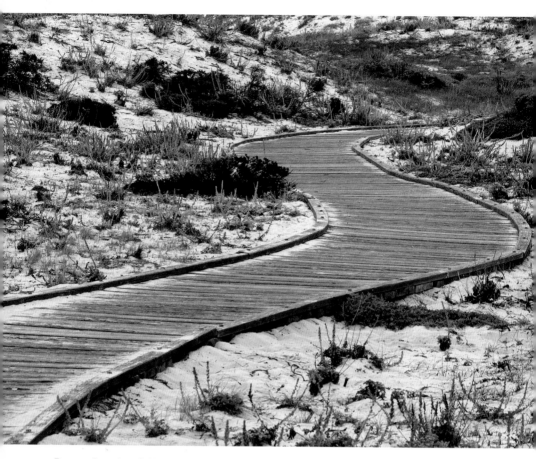

Protecting the delicate plants on the sand dunes of Asilomar State Beach is this winding boardwalk.

attraction even in 1881, when horse-drawn carriages rolled through the ghostly cypresses of Del Monte Forest and wolves and elk still hid in the woods. Red lichen–painted rocks frame vista points where visitors stop, take photos, and explore the beaches and tide pools. As if in a Japanese brush painting, the dark arms of pines and cypresses lean away from steady, offshore winds. Only four native stands of Monterey pines exist in the world, all on the Monterey coast.

Driving along the Seventeen Mile Drive, lovers of golf enjoy glimpses of some of the most famous and most difficult courses in the world— Pebble Beach Golf Links, the Links at Spanish Bay, and Cypress Point. The south end of the drive emerges in the city of Carmel-by-the-Sea.

STEINBECK'S WORLD

BORN AND RAISED IN THE SMALL VALLEY TOWN OF SALINAS, a few miles east of the Monterey Peninsula coastline, John Steinbeck wrote about the struggles and romances of early farm families and Dust Bowl migrant laborers. His novels—*Cannery Row*, *Tortilla Flats*, *East of Eden*, *The Grapes of Wrath*, and others—are American classics read by nearly every schoolchild. In the 1920s and 1930s, his socialistic leanings and sympathies toward unions and workers' rights were controversial enough to catch the eye of FBI Director J. Edgar Hoover, who had him investigated as a subversive; his writings were publicly burned in Salinas on at least two occasions.

Despite the controversy, Steinbeck became a world-famous writer who was awarded the Nobel Prize for Literature in 1962, the Pulitzer Prize for *The Grapes of Wrath*, and the United States Medal of Freedom, among other honors.

Pulitzer Prize–winning author John Steinbeck, from Salinas, California, was known for his documentation of the hardships of Depression-era life. *Library of Congress*

The great movie director John Ford won an Oscar as best director for the film based on *The Grapes of Wrath*, which starred Henry Fonda and John Carradine as migrant sharecroppers during the Depression.

In spite of the rocky beginnings, Salinas loves its favorite son. To honor its most famous of citizens, the city erected an expansive, interactive, glass-walled monolith of a museum where you can experience some of the sights, sounds, and smells of Steinbeck's stories and the time and place in which he lived. Pull out a drawer to see his childhood treasures. Feel the chill of a re-created ice-packed boxcar filled with lettuce and get a glimpse of migrant life in the Salinas Valley. Videos and movies that play as part of the exhibit feature historic vignettes and a look at Steinbeck's charming camper truck, in which he motored with his dog and wrote *Travels with Charley*. A few blocks away, Steinbeck's boyhood home, now a museum, is an elaborately decorated Victorian loaded with memorabilia.

ROUTE **13**

A Wild Coast

CARMEL TO SAN SIMEON

Directions From Carmel on State Route 1 (Highway 1), drive south 90 miles to San Simeon.

"The place itself is so overwhelmingly bigger, greater than anyone could hope to make it, that it engenders a humility and reverence not frequently met with in Americans. There being nothing to improve on in the surroundings, the tendency is to set about improving oneself." That's how author and painter Henry Miller described his beloved Big Sur, where he lived for eighteen years, in his book *Big Sur and the Oranges of Heironymous Bosch.*

Big Sur is a misty, magical mountain kingdom off State Route 1 (Highway 1), fringed with precipitous cliffs above craggy beaches sparkling with waterfalls. Until 1937, when the two-lane road was carved and blasted into granite mountainsides, this section of the coastline was inaccessible and virtually unknown. Spanish explorers called it *El Pais Grande del Sur*—the big country to the south—and they didn't brave the harsh topography dominated by the Santa Lucia Mountains that lunge in thousand-foot cliffs into the sea. Most of today's travelers venture just a few miles down the road, exploring forest trails in the state parks and searching for the spectacular scenes they have seen in photographs. Adventurers with plenty of time on their hands set off, cameras in hand, for the drive of a lifetime, all the way to San Simeon.

Spring through fall, Big Sur enjoys higher temperatures than Carmel and Monterey, receiving more rain, yet also more sunny days. Winters can be treacherous, when rock and mudslides and torrents of water may block the route. This drive is not to be taken after dark on a moonless night or when thick fog obscures the road and the spectacular sights. Anytime, day or night, deer and other wildlife frequently wander onto the road.

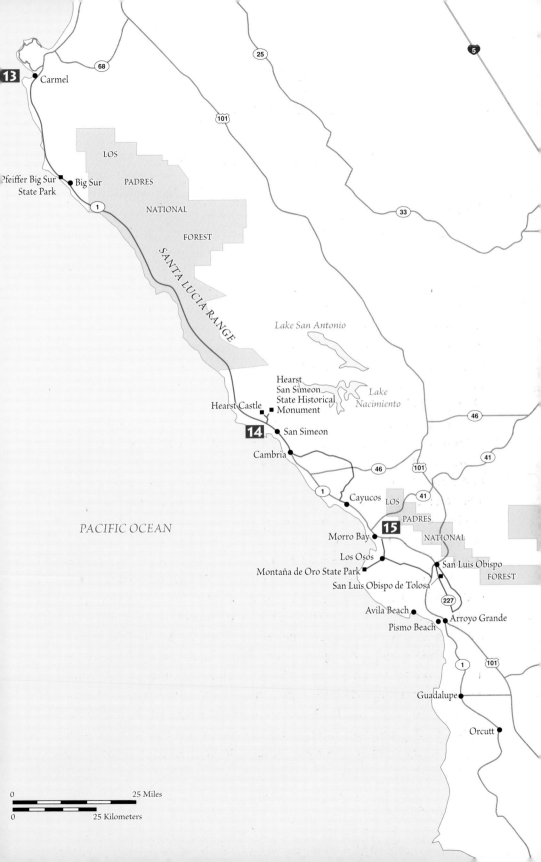

13 Carmel

68

25

101

LOS

PADRES

Big Sur

Pfeiffer Big Sur
State Park

1

NATIONAL

FOREST

33

SANTA LUCIA RANGE

Lake San Antonio

Hearst
San Simeon
State Historical
Monument

*Lake
Nacimiento*

Hearst Castle

46

14 San Simeon

Cambria

46

101

41

PACIFIC OCEAN

1

Cayucos

LOS

41

PADRES

15

NATIONAL

Morro Bay

Los Osos

San Luis Obispo

FOREST

Montaña de Oro State Park

San Luis Obispo de Tolosa

227

Avila Beach

Arroyo Grande

Pismo Beach

1

101

Guadalupe

Orcutt

5

0 25 Miles

0 25 Kilometers

Crossed by nearly thirty bridges over deep canyons and the Big and Little Sur River valleys, the road is sprinkled liberally with vista points. By pulling off at one, visitors can take a break from white-knuckled driving and drink in a panorama of ferocious ocean surf smashing into natural arches and sea stacks, stony guardians of ancient shores. Making for stunning photos, the Bixby Creek Bridge, also known as the Rainbow Bridge, is a 260-foot-high single-spanner. At low tide, the skeletons of shipwrecks are sometimes visible far below the bridge.

The first tourist attraction south of Carmel is Point Sur Lightstation, an 1889 stone lighthouse. A two- to three-hour guided tour includes a half-mile walk with a three-hundred-foot gradual climb to the lighthouse, which is located on a dramatic promontory. Wildflowers and the sight of migrating whales are among the rewards.

THE LIONS

FOUR MILES SOUTH OF CARMEL on U.S. Highway 1, the forested peninsula of Point Lobos is named for the sea lions that lie about on rocks offshore. A state reserve so fragile that visitation is limited, Point Lobos is nearly surrounded by a protected marine environment and consists of several miles of trails, pebbled beaches, and one of only two naturally occurring stands of Monterey cypress (the other is at Pebble Beach). Author Robert Louis Stevenson called the point the "most beautiful meeting of land and sea on earth."

From six miles of oceanfront, visitors see harbor seals, otters, scuba divers, pelicans, gulls, cormorants, and often whales. In the meadows, mule deer tiptoe through purple needlegrass and wild lilac. In China Cove, the water can be as green as emeralds, a stunning setting for blue-gray granite outcroppings draped with red lichen. Monterey cypress stand like moss-bearded druids in the fog on steep cliffs above the boiling surf. Kids particularly like Sea Lion Point, accessed by an easy half-hour walk to Headland Cove, where sea lions bark and otters float on their backs, tap-tap-tapping on abalone shells.

Point Lobos is completely protected—the land, the marine life on the beach, the tide pools, and the underwater. Not a thing may be removed or disturbed; dogs are not allowed, and visitors are required to stay on hiking trails or beaches to ensure that this treasure will be around for future generations to discover and enjoy just as visitors do today.

Beachgoers everywhere walk while looking down, searching the sand for small bits of manmade or natural treasures that may have washed ashore—like this section of kelp on the sand at Pfeiffer Beach.

The Big Sur River flows down from the Santa Lucia Mountains through the Los Padres National Forest into Andrew Molera State Park, falling into the Pacific at a long, sandy strand. One of many hiking trails in the park runs along the river through a eucalyptus grove where monarch butterflies overwinter at the river's mouth. Horseback riders wander through redwoods and Santa Lucia fir trees found only here.

Where Highway 1 turns away from the coast for a few miles, you'll find the town of Big Sur Valley. It's an unruly scattering of riverside cabin resorts and motels, a few art galleries, and campgrounds, anchored by

An SUV navigates the old dirt road leading through the headlands of the Big Sur coast.

Pfeiffer Big Sur State Park. The park is popular for swimming in the Big Sur River and camping in the redwoods. A short hike along the banks of Pfeiffer-Redwood Creek, crisscrossed by wooden bridges several times, leads through ancient redwoods to Pfeiffer Falls, a sixty-foot-tall torrent at its best after a rain. A little farther on, the Valley View Trail arrives at benches overlooking Point Sur and the lush Big Sur Valley, which in the fall turns into a bowl of golden and fiery red maples, alders, sycamores, and oaks.

Near the park, off the highway at the western end of two-mile-long, narrow and winding Sycamore Canyon Road, is a white-sand beach decorated with sea stacks and rock arches.

On the highway just south of this beach, the restaurant, Nepenthe, has been a beloved daytrip destination since 1949. The restaurant's tables are set on a rambling stone terrace perched on a high bluff overlooking a long and dizzying curve of the coastline, just the spot for enjoying an Ambrosia burger and a glass of Central Coast wine in the sunshine or lounging by the fire pit as the sun sinks slowly into the western horizon.

One of the main attractions in Julia Pfeiffer Burns State Park is the paved, half-mile trail along McWay Creek that leads to a waterfall plunging over a fifty-foot cliff. This is the only fall in California emptying directly into the ocean. Wild iris and columbine bloom in redwood

OPPOSITE: Fog shrouds the hills and cliffs along Pfeiffer Beach, part of which has purple-colored sand.

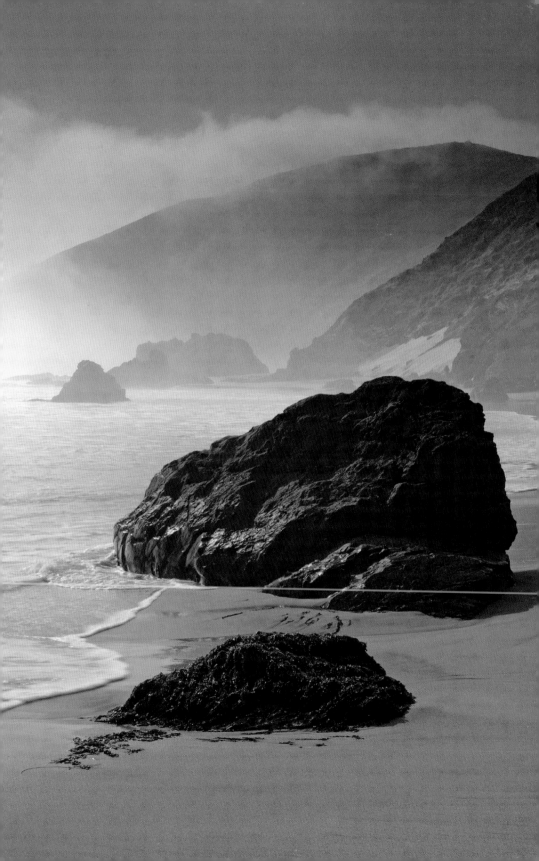

glens and fern grottoes on Pine Ridge Trail, where river cascades, hot springs, and quiet swimming holes are to be discovered.

On the west side of the park, Partington Creek Trail enters a canyon and a two-hundred-foot-long rock tunnel—said to have been carved by pirates to hide their cache. The trail emerges at Partington Cove, where sea otters and scuba divers play in the kelp beds. Believed to be extinct by the 1930s, wiped out by fur traders, sea otters were rediscovered in a single Big Sur cove. From only a few survivors, the endangered otter population has increased to more than two thousand today. Another endangered creature, the California condor, was reintroduced in Big Sur and can occasionally be seen soaring over the redwoods.

About halfway between Carmel to San Simeon, Jade Cove is actually a string of coves, where nephrite jade is exposed on the beaches at

The Big Sur coast hosts a number of diverse habitats, from pine forest to chaparral and riparian woodlands. The climate close to the ocean—thick with cool, moisture-laden fog—allows Indian paintbrush and other wildflowers to bloom on the coast's hillsides for an extended period of time each year.

low tide and following storms. Wave action and the movements of the submerged Pacific tectonic plate break off boulders and smaller stones from an underwater vein. The jade stones tumble in a frothy seawater and pebble bath, emerging as found treasure for beachcombers, who are allowed to take what they can hand-carry.

A few miles north of Hearst Castle, Ragged Point—a peninsula promontory atop four-hundred-foot cliffs—is the last stop for views of the Big Sur coastline. A steep switchback trail traces the face of the cliff past an impressive waterfall on the way to a small beach.

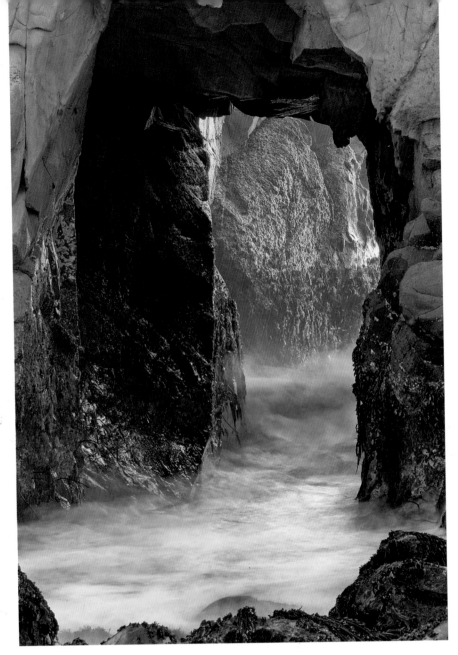

A narrow keyhole through the coastal rocks allows for crashing waves and golden sunlight to pass through this stone fortress at Pfeiffer Beach in Big Sur, California.

OPPOSITE: A short hike through redwood-covered hills in Pfeiffer Big Sur State Park allows families to enjoy discovering nature together. Here, a young brother and sister take time to watch the cascading water of Pfeiffer Falls.

Elephants and Moonstones

SAN SIMEON TO CAYUCOS

||

Directions From State Route 1 (Highway 1) at Hearst San Simeon State Historical Monument, drive south on Highway 1 to Cambria. Then follow Santa Rosa Creek Road as it loops south toward Cayucos.

||

South of the blockbuster historic attraction, Hearst Castle, the handful of seaside villages and beaches in north San Luis Obispo County would be largely unknown if it were not for tourists stopping off on their way to and from the castle.

Of special interest to animal lovers, Point Piedras Blancas is the southernmost resting and mating site in California for northern elephant seals. Wintertime is when they are most evident, when they gather to give birth and mate. Unlike those at Año Nuevo State Reserve in San Mateo County, the animals here can be seen from the highway and the parking lot, and they can be approached, with caution, on the beach. Offshore on the rocks, sea lions and harbor seals lounge in the sun.

Directly across the road from the castle, William R. Hearst Memorial State Beach invites a walk on the fishing pier and a swim in the calm waters of the cove, which is protected from wind and surf by San Simeon Point. For the energetic and adventurous traveler, kayaks and boogie boards can be rented right here. Nearby is what's left of the village of San Simeon, consisting of the circa-1870 Sebastian's General Store, an old schoolhouse, and a marine education center.

Rather more developed, San Simeon State Park has a wildflower-rimmed boardwalk and paths that cross and border San Simeon Creek and Santa Rosa Creek Preserve, fragile sanctuaries of wetlands and

OPPOSITE: Cambria is a charming village known for its wooden walking path along the coastal bluffs. At the far end of the coastal drive is Leffingwell Landing, where wooden stairs lead down to the ocean.

MR. HEARST'S PLACE

An aerial view of William R. Heart's castle at San Simeon. Built between 1919 and 1947, the massive mansion has 165 elaborately decorated rooms. *Library of Congress*

FAMILIARLY KNOWN AS HEARST CASTLE, Hearst San Simeon State Historical Monument has been a popular attraction on California's central coast since it opened to the public in 1958. In the Santa Lucia Mountains overlooking the Pacific Ocean, the massive Mediterranean Revival palace was designed by famed architect Julia Morgan and built between 1919 and 1947 for the pleasure-filled life of William Randolph Hearst, a stupendously wealthy San Francisco newspaper publisher. With expansive gardens and grounds, the home's monumental architecture, art, and furnishings make up, even today, one of the most spectacular estates in the world.

During the Roaring Twenties, Charles Lindbergh, Winston Churchill, and film stars often came for parties and weekend getaways. At the Neptune Pool, surrounded by white caryatids from a Greek temple, Greta Garbo, Clark Gable, and Mary Astor looked out over the Pacific Ocean from the mountain aerie, sipping cosmopolitans between World War I and World War II.

Priceless European art and antiques—from gilded Spanish ceilings to Greek, Roman, and Egyptian sculpture; Flemish tapestries; Renaissance paintings; and hundreds more museum-quality artifacts and furnishings

brought from around the world—fill 165 elaborately decorated rooms. In the cavernous main sitting room are white marble, neo-classic statues including *Venus Emerging from the Bath*, as well as gilded tables and chairs from the French Empire period, fifteenth- and sixteenth-century Flemish tapestries, and a Reubens tapestry. Catherine de Medici's wedding dowry tapestries hang in the medieval-style dining room, where the fireplace is thirty feet tall.

The Roman Pool is said to be the most beautiful indoor swimming pool ever constructed. The glowing creation of cerulean-colored Venetian glass and hammered gold tiles sparkles with its crystal-clear water lit by alabaster lights topped by marble columns.

Sprawling gardens, terraces and pools, and fruit trees and palms create a lush backdrop for marble figures, dazzling white against brilliant magenta bougainvillea cascading over the jewel-like guest houses.

A writer for *Fortune* magazine in 1931 wrote the following about this architectural masterpiece: "Standing there, you can look back, out over the hills to the Pacific; then look around you to find Moorish palaces amid enchanted gardens . . . set off by the great twin towers of the Spanish mission cathedral, which is La Casa Grande. You are now in the heart of the Hearst estate."

Shown here is the impressive Roman-style Neptune Pool at Hearst Castle in San Simeon State Historic Park.

riparian forests. In the boggy, reedy shallows, turtles, egrets, herons, endangered red-legged frogs, and colorful waterfowl like cinnamon teal are often in residence.

On the western edge of the small town of Cambria, a mile-long boardwalk traces the bluffs above Moonstone Beach, named for the white agates that accumulate here. Stairways and steep paths lead to the sands where rock hounds are welcome to carry off fifteen pounds of booty a day; sometimes they find jasper and jade among the stones that have been smoothed by the sea.

The north end of the beach at Leffingwell Landing is the best spot to park and watch seals and otters gamboling around the rocks and in the pools of the California Sea Otter Game Refuge. The otters are charming, basking in rather shallow waters, wrapping themselves in kelp, and floating together in groups called rafts. The largest raft ever recorded contained more than two thousand otters. Gray whales also can be seen offshore, migrating south from December to early February and back north again in March and April.

The pretty little town of Cambria was once a community of miners, loggers, farmers, and whalers. Today, a few thousand artists and craftspeople guard their isolation as best they can, preserving a collection of garden cottages and Victorian-era wooden buildings on Main Street where art galleries and small boutiques fuel the economy. The town lies on both sides of the main highway, between wooded hillsides and the Pacific Ocean.

The oldest home in Cambria is a simple saltbox built in 1870, the Guthrie-Bianchini House. It stands at Burton Drive and Center Street and is also notable for the magnificent Port Orford cedar, which was planted in 1900. On Main Street, architectural highlights are the Olallieberry Inn—built circa 1870 by pharmacists from Germany— and the Old Santa Rosa Chapel, where the cemetery is worth a walk-through to see headstones of nineteenth-century Italian-Swiss immigrant farmers. Camozzi's Saloon is loaded inside with historical memorabilia, while the Bucket of Blood Saloon on Center Street got

Linn's Original Fruit Bin Farmstore is known for its fresh olallieberry jellies and pies. Locals travel down the backroads to the store or stop by its restaurant in Cambria to get a slice of pie while it's warm out of the oven.

its name from the fights that broke out over competition for ladies of the evening.

Although most of the town's artists have sophisticated sensibilities, a local folk artist, who passed away in his nineties, spent nearly fifty years, beginning in 1928, hand-sculpting terraces on several acres of hillside and decorating his three-story, balconied abode with hundreds of scavenged items, such as seashells, beer cans, driftwood, scrap lumber, and car parts. Nitt Witt Ridge, as it's now called, is a folk-art masterpiece that visitors can tour.

Running directly east out of downtown Cambria, the winding Santa Rosa Creek Road heads past century-old cattle ranches, orchards, and vineyards. Many visitors get only as far as five miles up the road, stopping at Linn's Farmstore for the famous olallieberry pie and fresh berries. Some people drive on into the hills for another dozen miles or so, looping back southwest to the Whale Rock Reservoir and back to the coast at the hamlet of Cayucos.

Looking rather like a Western movie set, Cayucos is distinguished by not much except a few antiques shops and a colorful cacophony of building-size murals—on the hardware and grocery stores, the surf shop, and the elementary school, and inside the Old Cayucos Tavern, among other locations.

Passing through rural landscapes with rolled hay bales and tractors in fields, you could easily think you were driving across America's heartland, not California.

The Seven Sisters

MORRO BAY AND THE EDNA VALLEY

Directions
From State Route 1 (Highway 1), take Main Street south into the town of Morro Bay. Go west on Morro Bay Boulevard to Embarcadero Road, which skirts the bay. Drive north to Morro Rock, returning south on Embarcadero Road to Tidelands Park. Return to Morro Bay's Main Street and proceed south to Morro Bay State Park Road. From there, continue south to South Bay Boulevard, where you'll head south again. At Los Osos Valley Road, head west to Montaña de Oro State Park. Then take Los Osos Valley Road southeast to California Highway 227, where you'll head south on the highway into the Edna Valley and loop back north on Orcutt Road to U.S. Highway 101 near San Luis Obispo.

The California version of the Rock of Gibraltar, a craggy, 576-foot-tall peak called Morro Rock looms as a dark sentinel at the mouth of Morro Bay. The seventh in a chain of fifty-million-year-old volcanic plug domes, or morros, called the Seven Sisters, Morro Rock is a sailor's landmark and a nesting site for peregrine falcons. One of a handful of natural coastal estuaries still existing in this country, the bay and surrounding marsh shelter thousands of birds. These include more than two dozen endangered and threatened species, notably the sand-colored western snowy plover and the least tern. One of the largest overwintering bird sites in North America, the estuary is also an important great blue heron rookery and a nursery for newborn sea creatures, such as rays, sharks, and fish.

A magical day begins in early morning, when mist hovers over the still, mirrorlike bay. Snowy egrets and black-crowned night herons stand motionless in the eel grass and pickleweed marsh, in a primordial scene. Common loons, grebes, and teal float between the dense grasses, searching for insects. Belted kingfishers—vibrant blue and white with rakish topknots—perch on the reeds, then hover and dive into the shallow waters for small fish. The heads of curious harbor seals, sea

Tranquil is an understatement for describing this serene view of a full moon setting at dawn over a small sailboat anchored in Morro Bay.

PAGES 160–161: The first warm rays of sunlight on Morro Rock turn the monolith into something resembling a huge golden pyramid. On the water-front, a pigeon sits alone on a wooden railing, staring out over the calm blue waters of Morro Bay.

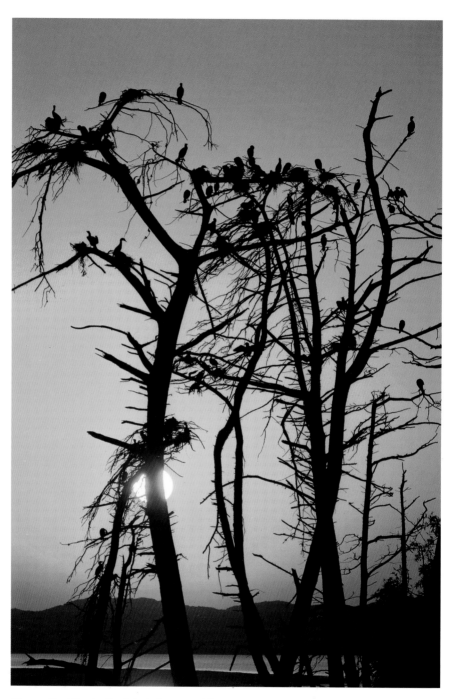

Morro Bay State Park is home to this protected bird rookery, where herons and cormorants return at sunset to their nests perched high in these trees.

lions, and sea otters bob up near fishing boats as they glide out through the narrow bay entrance into the open ocean.

Sightseers and bird-watchers park their vehicles at the foot of Morro Rock, while on the north side of the rock, surfers ride the waves off Morro Strand State Beach. At the south end of Embarcadero Road, the street that skirts the bay, Tidelands Park is another pleasant spot from which to contemplate the bay, have a picnic, or launch a kayak. Canoes and kayaks are the transport of choice here for bird-watchers who find this one of the richest habitats in the

Similar to signs in the Northern California sister valleys of Napa and Sonoma, wine lovers in the Edna Valley are guided by these helpful arrows that point the way to various wineries along the San Luis Obispo Coastal Wine Trail.

state, considering that more than 90 percent of California's coastal wetlands have disappeared due to development.

Headquartered at the Morro Bay State Park Museum of Natural History, the annual Winter Bird Festival attracts about five hundred enthusiasts in January, when a typical false spring bathes Morro Bay and the Central Coast in winter warmth and bird migrations are at their peak.

On the west side of the bay in Montaña de Oro State Park, on narrow beaches protected from the open sea by a four-mile-long sand spit, you'll find Morro Dunes Natural Preserve. The preserve consists of scrub-covered dunes up to one hundred feet high. Vista points afford lovely coastline views, while footpaths lead to the dunes and the beaches. About fifty miles of hiking, biking, and equestrian trails ramble through the hills and riparian stream canyons above.

Off Los Osos Valley Road, the Los Osos Oaks State Reserve is a ninety-acre grove of eight-hundred-year-old, dwarfed, mossy, gnarled coast live oaks on ancient dunes. Drivers on this road can see the other six morros, all in a row, parading east into the winelands of the Edna Valley.

Just four miles from the ocean, homesteading pioneers planted the first grape vines in the Edna Valley, along with apple orchards and grain crops, in the late 1870s. Some of those Zinfandel vineyards continue to produce today, thriving in the sea breezes that funnel through the four-mile-wide valley and lower the summer temperatures, allowing a long season for the grapes to develop the intense, complex flavors of the famous Edna Valley chardonnays, pinot noirs, syrahs, and white rhone varietals.

California Highway 227 rolls through the valley below the low foothills of the Santa Lucia Mountains past vineyards, old farms and orchards, and signs advertising "Hay for Sale." A dozen or so premium wineries are scattered throughout the valley, alongside horse and cattle ranches. The best view of the Edna Valley and the Seven Sisters morros is from the terrace of Edna Valley Vineyard, one of the oldest wineries in the state. It's famous for its chardonnay, some of which comes from decades-old vines.

Just up the road at Old Price Canyon Road and Highway 227, the Old Edna store is a welcome stop for refreshments and antiques browsing. This is the site where in the early 1880s stagecoaches stopped regularly, and dairy and cattle farmers in the valley patronized the livery stables, the large creamery, and the slaughterhouse. At the time, the township of Edna was also home to a hotel, a railroad depot, and three saloons—one for the cattlemen, one for the Pacific Coast Railroad workers, and one for asphalt miners. In 1906, Edna had a population of nearly two thousand when a local dairyman built a mercantile and dance hall large enough for one hundred couples. By the 1930s, valley residents were automobile owners and drove into San Luis Obispo for their needs, so the town of Edna waned. Eventually, all of the buildings except a barn, the railroad depot, and Edna Hall—and today's store—either burned down or crumbled.

On a short detour on Corbett Canyon Road, a vintage tractor on the roadside marks the tasting room at Kynsi Winery, housed in a restored 1940s dairy. On the Talley Vineyards estate stands a two-story, restored adobe home built in 1863 on the Mexican land grant, Santa Manuela

PAGES 166–167: Rows of young wine grape vines stretch out along the green hills of San Luis Obispo County's Edna Valley in spring, giving promise to the coming harvest.

A horseback rider sits atop her horse after riding through the sand dunes and beaches between the ocean and Morro Bay at Montaña de Oro State Park.

Rancho. Wine lovers stop in to taste Talley chardonnay, which has been described as redolent of peaches, apricots, citrus, and hazelnut oil. Biddle Regional Park invites a stroll or a picnic beneath huge old sycamores and oaks.

Toward the north end of Orcutt Road, in a circa-1909, bright yellow former schoolhouse, Baileyana Winery offers tastes of a ruby-colored, berry-flavored pinot noir. Valley views are stunning from here, and visitors are welcome to linger for a game of croquet or bocce ball.

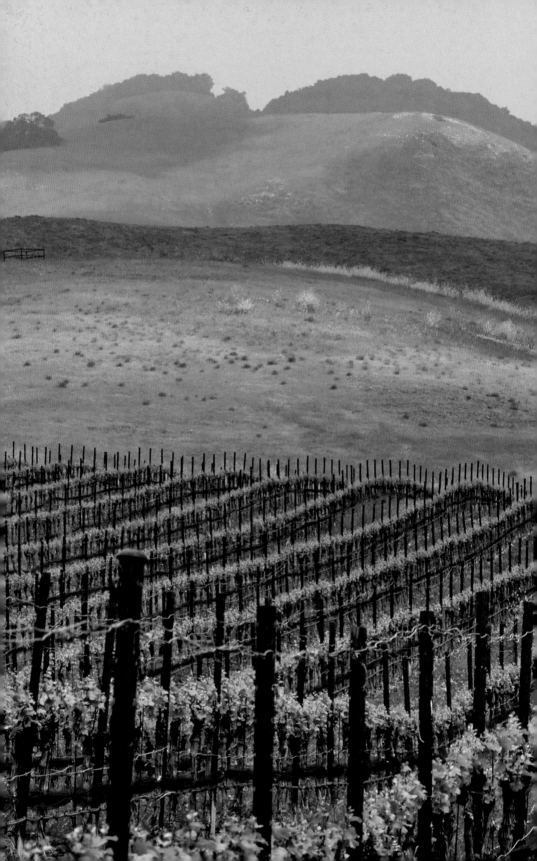

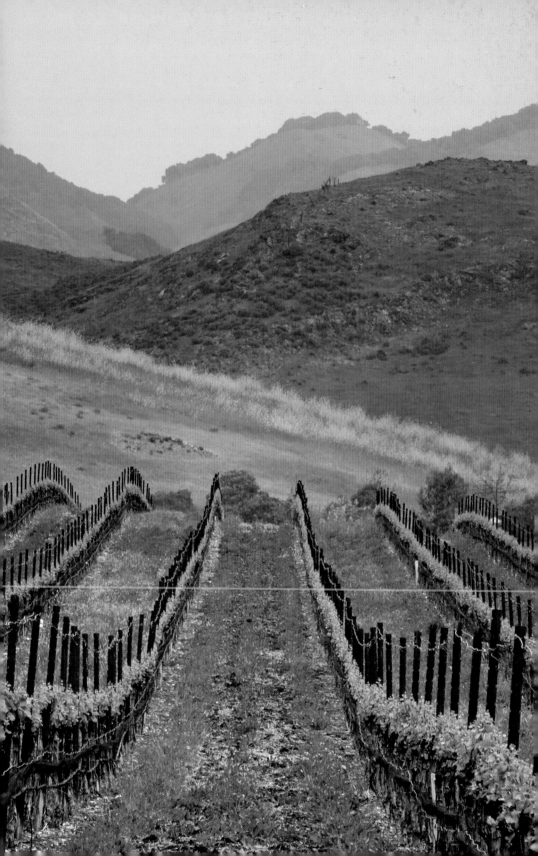

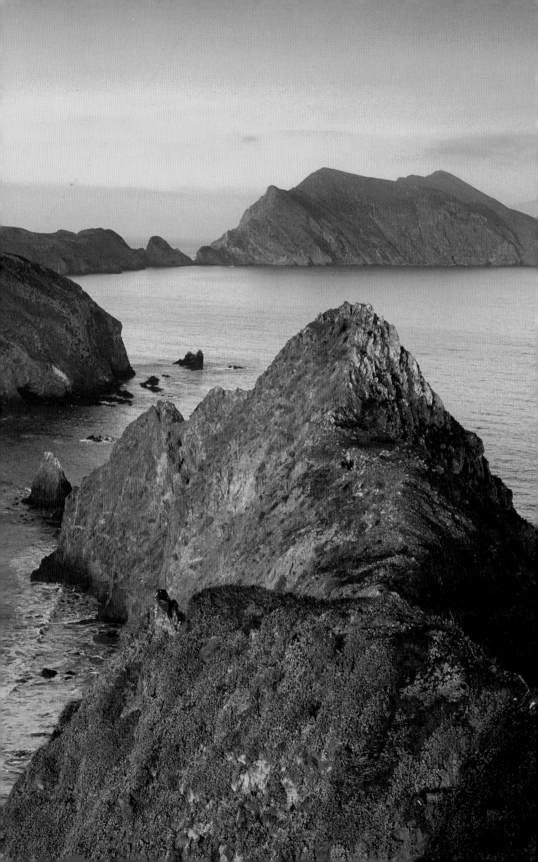

PART III

The South Coast

Discovering Peaceful Beach Retreats

The Spanish word for peaceful is *pacifico*. In Southern California, warm, sunny, *pacifico* days seem to melt one into another, compelling city dwellers, tourists, movie stars, and moguls to slap on sunscreen, slide into their flip-flops, and turn away from the megalopolis of the Los Angeles basin and the San Diego freeways to bask on beaches with famous names—Santa Monica, Redondo, Malibu, Venice, and Huntington.

Seeking a respite from the highly energetic beachgoing crowds, thoughtful travelers look for lesser-known sections of the coast. Although true backroads are hard to come by in this part of the state,

OPPOSITE: The Channel Islands, off the Southern California coast, comprise five remarkable islands: Anacapa, Santa Cruz, Santa Rosa, San Miguel, and Santa Barbara.

A young girl sits alone, peacefully watching a stunning sunset along the beach at San Diego's Torrey Pines State Reserve.

just north of Santa Barbara, California's State Route 1 (Highway 1) turns into a country lane winding through agricultural lands on what are known as the Santa Maria Coast and the Gaviota Coast. Among the highlights are the one-horse town of Guadalupe, the gateway to the immense and dramatic Guadalupe-Nipomo Dunes Preserve, and Jalama Beach County Park, a remote and beautiful beach beloved by surfers and campers.

A massive headland surrounded by busy cities, the Palos Verdes Peninsula offers a day's worth of sea-breezy adventures. Catalina Island and Crystal Cove State Park are enclaves of retro architecture, and early California history comes alive at a historic *rancho* at Mission San Juan Capistrano and in the mystical Los Peñasquitos Canyon.

The Spanish-style town of Santa Barbara is a major tourist destination, and yet, a meandering circle tour turns up quiet retreats—from a bird refuge and world-famous botanical garden to a Spanish Colonial Revival masterpiece and the "Queen of the Missions."

Wine lovers take slow expeditions to vineyards scattered through-out the bucolic Santa Ynez Valley, while nature lovers stroll in Torrey Pines State Reserve, a precious world of sandy coves, deep ravines, and a dense forest of one of the rarest trees in the United States.

For explorers in a backroads state of mind, quiet pleasures can indeed be found along the Southern California coastline.

The Gaviota Coast

GUADALUPE TO GAVIOTA

Directions From the town of Guadalupe on State Route 1 (Highway 1), take Main Street west to Guadalupe-Nipomo Dunes Preserve. Then drive south on Highway 1 to Jalama Road. There head west to Jalama Beach County Park. After visiting the beach, retrace your way back to Highway 1, where you'll proceed south to Gaviota.

For more than a half century, travelers along State Route 1 (Highway 1) have stopped in the unassuming farm town of Guadalupe just to eat Santa Maria–style barbecue at the Far West Tavern, a favorite watering hole of local ranchers. Originally the 1912 Palace Hotel, today's tavern is a tourist attraction, a sort of museum decorated liberally with cowhides, branding irons, moose heads, paintings, and murals depicting the lives of the cowboys. A spectacular mahogany Brunswick back bar is rumored to have arrived at the hotel via a ship that sailed around Drakes Passage.

Originating during the *Californio* era of the mid-nineteenth century, when *rancheros* gathered to help brand each other's calves in the spring and barbecues were held to thank the *vaqueros* (the cowboys), Santa Maria–style barbecue is typically made from tri-tip, a cut that originated in the Santa Maria Valley. The meat is dry-rubbed with several spices and other secret ingredients and slow-cooked over smoky red oak charcoal. The traditional dinner includes sourdough French bread, tossed green salad, and whole *pinquito* beans, a small pink bean that is grown only in the Santa Maria Valley. On Saturdays, barbecue grills are set up in parking lots and shopping centers all along Broadway in the town of Santa Maria for hungry residents and visitors "in the know" who look forward to their barbecue every week.

West of Guadalupe on the shoreline, Guadalupe-Nipomo Dunes Preserve is an immense, active sand dune system. This central coast phenomenon includes eighteen miles of a seemingly endless Sahara

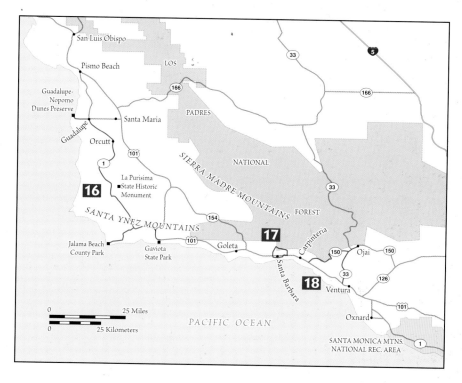

On the map:
San Luis Obispo
Pismo Beach
LOS
Guadalupe-Nopomo Dunes Preserve
Santa Maria
Guadalupe
PADRES
Orcutt
101
1
La Purisima State Historic Monument
16
SANTA YNEZ MOUNTAINS
SIERRA MADRE MOUNTAINS
NATIONAL
FOREST
154
Jalama Beach County Park
Gaviota State Park
101
Goleta
17
Carpinteria
Santa Barbara
18
Ventura
150 Ojai 150
33
126
101
Oxnard
SANTA MONICA MTNS. NATIONAL REC. AREA
PACIFIC OCEAN
33
5
166
166
1

0 25 Miles
0 25 Kilometers

of tilting, whirling, shifting sand mountains and swales, some as high as five hundred feet. Movie buffs explore the dunes, searching for the mostly sand-covered ruins of the original movie set for *The Ten Commandments*. In March and April, the dunes look like watercolor paintings, with washes of vivid yellow coreopsis and beach primrose and lavender sea rocket. Most of the year, yellow and blue lupine, flame-colored Indian paintbrush, and vivid orange and blood-red poppies are on display. Photographers gather in the rosy dawns and in the shadows shortly before sunset to catch dramatic images of the scenery.

A boardwalk from one of the entrances to the preserve snakes through a riparian woodland and across a swampy freshwater lake, where willows, reeds, and cattails shelter a variety of wildlife—from marsh wrens to cinnamon ducks, bitterns, and red-legged tree frogs.

OPPOSITE: A mile-long boardwalk path leads visitors to this natural area along a creek, across Oso Flaco Lake, and onward to the ocean. The Oso Flaco Lake Natural Area is part of the Guadalupe-Nipomo Dunes complex that stretches nearly twenty miles along the coast.

South of Guadalupe, jet trails are often seen overhead from aircraft based at Vandenberg Air Force Base. The base is home of the 30th Space Wing that manages space and missile testing and sends satellites into orbit.

At the south end of Vandenberg, you'll find the most remote California beach along Highway 1 at Jalama Beach County Park. The park is accessed by a winding road that slows down and ambles up and down through the canyons, valleys, and oak groves of the western Santa Ynez Mountains, passing old barns and fields of strawberries, broccoli, and celery. Among the rewards of the drive, and favorites of the surfers and windsurfers who brave the waves here, are the Jalama Beach Store and Grill's world-famous Jalama Burgers and Jalamadogs. Surfboards, windsurfing sails, and fishing gear are often laid out on the lawn in front of the store.

The beach is a half-mile sandy and rocky shore with tide pools and a blufftop campground. Accessible at low tide, a trail runs south a few miles to Point Conception, where the coastline switches from north–south to west–east orientation, the official dividing line between Northern and Southern California.

South down the highway, on the east side of Gaviota State Park, hikers explore rugged canyons, taking some relaxation time in the spring-fed, sulphurous hot springs after ascending Gaviota Peak to enjoy views of the Channel Islands and the coastline. On the west side of the park, Amtrak's *Coast Starlight* rumbles across Gaviota Creek on a tall, old iron trestle. Anglers cast off the fishing pier, and scuba divers, surfers, swimmers, and campers frequent the littoral. Visitors in 1769, the Spanish adventurer Juan Gaspar de Portola and his crew named the place La Gaviota, after the seagulls.

After a few minutes' walk from another popular stretch of sand, El Capitan State Beach, you'll come upon a unique, private campground tucked into El Capitan Canyon. Safari-style tents and cabins are scattered on the banks of El Capitan Creek, and on summer weekends, live concerts are held on the central greensward. After dark, campfires blaze and tents glow with lantern light, while bullfrogs croak, coyotes yip in the foothills, and owls hoot in the sycamores.

Just south of Gaviota is the magnificent canyon of the Arroyo Hondo Preserve, an old Spanish rancho that is open to the public twice

Customers sit at an antique wooden bar in Far Western Tavern in Guadalupe. The nearly one-hundred-year-old bar is rumored to have been brought to California on a ship that sailed around the tip of South America.

PAGES 176–177: The Guadalupe-Nipomo Dunes are home to many species of plants and animals, some of which are endangered. Environmentalists often clash with recreational users over concerns for the protection of this fragile ecosystem.

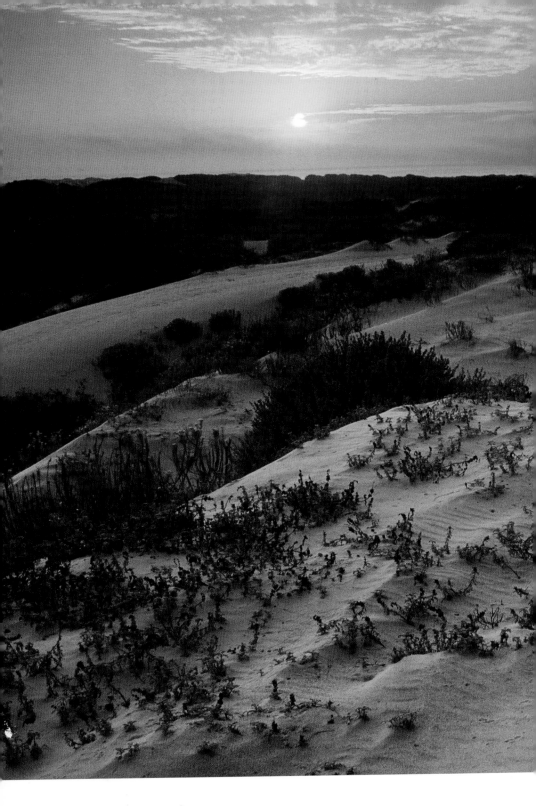

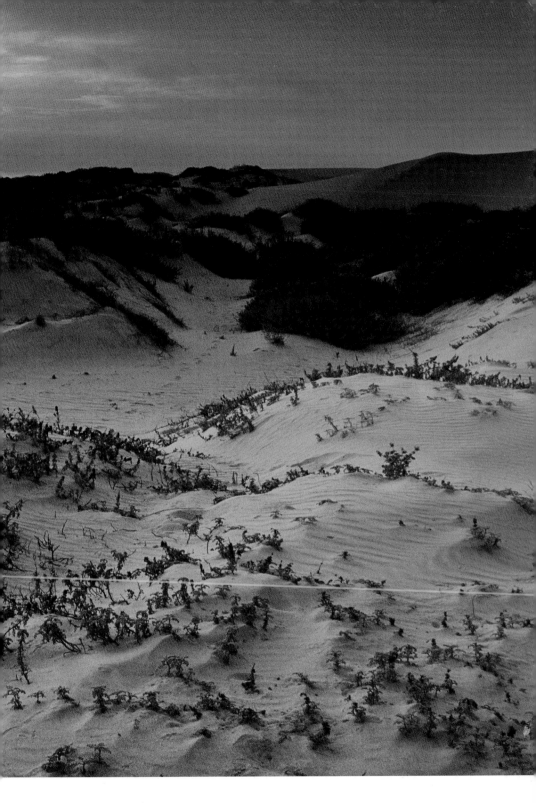

The perfect blend of rustic and luxury: a campfire burns in front of a wooden guest cabin, adding warmth to a cool coastal evening at the El Capitan Canyon Resort near Santa Barbara.

OPPOSITE: The warm sunlight stretching over the coastal hills, pier, and beach at Gaviota Beach State Park near Santa Barbara belies the cold, crisp chill in the air on this spring morning.

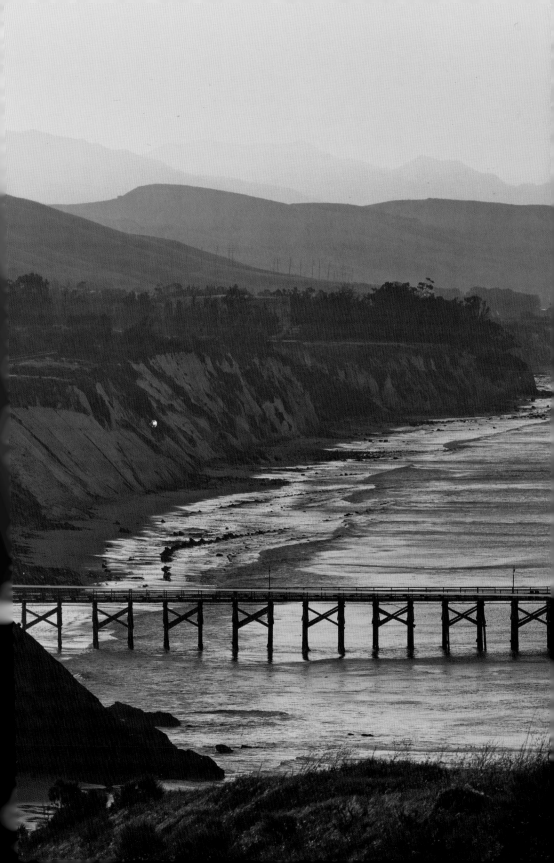

LA PURÍSIMA

Tens of thousands of Native Americans have lived at Misión La Purísima Concepción De María Santísima (Mission of the Immaculate Conception of Most Holy Mary) since its founding in 1787. Today a state historic park, La Purísima is considered the most completely and authentically restored of the twenty-one California missions of the Spanish era. Set in beautiful oak and willow groves in La Cañada de los Berros—the Canyon of the Watercress—the mission grounds offer a pleasant rest stop for history buffs and for travelers who want to picnic, walk, or take a bike ride.

Built of handmade adobe bricks and tiles, ten of the original mission buildings are fully restored and furnished, including the church, shops, living quarters, kitchen, fountains, stables, and blacksmith shop. The garden crops and the livestock represent what was found at the mission during the 1820s. A few times a month, costumed docents spin and weave wool, tan hides, make candles, operate the blacksmith shop, and guide visitors through the complex.

Located one day's horseback ride apart, Alta California's twenty-one Spanish missions were located along the six-hundred-mile El Camino Real, stretching from Mission San Diego de Alcalá in San Diego in the south to Mission San Francisco Solano in Sonoma in the north. La Purísima lies on the only original section of the "Royal Road" that is still in use.

a month. The visitor's center is housed in an adobe house that was built in 1842 by José Francisco de Ortega, a member of the Portola expedition of 1769 and later commandant of the Santa Barbara Presidio. The house was also a stagecoach stop in the late 1800s. Cool, streamside paths in the preserve meander through aromatic bays, sycamores, and oaks in a canyon that rises into the Santa Ynez Mountains, where steelhead trout flash in the shallow pools. In the lower reaches of the park, Spanish-era grapevines can still be found, along with orchard trees—bearing citrus, pears, and olives—from the 1800s.

ROUTE **17**

A Trip on the American Riviera

SANTA BARBARA CIRCLE

Directions From U.S. Highway 101 in Santa Barbara, take Cabrillo Boulevard west along the waterfront to Shoreline Drive. Continue west on Shoreline Drive to Cliff Drive, where you'll head west again to Los Positas Road. Follow Los Positas Road north, crossing over U.S. 101, and then follow San Roque Road north. At the junction with California Highway 192, go east to the Mission Canyon Road and follow it into the Santa Barbara Botanical Gardens. After visiting the gardens, continue east on Highway 192 through Montecito to Hot Springs Road and the starting point for this route.

Tracing the waterfront, wandering through a palmy horse ranch community and heading into the hills above the city, this loop drive around the scenic outskirts of Santa Barbara is a welcome relief from the sometimes congested, although rich and colorful, historic attractions of the city. At the beginning of this drive, opposite East Beach and next to the Santa Barbara Zoo, is the Andree Clark Bird Refuge, a serene complex of gardens and lagoons inhabited by hundreds of freshwater and marine birds. Footpaths rim the ponds and marshes where black-crowned night herons, egrets, bushtits, grebes, and mallards float or tiptoe in the reeds and oak woodlands. Elaborate plantings of the native species found here began in the 1920s.

From here, a three-mile paved bike path runs along Cabrillo Boulevard to Stearn's Wharf, several beaches, a busy marina in the

SEEING SANTA BARBARA

THE VIEW FROM THE TOP of the eighty-foot tower of Santa Barbara City Hall is of a vast sea of Spanish-tile roofs and white stucco walls and, beyond, the blue Pacific. Like an amphitheater, the city lies on a wide slope of foot-hills with palm-lined beaches as a front yard. At the end of the day, the sun slides into the sea, burnishing the tiles of city roofs red orange and washing gold across the Santa Ynez Mountains behind.

The palatial city hall is the ultimate example of the romanticized, almost theatrical interpretation of Colonial Spanish architecture that makes this one of America's most beautiful cities. To celebrate its Spanish and Mexican heritage, the city has restored and rebuilt its downtown over the years. All of the public spaces and many private estates showcase elegant, flamboyant California Mission Revival and Spanish Revival styles with a cacophony of wrought-iron balconies, brightly painted ceramic tiles, fountains, arch-ways, and whitewashed stucco. Add thousands of palms and exuberantly blooming courtyard-enclosed gardens and Ferdinand and Isabella, Spain's king and queen, who backed exploration of the New World, might have mistaken Santa Barbara for Seville.

Adobe structures remaining from the Spanish, Mexican, and early American eras also are right at home, as they have always been, on streets with names like Lobero, Anapamu, Carillo, and Figueroa. And in the Red Tile District, a midtown area about twelve blocks long, more adobes survive

Weathered by millennia of wind and waves, this arch rock has formed
in the blue ocean waters offshore of Anacapa Island, part of the Channel
Islands National Park on the Southern California coast.

from the early and mid-1800s. Many are concentrated in El Presidio de
Santa Barbara State Historic Park, founded in 1782. This was the last military
outpost of the Spanish Empire in the New World.

Off State Street, the main boulevard, Spanish Colonial Revival archi-
tecture is at its most melodramatic in El Paseo, a small shopping complex
built in the 1920s around the De la Guerra Adobe. Here, shops and galleries
are tucked snugly among flower-filled patios and arcades. In the summer-
time, huge magnolia trees are heavy with the scent of their creamy-white
blooms, and the blossoms of the jacaranda trees fall into lavender pools of
petals beneath overarching branches, forming canopies over European-style
outdoor cafés.

The many fiestas and the equestrian traditions of the Spanish era
are heralded with annual costume parades, pageants, dances, musical
concerts, and a rodeo. Since 1924, the days of the wealthy rancheros have
been reenacted at Old Spanish Days Fiesta in August. A mercado is set up
in the plaza of the city hall, and historic carriages and stagecoaches from
the Carriage Museum roll in the big parade, along with a horse-drawn fire
truck, an antique hearse, and an old wine cask cart. Stars of the parade are
descendants of the original Spanish land grant owners, dressed in elaborate,
fringed riding outfits, and ladies in ruffled gowns and Spanish shawls, sitting
high on fancy silver saddles.

The waters off the Santa Barbara shore are warm, calm, and sapphire
blue, the same blue as a summer sky. Seen from the beaches at sunset,
shaggy cypress trees and palms are dark silhouettes on the rims of the high
cliffs—looking to all the world as if they are conquistadors on horseback.

The interior of the rustic and historic Cold Spring Tavern.

harbor, and Chase Palm Park. Originally built in 1924 and expanded in the late 1990s, Chase Palm Park consists of plazas and fountains, an antique carousel and amphitheater, and picnic grounds and a shipwreck playground, complete with a whale that spouts water onto unsuspecting kids. A string of sandy beaches and grassy parks line this shore between the city's streets and the Pacific Ocean. The bluffs of Shoreline Park are prime platforms for views of the Channel Islands and for whale-watching in the wintertime.

Built in 1872 as a breezy site for seafood cafés and souvenir shops, Stearn's Wharf remains a landmark, jutting out into the ocean at the foot of State Street. Anglers still buy bait and tackle here to try for crab and rockfish off the pier, and tourists still stroll up and down, eating ice cream and fish and chips. On both sides of the wharf, the beaches are framed by a waving phalanx of palm trees and a paved path for biking and walking on one of the prettiest esplanades in the world.

Down the road, the Douglas Family Preserve rides the cliffs above the crescent of Arroyo Burro Beach, providing ocean vista views and a place for off-leash dog walking. Right on the beach, The Boathouse restaurant is a prime spot for sunset dinners.

From here, Cliff Drive rolls on west, hugging the shore, to Las Palmas Drive, which winds through Hope Ranch, a hilly area crisscrossed by a labyrinth of leafy residential streets and bridle paths. A glorious, decades-old phalanx of mature palms lines the road.

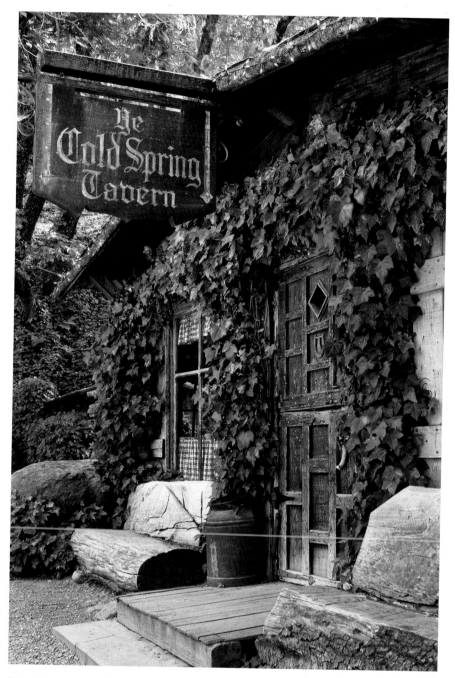

Thick ivy covers the entrance to the Cold Spring Tavern, as if trying to hide it from the hands of time. In its heyday, this was a popular stop on the historic stagecoach route between Santa Ynez and Santa Barbara.

The Mission Santa Barbara, with its distinctive twin towers, was the tenth California mission to be founded by the Spanish Franciscans. This drawing of the mission dates to 1902. *Library of Congress*

On the north side of U.S. Highway 101, the Santa Barbara Botanical Garden graces the hills above the city. Carol Bornstein, the director of horticulture, notes that there is a long tradition of gardening in Santa Barbara, partly because of the area's climate but also because of the tremendous wealth of the area's early Anglo settlers. They had traveled extensively in Europe and were influenced by gardens of the Mediterranean basin, so they wanted to create that effect in this similar climate.

"All around town, olive trees, Italian stone pines, and deodar cedars reflect our Mediterranean heritage. In some of the residential and public gardens, you see citrus, cork oaks, and always loads of palms—from European fan to Chilean, windmill, and Canary Island date palms. The courthouse downtown has a wonderful collection of palms."

Thousands of native California plant and tree species are on view in the garden, where five miles of walking trails meander along the banks of upper Mission Creek and through wildflower-filled meadows and arroyos scattered with cacti, oak, and sycamore.

OPPOSITE: Shown here is the sunset over Santa Ynez Peak and the distant Lake Cachuma, as seen from the Santa Ynez Mountains near Santa Barbara. This range, overlooking the Pacific, is also known as California's Riviera.

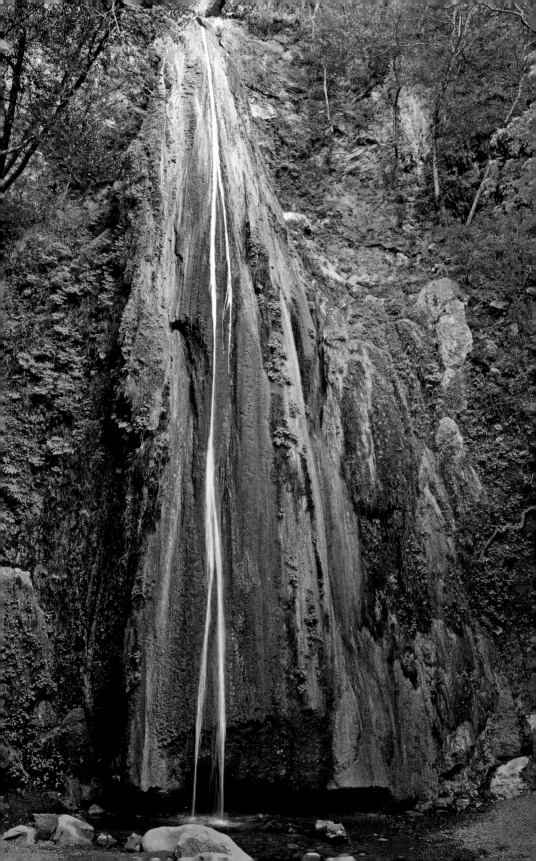

Lush flora and dependably sunny skies have lured creative types to Santa Barbara and the central coast for decades. The literary critic, Edmund Wilson struggled to focus on his work here in the 1920s, writing to his New York editor, "I have done nothing but read, write, and swim. The weather is beautiful, and all the days are exactly alike. The calm Pacific spaces are excellent for work. But if you stayed out here very long, you would probably cease to write anything, because you would cease to think—it isn't necessary out here, and the natives regard it as morbid."

From near the botanical garden entrance on California Highway 92, Mission Canyon Road drops south a short way to Mission Santa Barbara, known as the Queen of the Missions for its massive twin towers and commanding hilltop setting above the town. Hundreds of rose bushes are a fragrant ocean of bloom around the pink sandstone Greco-Roman façade with its Ionic columns and other architectural details of the late 1700s and early 1800s, when the cathedral was rebuilt after a major earthquake. On hot summer days, visitors cool off in the dim, candlelit nave and stroll in the shade of the cloister gardens, lingering in the courtyard by a beautiful Moorish-style fountain.

Farther east along Highway 92, the oak-studded hills and creek canyons of Parma Park are beloved by hikers and horseback riders. The road then sails along in the hills above Santa Barbara through Montecito, a tony village called home by Oprah Winfrey and other television and Hollywood stars. For a glimpse of the elegant lifestyle and Spanish Colonial Revival architecture that has characterized Montecito's legendary estates since the 1920s, visitors are welcome, with reservations, to visit Casa del Herrero. This home, built in 1925, is decorated with vivid Talavera-tiled fountains; ironwork from Spain; and thirteenth- to eighteenth-century Spanish furnishings, artifacts, and art. Eleven acres of decades-old magnificent trees and plantings are just waiting to be discovered in a series of formal gardens and terraces here. Nearly two hundred types of citrus, hundreds of roses, and rare dragon trees are among the standouts.

SIDEWAYS IN SANTA YNEZ

A MODERN VERSION OF A **D**ANISH VILLAGE, Solvang is definitely not backroads, yet the small, tourism-oriented town makes a good launching pad for exploring the Santa Ynez Valley. The valley enjoys a microclimate of cool nights and mornings and warm, dry days, perfect for the peppery syrahs, intense pinot noirs, and sensuous chardonnays produced by the premium wineries scattered in a triangle called the Santa Ynez Wine Trail. The vineyard-friendly area extends between Solvang and the tiny western towns of Santa Ynez and Los Olivos.

A slow drive along Solvang's Alamo Pintado Road leads past bucolic countryside and historic buildings, such as the 1926 Craftsman farmhouse, turned tasting room, at Foley Estates Winery. Here, former dairy barns are now cellars and barrel rooms. Nearby, in a rare 1884 adobe home nestled in a grove of magnificent old oaks, is Rideau Vineyard, where visitors can relax in Adirondack chairs in the gardens.

A 1918 flagpole stands guard in the one-horse town of Los Olivos. Lining the main street are clapboard buildings, some from the 1800s. These buildings house art galleries, antiques shops, and wine tasting rooms. On sale in a tiny log cabin, you'll find Kahn Winery's Cabernet Franc, named after Frank Sinatra and nicknamed "Cab Frank." His music is played during the winemaking to infuse the vino with smooth sounds, and the labels feature paintings by Old Blue Eyes. On the edge of town, the cavernous former 1880 stagecoach-stop building is now The Brothers at Mattei's Tavern, where visitors lounge in armchairs by a river-rock hearth, sipping local wines and perusing the tavern's photos of bygone days.

On meandering roads east of town are wineries galore, one of which is Clairmont Farms, found on a lane lined with century-old olive trees. Other than grape-producing vines, an abundance of lavender grows here. On Roblar Road, you'll find Brander Vineyards, headquartered in a steep-roofed, pink, French-style building. Among the winery's offerings are Bouillabaisse Rosé and Bouchet and Tête de Cuvée, a dark award-winner with a cassis cherry aroma.

Old-style Dutch wooden windmills abound as a motif throughout the Danish-style village of Solvang in Santa Barbara County.

In the rustic little burg of Santa Ynez, about four hundred horseshoes are embedded in the street. Stagecoaches, cowboy memorabilia, art, and antiques are among the distractions along the two-block-long main street. At the Santa Ynez Valley Historical Museum, native Chumash Indian baskets are on display, as well as old coaches, surreys, wagons, and carriages. A good place to hear local gossip, the Maverick Saloon looks like an old western movie set, complete with dollar bills on the ceiling and grizzled cowpokes at the long bar.

Heading out of Los Olivos, California Highway 154 winds up through eucalyptus and manzanita into the Los Padres National Forest, topping out at San Marcos Pass, a thousand feet above the valley. For a century and more, travelers have stopped for refreshments or a meal at the Cold Spring Tavern at the top of the pass, where rattling stagecoaches once changed their teams of horses and allowed passengers to rest and eat. Beyond the tavern, the Cold Spring Canyon Arched Bridge is one of the longest arched steel bridges in the country, spanning four hundred feet above the gaping canyon below.

High Valley Shangri-la

VENTURA TO OJAI,
LAKE CASITAS, AND CARPINTERIA

Directions From U.S. Highway 101 near Ventura, take California Highway 33 north for 14 miles to Ojai. From Ojai, take California Highway 150 west to Lake Casitas; continue on Highway 150 southwest to U.S. 101 near Carpinteria.

High above the haze of Southern California cities at the foot of the Topa Topa Mountains lies a magical green valley, shaded by ancient oaks and warmed by a Mediterranean climate. Since the 1920s, movie stars and weekenders have escaped from the nearby hubbub of Santa Barbara and Los Angeles to linger in the Ojai Valley for horseback riding on wooded trails, playing golf or tennis, or browsing in art galleries. Add to that fishing, hiking, and picnicking at the Lake Casitas Recreational Area and more than a daytrip is warranted for adventures in Ojai.

Rugged mountains encircle the little town of Ojai, creating a Shangri-la atmosphere as gossamer mists from the coast, only fourteen miles away as the crow flies, hang on the ridges at dawn and melt into a blaze of warmth at midday. In fact, the area was photographed to represent Shangri-la in the 1939 movie *The Lost Horizon*. The ten-mile-long east–west valley is one of few in the world where, as the sun sets, a "pink moment" occurs, when fading sunlight creates a rosy pink glow across the Topa Topa bluffs to the east.

One of the prime viewing spots for stunning valley views and the pink moment experience is Meditation Mount, a retreat center about five miles out of town at the end of Reeves Road. It is open to the public every day. In the center's lovely gardens, a full moon meditation is held

OPPOSITE: Beautiful Mediterranean architecture, carefully manicured grounds, pampered luxury for the body and soul, and even the gentle songs of birds soothe the aches of visitors to The Spa Ojai, crown jewel of the Ojai Valley Inn and Spa.

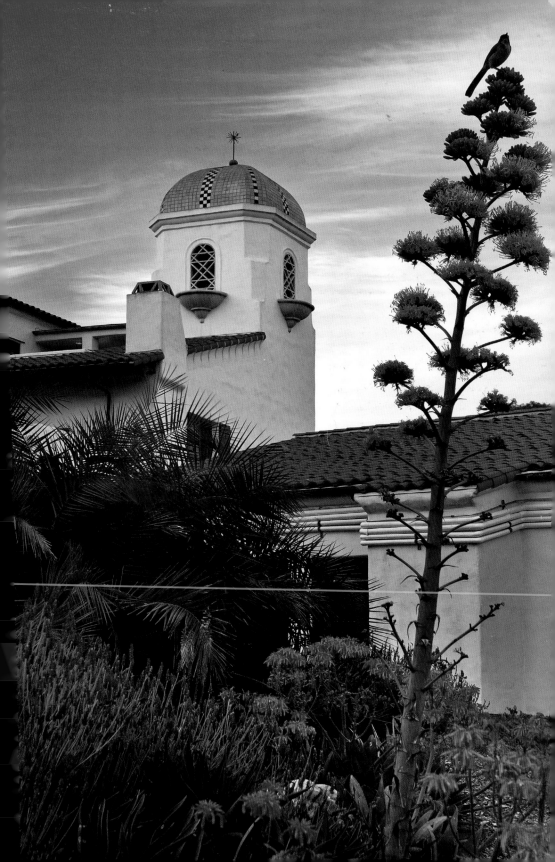

PREVIOUS PAGES: Sunrise turns the sky a golden orange over Lake Casitas, a popular camping and fishing resort nestled in the rolling hills near Ojai.

on the ascension of each full moon, which is often the day before the actual full moon.

An artists' colony filled with delightful shops and galleries, Ojai has a notable collection of Spanish Revival buildings, notably the iconic post office bell tower. It is a copy of a campanile in Havana. The Ojai Valley Museum, in a 1919-era former chapel, exhibits Native American and pioneer relics and photographs. A ride on the Ojai Valley Trolley is an easy way to get an overview of the town.

For culture vultures, early October is a good time to visit, in order to take in the Ojai Studio Artists Tour, a self-guided weekend open house at some forty studios and gardens of the town's noted painters, sculptors, photographers, and ceramicists.

Aside from the arts, the denizens of Ojai are literary types. Since 1964, they have supported an outdoor bookshop, Bart's Books, where most of the 100,000 used and rare volumes are available for sale twenty-four hours a day. Patrons toss coins through the door to pay for books when the main store is closed. Among local residents seen at Bart's and in the galleries are Anthony Hopkins, Julie Christie, Jake Gyllenhaal, Ted Danson, and other movie stars.

When they aren't browsing for books, half the residents of the town, it seems, can be found on the Ojai Valley Trail biking, walking, running, or pushing baby strollers. Rimmed by wooden railings and roaming through oak groves and along creeks and riverbeds, the trail runs for more than nine miles around and out of town. With a parallel path for horses, it links to the Ventura River Trail, an old Southern Pacific Railroad right-of-way, for a total of seventeen miles of paved trail ending at Ventura Pier at the ocean.

Travelers who explore the two-lane roads and some of the many trails in the area will get an idea of what California looked like when Spanish *conquistadors* first saw this countryside in the 1700s. Today, thousands of massive oaks are specters of the past, along with 150-foot-tall eucalyptus trees; feathery pepper and olive trees; vineyards; and groves of tangerines, oranges, and avocadoes. On property planted with more than a thousand cherry trees and hundreds of roses, Old

An eclectic collection of art—painted wall-clinging geckos, metallic birds, buddhas, mirrors, and so much more—surrounds you at Janis' Art Garden Gallery and Ojai Art Workshop in downtown Ojai.

This vintage postcard shows a car traveling on U.S. Highway 101. Parts of this highway are known as the Pacific Coast Highway, a name also used to describe sections of State Route 1. *Department of Archives and Special Collections, Library, Loyola Marymount University*

Creek Ranch Winery on Old Creek Road was part of an original Spanish land grant. In the 1800s, the land was purchased by an Italian chef, Antonio Riva, who produced wine right through Prohibition until about 1942. Illicit wine buyers used to pin their money on the clothesline and return later to pick up jugs of red wine left beneath an oak tree.

In addition to wine grapes, family-owned farms in the area specialize in citrus, olives, and nuts. The climate is perfect for the Ojai Pixie tangerines, five thousand lavender plants, and fourteen hundred or so olive trees grown on New Oak Ranch, a couple of miles east off California Highway 150. Crates of tangerines, blood oranges, and Meyer lemons are available to buy at the packinghouse at Friend's Ranches in Matilija Canyon and at the Ojai Farmer's Market, which operates every Sunday, rain or shine, behind the arcade.

Hikers yearning for wilderness and travelers with a little time on their hands head out of Ojai toward the coast on Highway 150, a scenic route that accesses the Lake Casitas Recreational Area. Backpackers and day-hikers disappear into the Los Padres National Forest, while anglers cast their lines and picnickers and bird-watchers linger on the thirty-two-mile-around lakeshore, keeping their eyes peeled for snowy egrets, herons, grebes, and kingfishers.

ROUTE 19

Cliffs and Coves of Palos Verdes Peninsula

REDONDO BEACH TO CRENSHAW

Directions From Harbor Drive in Redondo Beach, take Catalina Avenue south to Esplanade. Continue south to Paseo de la Playa and then follow Palos Verdes Drive south. Follow Palos Verdes Drive along the rim of the peninsula to Western Avenue, where you'll head south to Paseo Del Mar. There head east, tracing the shoreline. At the intersection with Gaffey Street, head north to 25th Street, where you'll turn west. At Western Avenue, head north to Palos Verdes Drive and continue north to the botanical garden at Crenshaw.

From the palm-lined boulevards and yacht harbors of Redondo Beach, the headlands of the Palos Verdes Peninsula loom to the south, jutting into the Pacific, cut off from the jam-packed freeways and even from the smog of Los Angeles. Setting off on a daytrip around the fifteen-mile perimeter of the peninsula, motorists rise swiftly to clifftops along Paseo Del Mar, home to the Palos Verdes Estates Shoreline Preserve. The preserve's vista points and blufftop parks are the perfect places from which to ponder Bluff Cove below and the great curve of Santa Monica Bay. Walking trails run along the cliffs in the four-and-a-half-mile

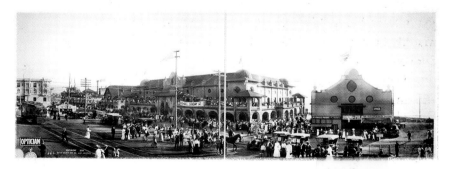

Redondo Beach has long drawn those seeking sun, sand, and water. This scene of the busy oceanside dates from 1910. *Library of Congress*

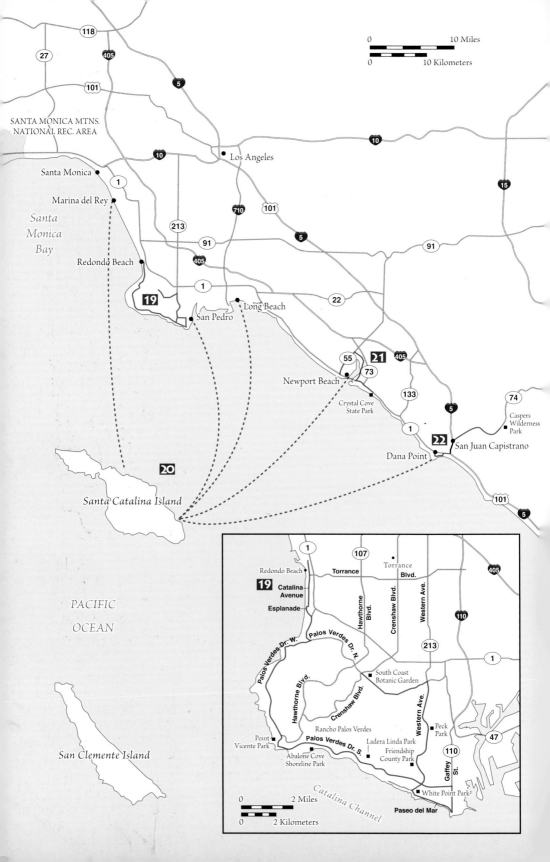

0 10 Miles

0 10 Kilometers

118

27

405

101

5

SANTA MONICA MTNS.
NATIONAL REC. AREA

10

Los Angeles

10

15

Santa Monica

1

Marina del Rey

Santa
Monica
Bay

710

101

213

15

Redondo Beach

91

91

405

5

1

22

Long Beach

San Pedro

19

55

21

405

73

Newport Beach

133

Crystal Cove
State Park

74

Caspers
Wilderness
Park

5

1

20

22

San Juan Capistrano

Santa Catalina Island

Dana Point

101

5

PACIFIC
OCEAN

San Clemente Island

Inset map

1

107

405

Redondo Beach

Torrance

Torrance
Blvd.

19

Catalina
Avenue

Hawthorne
Blvd.

Crenshaw Blvd.

Western Ave.

110

Esplanade

213

1

Palos Verdes Dr. W.

Palos Verdes Dr. N.

South Coast
Botanic Garden

Hawthorne Blvd.

Crenshaw Blvd.

Western Ave.

Peck
Park

47

Rancho Palos Verdes

Point
Vicente Park

Palos Verdes Dr. S.

Ladera Linda Park

Friendship
County Park

Abalone Cove
Shoreline Park

110

Gaffey
St.

White Point Park

Catalina Channel

Paseo del Mar

0 2 Miles

0 2 Kilometers

This vintage advertisement for Manhattan Beach, just a few miles north of Redondo, touts the area as one in which " . . . living all year 'round is vacation every day!" *Voyageur Press Archives*

MANHATTAN BEACH
California!

WHERE LIVING ALL YEAR 'ROUND IS VACATION EVERY DAY!
At the ocean edge of Los Angeles County

preserve, and steep paths connect to several small coves popular with divers and surfers.

On a promontory at the outer edge of the peninsula, next to Point Vicente Lighthouse, Point Vicente Park has a natural-history museum focused on the geology, flora, fauna, and human history of the area, along with picnic sites, beach access, and walking paths. Because the museum's decks are prime perches from which to whale-watch, docents and naturalists are often on site from December to May to explain the whale migration that takes place at that time of year through the Catalina channel.

The U.S. Coast Guard's 1926 lighthouse is open on one Saturday a month for tours. One of the brightest lights along the coast, the sixty-seven-foot-tall tower produces two million candlepower with a circa-1886 French lens that spent forty years in Alaska before being brought here. Nearly two hundred feet above sea level, the light can be seen from twenty miles at sea.

PAGES 202–203: Designed to be a place for peaceful reflection and quiet prayer, The Wayfarers Chapel was designed by Lloyd Wright, son of the famed architect Frank Lloyd Wright. Nestled along the Palos Verdes Peninsula, the chapel feels to be a million spiritual miles away from the nearby urban centers of Long Beach and San Pedro.

Just south, the rocky beach at Abalone Cove, reached by a steep dirt path, is a favorite of tide pool explorers, surfers, and divers; guided tide pool hikes are offered daily. Nearby, the unique Wayfarers Chapel is a tourist attraction and a popular wedding site. Designed in the mid-1940s by Lloyd Wright, son of the American architect Frank Lloyd Wright, the lofty, all-glass chapel set in a grove of redwood trees is said to be an example of organic architecture. Its soaring wooden columns echo the tall tree trunks that can be seen through the glass walls. Visitors are welcome to wander the adjacent gardens and enjoy the ocean view.

Farther along Palos Verdes Drive, on a flat plateau high above the ocean, the course at Trump National Golf Club is laid out in all its green glory and anchored by a spectacular clubhouse. For those interested in shooting a round or seeing the grounds, the golf course and the club-house restaurants are open to the public. Walking trails (rarities on golf courses) meander beside the golf cart paths through carefully preserved native plant habitat and onto a bluff-top park with access to a beach.

At another vista point, Royal Palms State Beach can be seen below along with the ruins of the Royal Palms Hotel, which had its heyday in 1915 and was washed away by a storm in 1920. Anglers often cast from the rocky outcroppings here, and in the summertime, lifeguards are on hand to protect swimmers, divers, and surfers.

At the bottom of the peninsula, marked by a charming Victorian-style, 1874 lighthouse (not open to the public), Point Fermin Park is a cliff-top greensward shaded by expansive Moreton Bay fig trees. Visitors watch for whales and for harbor seals hauling out on the rocks. From here, the north end of the Long Beach/Los Angeles harbor—one of the largest manmade ports in the world—can be seen stretching to the south. An even wider view of the port is gained from Angels Gate Park, where a large pagoda shelters a massive bronze bell, a gift from South Korea in the 1970s.

Within Angels Gate Park is also the Fort McArthur Mammal Center, a hospital for ill, injured, and orphaned marine mammals, primarily rescued California sea lions, northern elephant seals, harbor seals, and northern fur seals.

OPPOSITE: A break in the low clouds provides a hint of light on the coastal cliffs and the Point Vicente Lighthouse on the Palos Verdes Peninsula.

Located in the heart of the Palos Verdes Peninsula, the South Coast Botanical Garden is a popular place for local residents to volunteer time tending to the plants and flowers.

On eighty-seven acres in the highlands of the peninsula, the South Coast Botanical Garden displays 2,500 species of plants and trees from around the world, so something is always in bloom. Among the many horticulture features are a dramatic cactus garden; a 150-year-old stone lantern and a koi pond in the Japanese garden; 300 varieties of roses; hundreds of fuchsias, dahlias, and herbs; and an aromatic garden for the senses.

Left My Love in Avalon

SAILING TO CATALINA ISLAND

Directions Take a passenger ferry to Catalina Island from terminals at San Pedro, Long Beach, Newport Beach, Dana Point, or Marina Del Rey.

"From the beautiful Casino Ballroom overlooking Avalon Bay on Catalina Island, we bring you the music of Glen Miller," crooned a radio announcer in 1934. More than seventy years later, the harborfront town of Avalon looks much as it did when Miller's band and Benny Goodman played for crowds in the seaside dance pavilion, a landmark Art Deco, Moorish-style rotunda with a red tile roof. With their tresses flowing like sea grass, mermaids swim, Native Americans ride horses, and a Spanish galleon sails across the vibrantly painted tile murals of the

This vintage postcard shows that the Bay of Avalon has always been very picturesque with the Casino as its centerpiece. The Art Deco ballroom was built in 1929. *Voyageur Press Archives*

Residents of Avalon are passionate about keeping the tranquil feeling of their town intact. To that end, they have a long-instituted quota on the number of cars allowed, so golf carts are used for basic transportation and quietly populate the streets.

"casino," which was never a gambling hall and is still an entertainment center. Palm trees line Catalina Island's streets and harbor, and on stairways, fountains, and storefronts are Catalina's signature ceramic tiles, brightly painted with fish and tropical birds—including parrots, toucans, and macaws.

Twenty-two miles across the sea, an hour's ride on a passenger ferry, the backroads of Catalina Island are a world away from the hubbub of the Southern California mainland. Cars have long been off-limits to visitors and residents, and there are no traffic lights. Instead, golf carts, bikes, Segways, and touring vans compose the transport; in fact, most residents are allowed just one golf cart per household.

Daytrippers and weekenders cluster in Avalon, the main tourist destination and the only town. They lounge on the beaches and go sailing, kayaking, snorkeling, and scuba diving in the dazzling, clear waters and kelp beds offshore. A few hardy souls catch buses to a handful of campgrounds on the far side of the island, and adventurers sign on for sightseeing cruises and bus tours into the hills.

Beneath glass-bottomed boats and through the windows of the lemon-yellow Seamobile Submersible, marine creatures—from spiny lobsters to bat rays, pink scorpion fish, fluorescent-orange garibaldi, and octopi—are on parade in Lover's Cove. Even the occasional curious sea lion presses its face against the glass. A frequent diver in the protected marine preserve around Catalina, Jean-Michel Cousteau, son of the pioneer oceanographer Jacques Cousteau, once said, "Since 1968 I have been diving the coast and the island. You run into whales and dolphins and friendly harbor seals, and a forest of kelp, which could equate, perhaps, with what a bird would experience flying in Sequoia National Park. You literally can fly in a kelp forest, and on a sunny day, it is almost a religious experience. You find sunfish and electric rays; it is an amazingly rich environment."

OPPOSITE: Standing more than ten stories in height over Avalon Bay's harbor full of boats, Catalina Island's landmark Casino building has never been a true casino. It was built back in 1929 as a dance hall and was designed to help promote tourism to the island.

PAGES 211–212: Boats anchor offshore in calm blue waters half an island away from Avalon, in front of the isolated hamlet of Two Harbors on Catalina Island.

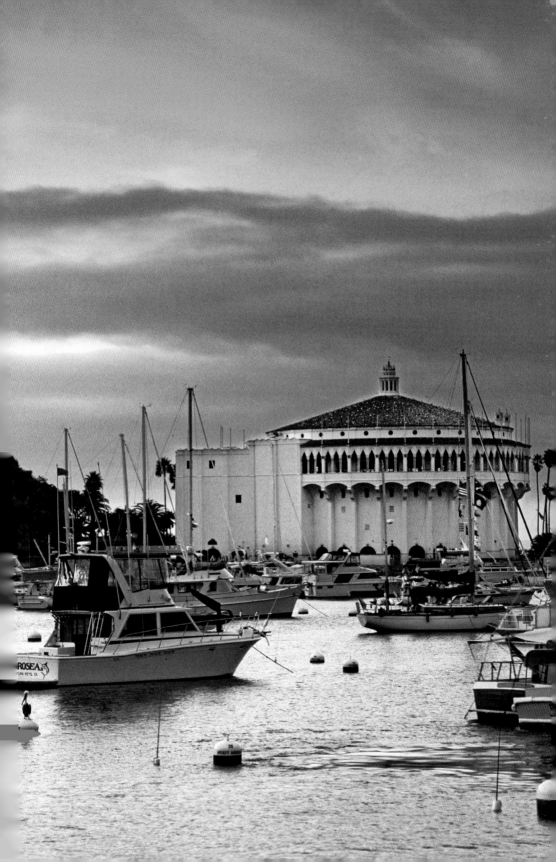

Avalon, a one-square-mile town of about three thousand (year-round population), has an appealing cacophony of flamboyant Spanish Revival–themed architecture that includes terra cotta tile roofs, white stucco exteriors with archways, wrought-iron balconies, fountains, towers, turrets, and colorful tile decoration. At Third and Descanso streets, a white wedding-cake of a house was once a turn-of-the-century steamship. Beyond the shops, eating places, and hotels at the harbor's edge, narrow side streets are lined with brightly hued clapboard vacation cottages and a few Victorian-era houses. The farther up the hillsides, the larger the houses, with rambling verandas on mansions high above. A marine-influenced climate encourages luxuriant Mediterranean gardens, banana palms, bird of paradise, pink and red hibiscus, and waves of magenta bougainvillea.

Visited by the Spanish explorer Juan Rodriguez Cabrillo in 1542, and a hiding place for Spanish smugglers in the early 1800s, the island turned to tourism in the late 1800s. In the 1920s, the chewing gum magnate William Wrigley Jr. purchased most of the island and built a golf course and the Georgian colonial-style St. Catherine Hotel, which is today the Inn on Mount Ada. Planted originally by Wrigley's wife, Ada, in 1935, the Wrigley Memorial and Botanical Garden displays California native species, in particular the rare Catalina ironwood that grows naturally only on the island.

Another vintage lodging, the Hopi Indian–style Pueblo Hotel, was once the home of Zane Grey, a famous author of Western novels who spent his later years writing and fishing here. The hotel rooms are named for his books, such as *Lone Star Ranger* and *Riders of the Purple Sage*, and guests sit on the deck overlooking the half moon of Avalon Bay reading works from the Zane Grey library stored in the lobby.

Near the middle of the island, a half-mile-wide isthmus has sheltered harbors on each side. It's here at Two Harbors, near a restaurant and a pier, that about eighty people get off a tour boat once or twice a day and share the place with just a handful of campers and pleasure-craft sailors. All can enjoy the area's solitude as they explore walking paths into the hills.

When the sightseeing cruises return to Avalon after dark, passengers marvel at a canopy of stars that seems to career right down into the sea. From about May to September, thousands of flying fish can be

Some of the local trademarks on Catalina Island are the historic and colorful tile installations, including several fountains along Avalon's waterfront promenade.

seen near the shoreline at night. The crew of the classic 1924 open-deck wooden sightseeing boat, the *Blanche W*, thrills passengers by using World War I–era, forty-million-candlepower searchlights to attract the silvery fish as they soar as high as thirty feet out of the water, skimming over the surface like silver bullets for distances as long as a quarter mile and creating a spectacular show.

Back in Avalon, lights twinkle off the sailboats moored in the harbor, and the 1925 Chimes Tower tolls on the quarter hour. The streets are empty of the tourists who flocked into town for the day, leaving the townspeople and a few dreamy souls who couldn't bear to leave the place known as the island of romance.

ROUTE 21

Secrets of Crystal Cove

AROUND NEWPORT BEACH
AND ITS PARKS

Directions From State Route 1 (Highway 1) in Newport, take Newport Boulevard south to Balboa Boulevard, where you'll head west. Then return to Highway 1, heading south, and take the Jamboree Road exit northeast. Proceed to Back Bay Drive and head north. Drive around the estuary and then connect with California Highway 73. Go north/left on Highway 73 and then take Irvine Avenue south to Highway 1. Head south on Highway 1 to Newport Coast Drive/Crystal Cove State Park.

Backroads? Not in this busy Southern California city, and yet visitors in the off-season (if Southern California can be said to have one) can discover quiet oceanfront boulevards and footpaths, a precious nature preserve, and a glimpse of what this coast was like in the 1930s.

For a century and more, sleek, varnished yachts and sailboats have tied up in front of vintage mansions in Newport Beach. Today, more than nine thousand pleasure craft are home-based in Newport Harbor, which is wrapped in the Balboa Peninsula, a narrow, six-mile-long arm of land between the city and the Pacific Ocean. Ground zero for summer vacationers are the glorious golden beaches, coves, and breezy bluffs that fringe the peninsula and the Newport and Balboa piers that reach out into the sea. Within the harbor, tiny Lido and Balboa islands are pricey residential enclaves ringed with shops, restaurants, and, in the case of Balboa, a waterfront promenade.

Alongside Newport Pier on the beach, the only dory fishing fleet on the West Coast has been selling fresh snapper, mackerel, spiny lobster, crab, and other local seafood since 1891. The dorymen head out to sea at midnight or so nearly every day, returning in a thrilling rush through the surf for beach landings by about seven a.m. to unload and sell their catches at the Dory Fishing Fleet market. The market is marked by an arch topped by a fisherman manning oars in a wooden boat. Near the

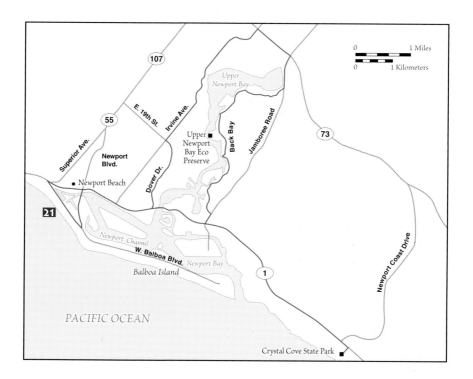

pier, a red neon fish sign reading "Don't Look Up Here" announces the Crab Cooker, where shrimp and scallops and crab and fish-and-chips have been served on paper plates since the 1950s.

A walking and biking trail runs the length of the Balboa Peninsula, about five miles, connecting the piers and accessing beaches, parks, and vista points. At the south end of the peninsula below West Jetty View Park, boats sail in and out of the harbor and bodysurfers brave the rough waves. Every summer, swells that originate off New Zealand slam against the jetty's boulders and, in the final seconds before they meet land, morph into monster waves, as high as twenty feet. Known collectively as the Newport Wedge, these waves are so treacherous they can only be ridden by bodyboarders and bodysurfers.

From Balboa Pier, sightseeing and whale-watching cruises depart, along with fishing charters and the huge *Catalina Flyer* catamaran that runs back and forth to Catalina Island. On the inner harbor, the Victorian-style, cupola-topped Balboa Pavilion was built in 1906 as the southern terminus of the Pacific Electric Railway, which connected with Los Angeles. Among the wildlife that can be spotted from the

BALBOA ISLAND

APPROACHED BY WAY OF JAMBOREE ROAD, and by ferries and small boats that cruise merrily across Newport Bay, Balboa Island is a mirage-like village of quaint Cape Cod–style cottages—a sort of Martha's Vineyard of California.

One of the great waterfront promenades of the world, a paved walkway known as the Boardwalk circles the island. Favorite modes of transportation are bikes, trikes, and six-passenger surreys. On one side of the walkway is the harbor, filled with zillion-dollar yachts, slow-moving electric sightseeing boats, and sea and shorebirds; on the other side are charming homes and gardens. The boardwalk also provides access to docks and small beaches.

The island's short, busy main street, Marine Avenue, is full of shops, cafés, and snack stands, notably Sugar 'n' Spice, topped by a ten-foot banana. The ice cream parlor and confectionary invented the Balboa Bar—vanilla ice cream dipped in chocolate and rolled in chopped peanuts or jimmies—and has served them at a walk-up window ever since. Frozen bananas and chocolate-covered frozen cheesecake on a stick are popular menu items, too.

Sightseers on the island find that locally made electric Duffy boats are easy to drive around Newport Harbor. The open-sided, canopied boats hold up to ten passengers who lounge on padded banquettes and snap photos of the hundreds of yachts, sailboats, and sea lions that inhabit the surrounding waters.

Christmastime brings crowds to the boardwalk and the beaches rimming the harbor to watch the annual holiday boat parade, actually a series of parades over several days. The parade was founded at the turn of the nineteenth century by an Italian gondolier, John Scarpa, who festooned his craft with glowing Japanese lanterns to attract passengers. Other boatmen soon followed his lead. Today the glowing parade winds through the fourteen-mile harbor and attracts a million spectators to watch more than 150 extravagantly decorated boats—from three-story cruisers and racing yachts to skiffs and kayaks—decked out for the holidays. (In fact, some boat owners spend tens of thousands of dollars on the trimmings and strings of lights.)

verandas at the pavilion are snowy egrets, great blue herons, gulls and pelicans, sea lions, and Rupert, a resident black swan.

Nearby, the Newport Harbor Nautical Museum displays model ships, historic photos, marine mammal skeletons, and a fully rigged Snowbird sailboat. Kids head for the touch tank, while their parents watch films and attend boat-building demonstrations.

On the opposite side of the Pacific Coast Highway from Newport Beach, Upper Newport Bay Ecological Reserve is Southern California's largest estuary, nearly three-and-a-half miles long and a half-mile wide. Here, fresh and saltwater come together in marshy wetlands, providing a lush and precious habitat for thousands of birds and waterfowl. Beloved by bicyclers, joggers, and slow-moving vehicle drivers, the reserve's Back Bay Drive is a one-way road bordering the water and offers views of huge flocks of migrating birds. As many as thirty-five thousand birds can be seen here on any given day during the winter. Among endangered species that live or tarry here are the light-footed clapper rail, Belding's savannah sparrows, peregrine falcons, and California least terns.

Just south of Newport Beach, on both sides of State Route 1 (Highway 1), Crystal Cove State Park is one of the largest and most multifaceted of Southern California's nature preserves. The park's thousands of acres of pristine oak woodlands in the rugged canyons of the San Joaquin Hills are popular with hikers, horseback riders, and mountain bikers. The upland area of the park connects to the Laguna Coast Wilderness Park and the Irvine Ranch Land Preserve, some of the last undeveloped canyons on the coastline.

This vintage postcard shows anglers lined up at Newport Beach's ocean pier, a popular fishing spot. *Voyageur Press Archives*

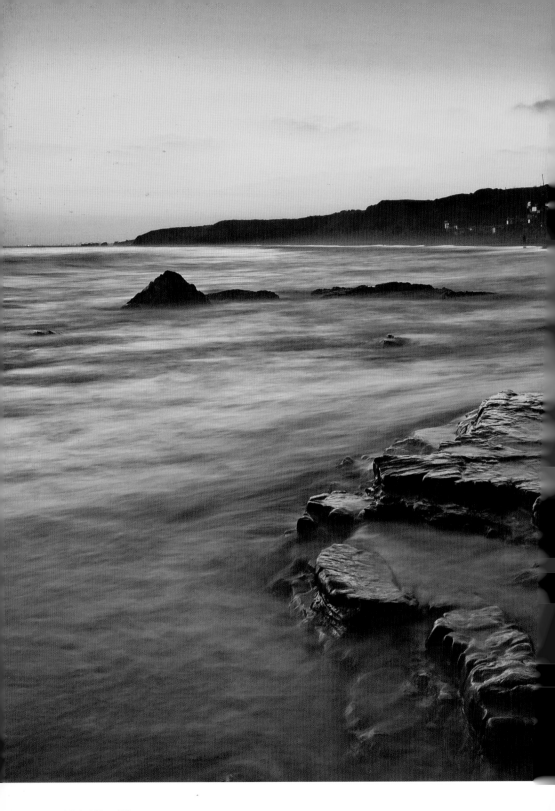

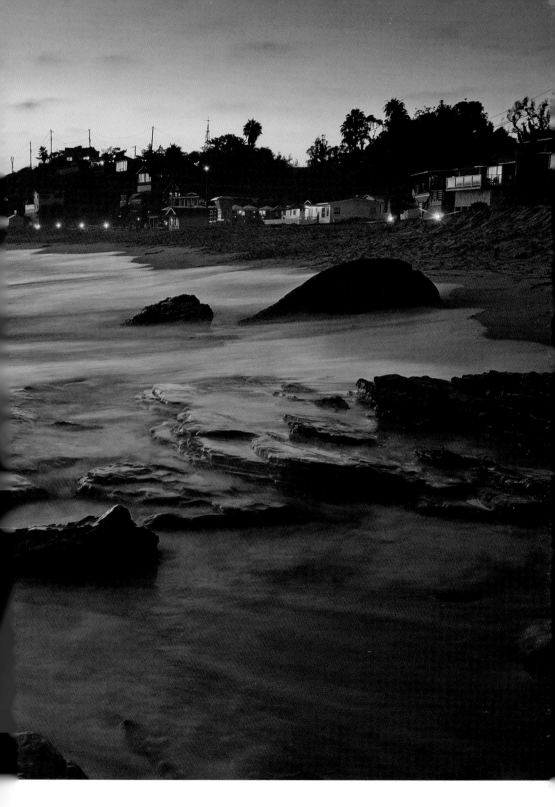

On the ocean side of the park, three-and-a-half miles of trails ramble along the grassy bluffs above the sands of Crystal Cove and other beaches. While divers dodge dolphins and prowl waters offshore, tide pools and rocky coves are waiting to be explored by landlubbers. The Pelican Point access area has several easily accessible trails and an extensive native plant collection, which was restored early in the twenty-first century. In meadows that have been cleared of introduced flora, wild lilac, California sage, elderberry, and sunflowers bloom amid stretches of aromatic coastal sage scrub. A boardwalk runs through part of the restored meadows where native plants are labeled. Bird-watchers keep their eyes peeled for California towhees, mourning doves, and white-tailed kites.

The treasure of Crystal Cove State Park, and unique on the entire West Coast, is an enclave of historic, hand-built beach cottages—a rare vestige of early Southern California. Built in the 1930s as a ramshackle South Seas movie set, the forty-six Crystal Cove Beach Cottages are clapboard and shingle bungalows that have been restored by the park service and outfitted with antique or replica furnishings. Boardwalks connect the wooden porches, which are decorated with vintage surfboards and old lobster traps.

Having a sunset meal or cocktails served on the patio of the Beachcomber Café in the heart of the Crystal Cove State Park Historic District is a hallmark of the local good life.

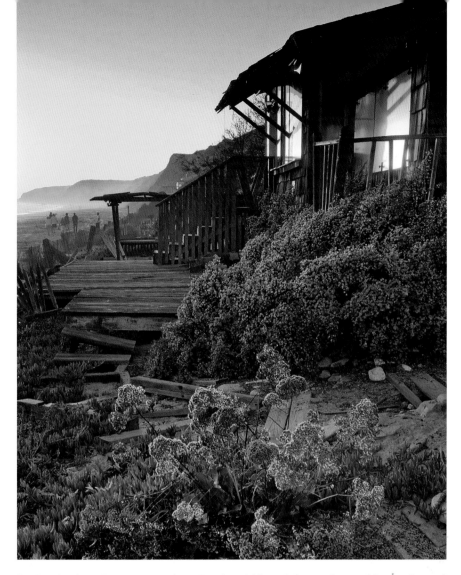

Dating back to the 1920s and 1930s, the old beach bungalow cabins at Crystal Cove State Park Historic District have been preserved to retain the classic feel of an original California beach getaway location. A number of the cabins have been restored and are again accepting guests for overnight stays.

Adjacent to the cottages here in the Crystal Cove Historic District, Dungeness crab cakes and Catalina Sunset martinis are on the menu at the Beachcomber Café, which was remodeled as an oceanfront restaurant from an existing cottage. Just off Highway 1, yet still within the park, the tiny, bright yellow Crystal Cove Shake Shack is a hot spot for burgers, fries, floats, malts, and fresh date shakes.

Dana's "Pilgrim" and the Swallows of San Juan Capistrano

DANA POINT TO CASPERS WILDERNESS PARK

||

Directions From State Route 1 (Highway 1) west of Dana Point, take Golden Lantern Street south to Dana Point Harbor Drive. Follow Dana Point Harbor Drive, and after taking in the view from the headlands, return to Highway 1 by going north on Green Lantern Street. Continue north on Highway 1 to Interstate 5. Follow Interstate 5 north to the San Juan Capistrano exit, where you'll head into the city. From San Juan Capistrano, drive 7.5 miles on the Ortega Highway (California Highway 74) to Caspers Wilderness Park.

||

Richard Henry Dana Jr.—author of the classic *Two Years Before the Mast*, a rousing narrative about his voyage aboard a square-rigger in 1834—loved the view from the headlands that overlook today's Dana Point Harbor. He often stood on the clifftop at the end of what is now the Street of the Blue Lantern to gaze down at his ship, *The Pilgrim*, on which he served as a sailor on a 150-day voyage from Boston, around Cape Horn, to California.

Describing the coastline, Dana wrote, " . . . It was a beautiful day, and so warm that we had on straw hats, duck trowsers, and all the summer gear; and as this was mid-winter, it spoke well for the climate; and we afterwards found that the thermometer never fell to the freezing point throughout the winter, and that there was very little difference between the seasons . . ."

Many streets in the town of Dana Point are named for the brightly colored glass in *The Pilgrim*'s lanterns, and some streetlights were modeled after maritime signal lanterns. Between Amber Lantern and

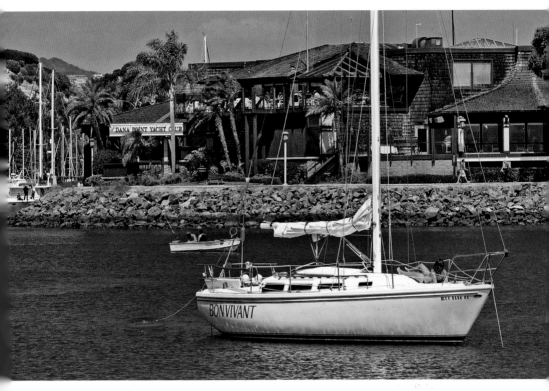

This sailboat is one of many anchored in front of the Dana Point Yacht Club in California's famous Orange County.

PAGES 226–227: Shown here is Dana Point Harbor at sunset, as seen from the overlook at the end of Blue Lantern Street. From here, you can look out over a near city of yachts and boats neatly docked in row after row.

Violet Lantern streets, with a loop around El Camino Capistrano, visitors and residents stroll on Bluff Top Trail, enjoying the salt air, the harbor views, and the neighborhood of Cape Cod–style cottages and lovely gardens. At the end of Golden Lantern Street, the sweeping lawns and picnic tables at Lantern Bay Park are pleasant places from which to enjoy the sea breezes.

A replica of Richard Henry Dana's 130-foot ship—a "snow brig" hosting fourteen sails—and a couple thousand modern pleasure craft are berthed in the harbor within a mile-long jetty. Students at the Ocean Institute, a marine science teaching center, live as 1830-era sailors on the ship and also on the *Spirit of Dana Point*, a 118-foot topsail

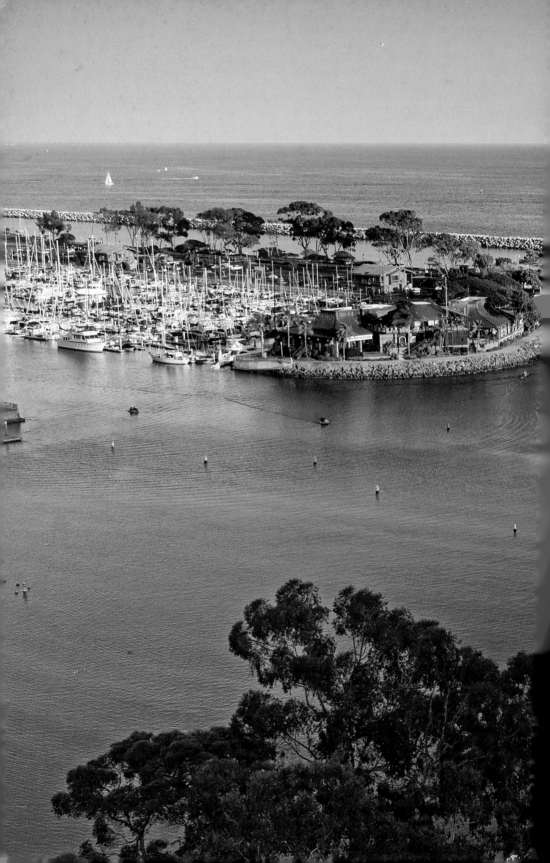

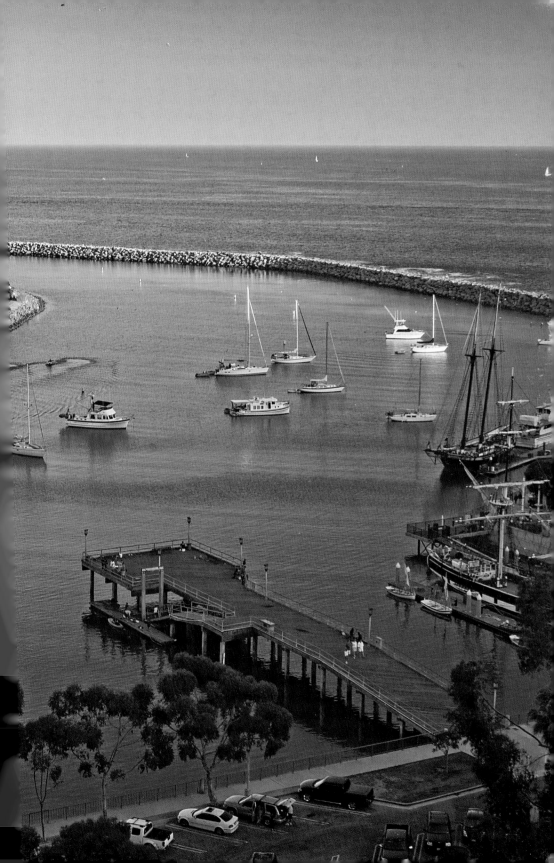

A tour docent in period dress stands aboard a full-size replica of *The Pilgrim*, a tall ship docked at Dana Point Harbor and based on the ship immortalized in Richard Henry Dana Jr.'s classic novel *Two Years Before the Mast*.

schooner also moored here. The ships, the facility, and the adjacent tide pools are open to the public on Sunday afternoons.

The annual Tall Ships Festival in September, the largest annual gathering of tall ships on the West Coast, is a breathtaking sight from the bluff. During the festival, multi-masted brigantines, square topsail schooners, and more historic vessels glide into the harbor in full sail, cannons blasting.

The deck of one of the many waterfront restaurants and Dana Point Harbor Drive that skirts the harbor are vantage points from which to watch a lively parade of watercraft—from kayaks to jet skis and outrigger canoes, fishing and whale-watching boats to sailboats and yachts—pass by. Sightseeing cruisers and ferries to Catalina Island are based here, too.

The Pilgrim cruised along the California coast from San Diego to San Francisco in the early 1800s, trading goods for hides from the ranchos and the Spanish missions. Five miles as the crow flies inland from Dana Point, Mission San Juan Capistrano was a major source of cow hides, which were hauled back to Boston for shoemaking. Founded by the Franciscan friar Junipero Serra in 1776, the mission and the leafy streets and historic houses surrounding it invite a pleasant short drive from Dana Point.

The seventh in California's twenty-one mission chain, Mission San Juan today consists of the rustic ruins of the Great Stone Church. The church was established in 1776, completed in 1806, and destroyed by an earthquake in 1812, along with Padre Serra's chapel. Adobe chapel walls surround an impressive, twenty-two-foot-tall, gold-leafed Baroque

altarpiece decorated with more than fifty angels. It was carved in Spain three centuries ago and sent to California in 1906. Visitors wander acres of walled gardens and grounds, encountering fountains and exhibits presenting early mission life.

Across the street from the mission, the public library is a striking Morris Graves–designed, postmodern edifice that pays homage to Spanish heritage by the use of stucco walls, mission clay roof tiles, wooden beams, mini-towers, small punched windows, stencil ornamentation, and loggias around a central courtyard.

San Juan Capistrano is also famous for a springtime influx of thousands of swallows. The birds migrate annually to Goya, Argentina, in October and return to their spring and summer home here in March.

The Mission San Juan Capistrano is considered to be the crown jewel of California missions. Dating back to its origins over two hundred years ago, the mission has long been a draw for visitors and still conducts mass, offers tours of the old stone buildings, and is the place thousands of swallows return to each March.

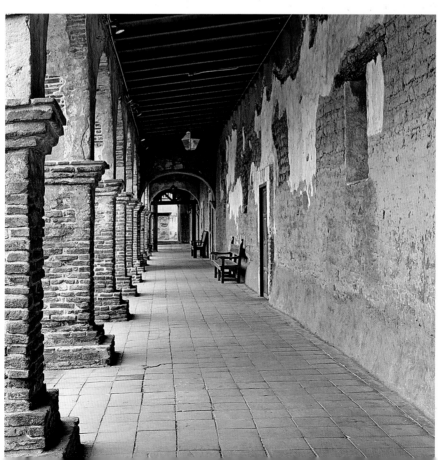

ENDLESS SUMMER IN LAGUNA BEACH

FAR FROM THE TANGLED FREEWAYS OF SOUTHERN CALIFORNIA, Laguna Canyon Road winds through the deep canyons of the San Joaquin Hills toward the sultry beach town of Laguna Beach, draped on rugged, golden-hued cliffs along a seven-mile-long sandy shore. In the early 1900s, artists began to discover the astonishing light on this stretch of coastline and the dramatic canyons and their flora. Influenced by French impressionism, they aimed to capture the vivid sunlight, the eucalyptus groves, and the poppy fields.

The first art gallery opened in 1918, and by the late 1920s, half the full-time residents were artists, living in ramshackle cottages and in tents on the beaches. During the Depression, they hung their works in trees on the roadsides, hoping to appeal to passersby, and to promote themselves, they founded the Pageant of the Masters in 1933. A series of tableaux featuring live human models in elaborate re-creations of masterworks by artists like Van Gogh and Matisse, the spectacular annual event continues to draw large crowds today. In an outdoor amphitheater in the mild evenings of July and August, local residents pose in ninety-minute sittings in life-size sets. The traditional grand finale is Leonardo da Vinci's *Last Supper*.

About three hundred feet above the surf at Rockpile Beach, the Laguna Art Museum (the oldest cultural institution in Orange County) showcases the early California school of impressionism and *plein air* painting. Right on the beach, the Hotel Laguna displays a museum's worth of photographs documenting the town's history in its lobby. On the side of the hotel, a dream-like underwater scene of a California gray whale and her calf floating in an azure sea is one of one hundred "whaling walls" around the world painted by the flamboyant artist known as Wyland. The Detroit native first visited Laguna Beach as a fourteen-year-old, getting his first look at the ocean, and as it happens, he saw two gray whales spouting just offshore of Main Beach. He said of the experience, "The barnacle encrusted backs broke the surface . . . and they raised their enormous flukes. Ten years later, I moved to Laguna Beach and painted those two whales life-size on a building, not more than a hundreds yards from the spot they had first appeared."

One of many bungalows and cottages from the late 1800s to the early 1900s in Laguna Beach, the clapboard Murphy Smith Historical Bungalow on Ocean Avenue exhibits circa-1920s décor

and photos of early days. Tiny St. Francis By-the-Sea on Park Avenue is the second-smallest Catholic church in the world, according to the *Guinness Book of World Records*. The mini-cathedral has just forty-two seats. On Forest Avenue, the Mediterranean Revival–style city hall is shaded by a glorious pepper tree that was planted in 1881. And the oldest house in town, at 154 Pearl Street, was built in 1883 with driftwood and pieces from shipwrecks.

A boardwalk runs the length of Main Beach, where under the eyes of life-guards perched in the circa-1929 tower, a playground and volleyball courts are ready for fun. At the north end of the boardwalk, you'll find Heisler Park, a flower-filled half-mile retreat with wide coastal views and beach access.

Heading back to Laguna after other daytripping adventures, travelers are greeted by a historic sign that hangs at the corner of Forest and Park avenues: "This Gate Hangs Well and Hinders None, Refresh and Rest, Then Travel On."

Morning walks are a ritual for many people who can take advantage of scenic places along the coast. Here, a woman walks her dog while strolling on the boardwalk at Laguna Beach.

A statue of Father Serra and a Native American boy stands over the main garden at Mission San Juan Capistrano. Locals often seek out the beauty of the mission and its gardens for their engagement, wedding, and anniversary photos.

The Swallows Day Parade and the Fiesta de las Golondrinas celebrate their return. (In recent years, the swallows have showed up in diminishing numbers, yet the festival goes on.)

A walk around the tree-shaded Los Rios Historic District, said to be the oldest residential street in the state, is an introduction to early California architecture. Dozens of adobe homes built for mission families, the earliest dating to 1794, are still in use as residences and restaurants. Famous for hearty breakfasts, the Ramos House Café on Verdugo Street is a board-and-batten house, one of several in the neighborhood erected between the late 1880s and 1910. Next door, the Combs House, now a gift shop called Hummingbird Cottage, was built in 1865 and was moved here in 1878 from an abandoned boomtown.

The O'Neill Museum, showcasing local history, resides in a sweet little Victorian home of the late 1870s, while the Mission Revival–style, domed, brick, circa-1894 Santa Fe Railroad station is now a restaurant and Amtrak stop.

Travelers seeking solitude head east on Ortega Highway about eight miles to Caspers Wilderness Park, a vast array of river terraces and sandstone canyons in the coastal Santa Ana Mountains. Adjacent to the Cleveland National Forest and the Audubon Society's Starr Ranch Sanctuary, the rustic park watered by rocky creeks is mainly groves of coastal live oaks and California sycamores, sage, and chaparral; the landscape here isn't much different from that encountered by the early Spanish explorers. A small museum and a mountain-view terrace at the visitor's center offer a preview of the delights of the park's thirty miles of equestrian and hiking trails.

ROUTE **23**

Flower Fields, Bulrushes, and a Rancho

OCEANSIDE TO CARLSBAD AND BATIQUITOS LAGOON

Directions From U.S. Highway 101/South Coast Highway, stop at the Vista Audubon Nature Center (2202 South Coast Highway) in Oceanside. Continue on south on U.S. 101 to Tamarack Avenue east, taking Park Drive south to Cove Drive above Agua Hedionda Lagoon. Return to Tamarack Avenue and proceed east to El Camino Real. Follow El Camino Real southeast to Palomar Airport Road. There head west to the Flower Fields at 5704 Paseo Del Norte. Then take Palomar Airport Road east to Melrose Avenue, where you'll head south to the Leo Carillo Ranch. Return west on Alga Road and Aviara Parkway to Batiquitos Drive. Follow the loop drive to Poinsettia Lane, where you'll continue west to Interstate 5.

Between a necklace of beaches and a backdrop of grassy, oak-studded, rolling hills, the busy seaside city of Carlsbad in north San Diego County is famous for its flower fields and three rare and fascinating lagoons.

Between Carlsbad and Oceanside, two hundred acres of freshwater marshlands—the Buena Vista Lagoon Ecological Reserve—are inhabited by large flocks of native and migratory birds, ducks, and geese, as well as turtles, frogs, and even an occasional flamingo. The reserve's nature center showcases some of the hundreds of species that are seen here, from green herons to avocets, moorhens, and several types of grebes. A walking trail leads through tall grasses and around the lagoon, and maps are available that indicate other bird-watching sites on the shoreline.

Just south along U.S. 101, Agua Hedionda Lagoon is another marshy, tidal wetlands where a botanical garden of more than fifty native species can be found.

Developed by a German pioneer and the California Southern Railway in the 1880s, the town of Carlsbad retains an Old World European look, with Dutch, Bohemian, and Victorian architecture. The mustard-colored Carlsbad railroad depot was a circa-1890 Wells Fargo express office, while the Ocean House, a massive Victorian, stands in gabled glory on Carlsbad Village Drive. The former Alt Karlsbad Haus, a rather striking, turreted, cross-timbered building erected in 1882, today houses the Carlsbad Mineral Water Spa where patrons bask in the warm waters that rise beneath the spa. A city that caters to a lively beachgoing crowd, Carlsbad's seafood shacks and open-air cafés have quirky names like Shrimply Delicious, the Belly Up Tavern, and Johnny Mañanas.

Right in the middle of town at the world-famous Flower Fields, on a mile of hillside, vast expanses of ranunculus, gladiolus, roses, poinsettias, and other flowers explode into vivid waves of red, yellow, orange, and pink from mid-March through April. The blooms attract thousands of spectators who are allowed to walk the fields, and nearly eight million *Tecolote Giant Ranunculus* bulbs are harvested annually here and shipped around the world.

Below the town along the coastline, several stairways lead from Ocean Street to the sandy strand of Carlsbad State Beach. Vista points and pathways along Carlsbad Boulevard and below by the seawall are beloved by joggers, bikers, skateboarders, and ambling sightseers. Tamarack Surf Beach is, not surprisingly, ground zero for those looking to catch a wave.

On the south end of town, Batiquitos Lagoon is accessed by several trailheads (maps can be found at the visitor's center at the end of Gabbiano Lane). Sightings along the two-mile trail may include red-winged blackbirds; egrets nesting in the eucalyptus trees; red-legged, black-necked stilts; several types of herons; green-winged and cinnamon teal; and many more birds. The endangered California least tern and the western snowy plover also find refuge here and in the few natural lagoons and wetlands that remain on the California coast. Sadly, over the years, development has destroyed more than 90 percent of the original coastal marshes, bogs, baylands, and estuaries in California.

Amid the lush riparian environment surrounding Batiquitos Lagoon, you'll find prickly pear cacti, yucca, fragrant coastal sage,

0 1 Mile

0 1 Kilometer

78

Buena Vista Lagoon

23

Tamarack Ave.

Park Dr. south to Cove Dr.

El Camino Real

Melrose Ave.

Cannon Road

College Blvd.

Road

Aqua Hedionda Lagoon

5

Flower Fields

Airport

Palomar

Carrillo Park (Leo Carrillo Ranch)

PACIFIC OCEAN

Paseo del Norte

Lane

Poinsettia

Aviara

Alga Road

Batiquitos

P kwy.

Drive

Batiquitos Lagoon

SANTA ANA MOUNTAINS

74

San Clemente

San Onofre State Park

5

76

23

Oceanside

Buena Vista Lagoon Ecological Reserve

Carlsbad

Area Enlarged Above

15

78

56

Lake Hodges

24

Del Mar

Los Peñasquitos Canyon Preserve

15

CALIFORNIA

Torrey Pines State Reserve

University of California San Diego

La Jolla

5

805

Mission Bay Park

8

Balboa Park

San Diego

San Diego Bay

Chula Vista

PACIFIC OCEAN

20 Miles

20 Kilometers

Border Field State Park

Tijuana

MEXICO

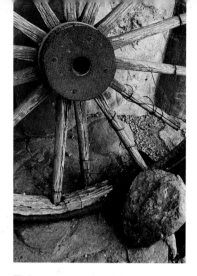

This wagon wheel leans against a wall at the historic ranch.

cattails, bulrushes, and tules growing. And in the lagoon's sandy bottom and eelgrass-sheltered shallows, rays, sharks, and fish are born and protected until they are big enough to survive in the open sea.

Hidden in the hills above town, Leo Carrillo Ranch was formerly owned by a mid-twentieth-century movie and television star, Leo Carrillo. Born in 1880 in what is now Old Town San Diego, Carrillo had a lively set of grandparents, to whom the state's governor awarded the title to Coronado Island (which they sold twenty-three years later for one million dollars).

Carrillo appeared in nearly 100 motion pictures in the 1930s and 1940s, and ultimately he became beloved, at the age of sixty-nine, for his portrayal of Pancho, the mischievous sidekick to Duncan Renaldo's Cisco Kid in a pioneering television series of the early 1950s. Carrillo served for nearly two decades on the California Beaches and Parks Commission and was instrumental in developing the Los Angeles Olvera Street complex and Anza-Borrego Desert State Park. In later years, he toured the world as the state's official ambassador of good will.

In 1937, Carrillo purchased the rambling two thousand or so acres known as Rancho de Los Kiotes, which he transformed into an Old California–style working rancho. Today's visitors, many who have never heard of Carrillo, enjoy wandering beneath the pepper and palm trees to see an adobe hacienda, courtyards, barns, a bunkhouse, stables, a cantina, windmills, and other reminders of the days when Carlsbad was just a village and cowboys roped cattle in the hills.

OPPOSITE: Every year in spring, a hillside in Carlsbad comes alive with rows of colorful blooming flowers. The Carslbad Flower Fields are a popular destination for residents and visitors to the Southern California coast.

PAGE 238: The main house at Leo Carrillo Ranch Historic Park near Carlsbad and a number of other important structures remain as a reminder of what life on a working rancho was like.

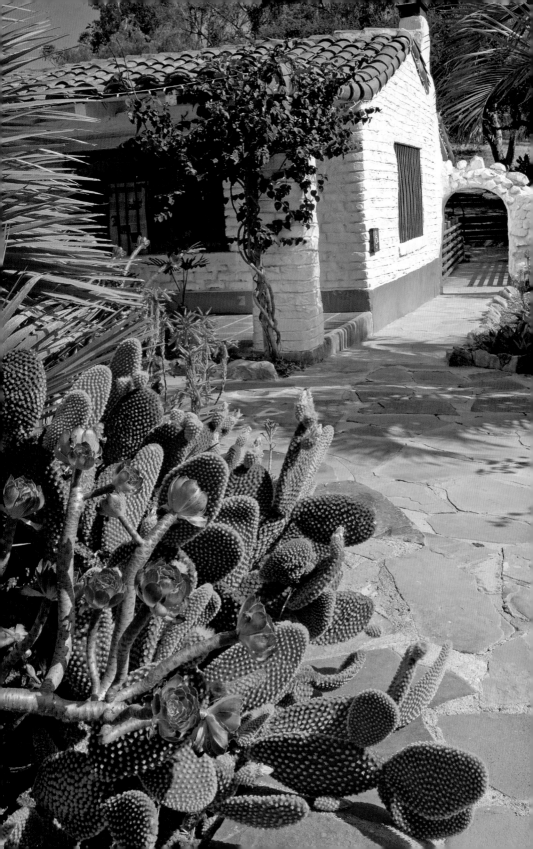

A Rare Pine Forest

TORREY PINES STATE RESERVE AND THE UNIVERSITY OF CALIFORNIA SAN DIEGO

Directions From Interstate 5, take Carmel Valley Road west to U.S. Highway 101. Turn south on U.S. 101 and head to the Torrey Pines State Reserve entrance. There follow Torrey Pines Park Road to its end. Then turn onto North Torrey Pines Road, going south to Torrey Pines Scenic Drive, where you'll head west. Return north on North Torrey Pines Road and turn east onto North Point Drive on the University of California San Diego campus.

A retreat from the busy beaches and even busier freeways of San Diego, Torrey Pines State Reserve is a universe of sandy coves, wind- and water-carved sandstone cliffs, and hundreds of gnarled pines cascading into steep ravines. The reserve is the closely guarded home of the Torrey pine—*Pinus torreyana*—which is said to be the rarest pine in the United

A vintage postcard looking west along the Prado in San Diego's picturesque Balboa Park. The park is home to fifteen major museums, renowned performing arts venues, beautiful gardens, and the San Diego Zoo. *Voyageur Press Archives*

States. The wild pine population amounts to about four thousand trees growing only here and on Santa Rosa Island in the Channel Islands.

In midsummer, it is not uncommon for coastal fog to hang on all day, creating a perfect climate for the pines. Creating dramatic scenes against a backdrop of San Diego County's sparkling azure seas and skies, the pine groves are swept back away from the ocean, due to steady saline mists blown ashore. The more open to the winds and salty air, the more dwarfed and distorted are the trees.

LOS PEÑASQUITOS CANYON

UNLIKE SEVERAL OTHER CREEK VALLEYS that run to the sea out of the coastal mountains in San Diego County, Los Peñasquitos Canyon Preserve is a rare patch of semiwilderness where a year-round artesian spring has provided a ribbon of life for about six thousand years or so.

Native Americans were the canyon's first inhabitants; they were acorn-grinders, huddling near the dense forest of California live oaks and trading with coastal and inland tribes. The vast canyon became the first Mexican land grant in the early 1800s and the site of one of the first adobes built in Alta California. Later in the century, the first intercontinental mail route ran through here, joining the western territories with the Midwest and the East, and it was followed by the Butterfield stagecoaches.

Today, miles of hiking and mountain biking trails wind through the sage scrub-covered hillsides and across the canyon floor of the preserve, meeting—just as bobcats, coyotes, deer, and Southern Californians have always done—at the bubbling stream of freshwater cascading downhill between a tumble of giant boulders. Along the streamside are groves of giant California oaks and towering sycamore trees. Pacific tree frogs, crayfish, and largemouth bass live in the stream, and the marshy areas are home to great blue herons, egrets, mallard ducks, and more.

Within the preserve is the oldest standing private residence in San Diego County, the Rancho Santa Maria de Los Peñasquitos. The adobe ranch house, built in the early 1820s by the commandante of the San Diego Presidio, is open to the public for tours.

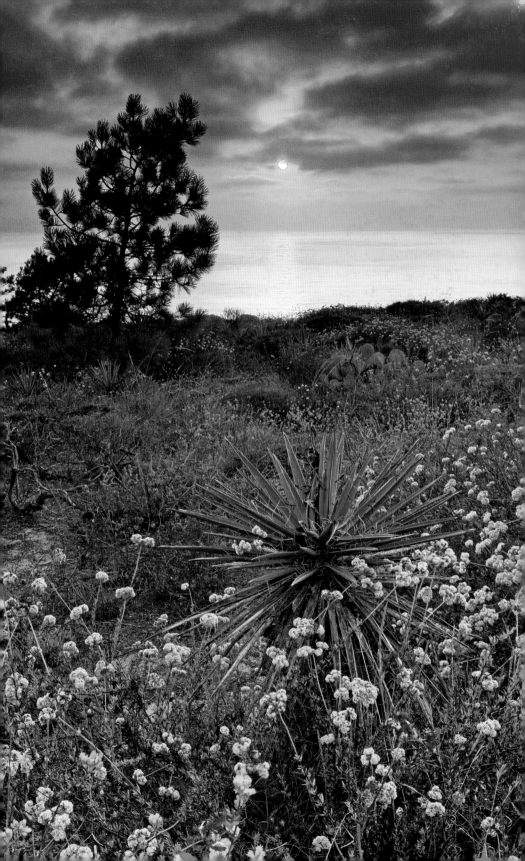

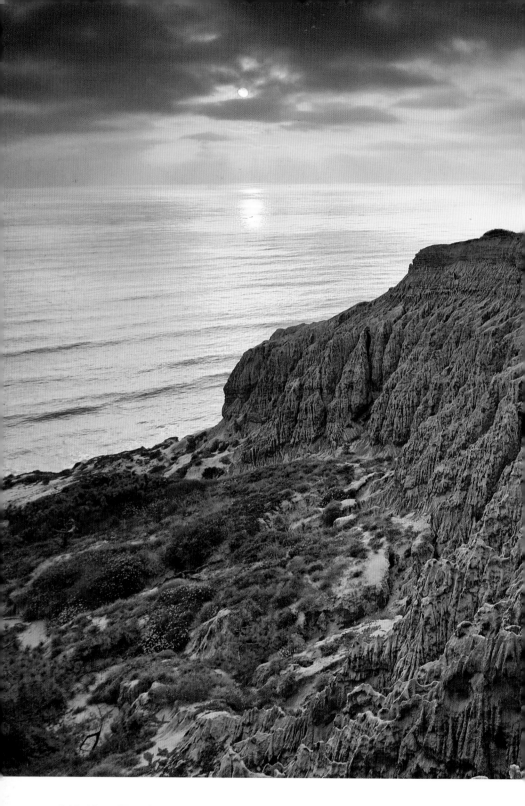

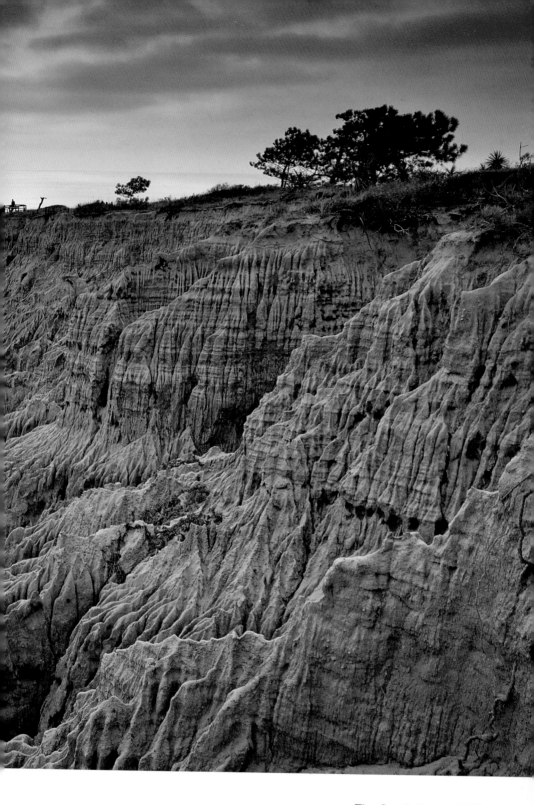

Roaming through the pine groves on the blufftops, walking trails overlook Los Peñasquitos Preserve, a salt marsh that provides a vital resting place for migrating birds. Viewing platforms along the cliffs are prime perches from which to observe the yearly migration of the gray whales and the dolphins that patrol offshore year-round. Seals and sea lions can be spotted, too, and occasionally in the shallower waters, you'll see spotted leopard rays and sharks. Sunsets are legendary from here. Many visitors are able to see the green flash optical illusion, when it appears that a green ray shoots up from the top of the setting sun.

At the adobe-block visitor's center, built in 1922, history and nature exhibits and a native plant garden are introductions to the delights to be found along the inland walking trails. In this rather arid climate, ferns and cacti, Monterey cypress, palms, and wildflowers are at their peak in the early spring.

Beach-lovers will find that a walk on the sands of Torrey Pines State Beach has its reward: a majestic ensemble of boulders as tall as three-story buildings. The beach stretches four-and-a-half miles from Del Mar past Los Peñasquitos Marsh Natural Preserve to the base of the cliffs at Torrey Pines Mesa. Intertidal zones along the sand are rich in sea life, including limpets, crabs, anemones, and various types of snails and shells. Great egrets stalk in the shallows, while western sandpipers and snowy plovers pick among the rocks and pelicans swoop low over the surface of the ocean.

Just off Torrey Pines Scenic Drive, overlooking Black's Beach (a clothing-optional beach frequented by University of San Diego students), Torrey Pines Gliderport has been a soaring site since 1928 and participated in pioneering motorless aviation. Charles Lindbergh was one of the first to fly a sailplane from the top of nearby Mount Soledad, using the lift generated by the Torrey Pines cliffs to land far down the beach. Prior to and during World War II, pilots trained here

Joggers, walkers, hikers, and mountain bikers all enjoy the miles of trails that traverse through the Los Peñasquitos Canyon Preserve in San Diego.

OPPOSITE: A living history museum, the Old Town San Diego State Historic Park, with its many outdoor bazaar gift shops, allows tourists to take home a keepsake to remind them of California's early heritage.

on gliders at Torrey Pines. Today, the facility is a center for hang gliding, paragliding, scale models, and sailplane flight. Relaxing on the benches provided, visitors become mesmerized by the miraculous feats of flight and the views down the coastline.

On the southeast end of the park on the campus of the University of California San Diego is a trove of spectacular contemporary architecture, notably William Pereira's modernist showpiece, the spacecraft-like Geisel Library. The eight-story, lantern-shaped tower is named in honor of author Theodor Seuss Geisel, better known as Dr. Seuss, who was a longtime resident of the area. When lit up at night, the building resembles a spaceship that has just landed. The doors of the library are actually an art installation entitled *Read/ Write/Think/Dream*, combining images on the colored glass doors, the benches, and the glass panels of the lobby.

Along the impressive Library Walk leading to the building, and throughout much of the campus, are striking sculptures, such as a fourteen-foot-tall, multicolored birdlike creature and a standing female

THE SPANISH AT POINT LOMA

THE SOUTHWESTERNMOST BIT OF LAND IN CALIFORNIA, high above the vacation wonderland city of San Diego, Point Loma was first sighted by a European in September 1542. When Juan Rodriguez Cabrillo sailed past the peninsula into the bay flying the red cross of Spain, his flagship galleon, the *San Salvador*, and two caravels must have been impressive and terrifying to the area's Native Americans. One hundred feet long and twenty-five feet wide, the *San Salvador* had about one hundred soldiers, sailors, and slaves on board, plus chickens, sheep, and a few horses, which had never been seen before by the natives.

The promise of gold convinced the Spanish of the 1500s to explore and eventually to claim the entire coastline of California. Cabrillo was searching for a river that was believed to connect the Pacific and Atlantic oceans. He had orders from the king of Spain to claim all the land north of what is now Baja, California. In 1769, the Spanish returned in earnest to set up housekeeping, building a military presidio and the first in a chain of Spanish missions on the El Camino Real—the "King's Road"—which ultimately stretched four hundred miles north. Thus, San Diego became the birthplace of California.

At the tip of Point Loma, the Cabrillo National Monument heralds in dioramas and exhibits the lasting influence of the Spanish, and later the Mexicans, in the New World. Sea winds blow ceaselessly on the green, chaparral-covered bluff, which is topped by the 1850s-era Old Point Loma Lighthouse. Visitors peek into the tide pools, stroll on two miles of trails, and peer out over the ocean during the winter months to see gray whales migrating to and from Mexico.

Four hundred twenty-two feet below the top of the peninsula, laid out just north of the border with Mexico, the city of San Diego lolls on a coastal plain facing a calm bay. It's protected from Pacific squalls and winds by an isthmus and the curve of Point Loma. Sunseekers flock to the warm waters and white sands on seventy miles of beaches, from the surfer's waves at Pacific and Mission beaches to the jewel-like coves of La Jolla and a chain of sandy strands in North County. It is hard to imagine a place on earth as perfectly designed by nature for enjoying the seaside.

with outstretched arms from which water flows. On the lawn near Galbraith Hall are seventy-one pink and gray granite blocks reminiscent of posts, lintels, columns, arches, windows, doorways, and thresholds, while another installation consists of seven pairs of words—vices and virtues—superimposed in blinking neon as a frieze around the top of a building.

An old cannon in Washington Square sits in the heart of the main plaza in Old Town San Diego State Historic Park, which re-creates and commemorates the city as it was in the mid-1800s.

INDEX

ABOUT THE AUTHOR AND PHOTOGRAPHER

Karen Misuraca is a travel writer from Sonoma, specializing in the subjects of golf and sustainable travel. She is the award-winning author of *The California Coast*, as well as *Our San Francisco*, *Backroads of the California Wine Country*, *The 100 Best Golf Resorts of the World*, *Fun with the Family in Northern California*, *Quick Escapes from San Francisco*, and other travel books. She is the founder of BestGolfResortsofTheWorld.com and contributes to a variety of publications, writing about "green" tourism, luxury resorts, and all things California.

When not discovering hidden gems along California's backroads, Karen enjoys the outdoors with her husband, Michael Capp, her three daughters, and a lively contingent of grandchildren.

Gary Crabbe is the owner of Enlightened Images Photography and the photographer for Voyageur Press's *Our San Francisco*, *Backroads of the California Wine Country*, and *The California Coast*. His other clients include the National Geographic Society, the *New York Times*, *Forbes*, L.L.Bean, the Nature Conservancy, and the Carnegie Museum of Natural History. He sells fine-art prints, murals, stock, and assignment photography through his website, www.enlightphoto.com.